Judith Evans Hanhisalo is an art historian who lectures at the Berklee College of Music in Boston, the Museum of Fine Arts in Boston, and the Isabella Stewart Gardner Museum. She holds degrees in art history and classical civilization and has written many articles on art in the *New Boston Review*.

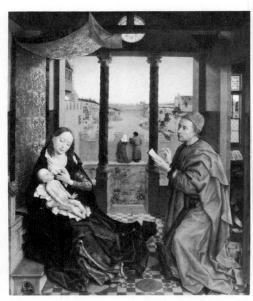

Judith Evans Hanhisalo

ENJOYING
ART

Painting, Sculpture, Architecture, & the Decorative Arts

A SPECTRUM BOOK

Prentice-Hall, Inc., Englewood Cliffs, New Jersey 07632

Library of Congress Cataloging in Publication Data

Hanhisalo, Judith Evans (date)
 Enjoying art.

 "A Spectrum Book."
 Bibliography: p.
 Includes index.
 1. Art appreciation. I. Title.
N7477.H36 1983 701'.1 82-19482
ISBN 0-13-281592-3
ISBN 0-13-281584-2 (pbk.)

10 9 8 7 6 5 4 3 2 1

Editorial/production supervision, interior
 design, and page layout by Maria Carella
Cover design by Hal Siegel
Manufacturing buyers: Christine Johnston
 and Cathie Lenard

ISBN 0-13-281592-3

ISBN 0-13-281584-2 {PBK.}

This book is available at a special discount when ordered
in bulk quantities. Contact Prentice-Hall, Inc.,
General Publishing Division, Special Sales, Englewood Cliffs, N. J. 07632.

Prentice-Hall International, Inc., *London*
Prentice-Hall of Australia Pty. Limited, *Sydney*
Prentice-Hall Canada Inc., *Toronto*
Prentice-Hall of India Private Limited, *New Delhi*
Prentice-Hall of Japan, Inc., *Tokyo*
Prentice-Hall of Southeast Asia Pte. Ltd., *Singapore*
Whitehall Books Limited, *Wellington, New Zealand*
Editora Prentice-Hall do Brasil Ltda., *Rio de Janeiro*

For _____

*Cornelius C. Vermeule III
and Malcolm E. Agnew—
beloved mentors*

Contents

Preface

This book will be useful both for the student in an art appreciation course and the individual who wants to learn about art on his or her own. Technical, compositional, and stylistic elements of art are discussed in detail, and there are numerous illustrations, drawn mostly from American collections. The reader also has guidelines for understanding the impact of a work of art and for judging its quality. After each section there are self-help exercises, in which questions are arranged so that by answering them the reader can apply the ideas in the book to works of art seen at firsthand. Classroom teachers will find the exercises useful for homework assignments or the basis of in-class discussions.

Enjoying Art brings together technical, analytical, and interpretive information in one informally written and compact volume. People with and without an art history background can use it to increase their understanding of the creation and organization of works of art from many different times and places. A short annotated bibliography directs the interested reader to more specialized sources of information.

The book is divided into four main sections: *Materials and Techniques, Organization and Arrangement, Impact,* and *Style. Materials and Techniques* describes in detail the technical processes used by artists, using specific examples. The meaning of each process is also evaluated. What are the limits and strengths of materials and technical skills? How can the viewer use this information to better understand the work itself?

Color, light, perspective, symmetry, entrances, and exits are some of the topics discussed in *Organization and Arrangement.* All the visual arts use similar concepts of composition to gain the maximum impact from each work. Examples chosen from paintings, sculpture, buildings, and prints—from antiquity to the present day— illustrate each concept.

Impact is the psychological aspect of the arts. Why is a work of art done the way it is? What is the artist trying to say? How does the artist judge how people will react to a work and how does he or she manipulate this reaction? The elusive idea of quality is also considered here.

Style is a much-used and misused word. Certain periods in time are said to have a unique style. *Enjoying Art* examines works from the major and minor visual arts from the same time and place to see what they have in common. Rembrandt and Picasso each had a style of his own. What is it? How can the viewer distinguish one artist's style from another's? By looking at the style of a time, at the style of some individual artists, and at the development of an artist's style over a career, the viewer can identify and evaluate different kinds of styles.

Enjoying Art helps the individual learn about art from many different angles, but with a constant emphasis on personal interaction between object and viewer.

ACKNOWLEDGMENTS
A great many people have contributed to this project. Joel Babb, Marie Diamond, Anthony E. Kurneta, and Ann Sievers offered critical comments. Karen Haas, Mirek Kocandrle, Sue Reed, Mary Robinson, and Janice Sorkow helped with the illustrations. Bryn E. Evans of the Paul Revere House provided up-to-date information and a photograph. Ann Griffith and Frank Buda of Longfellow House allowed photography there. Ellen Stathis typed the manuscript in record time. Mary E. Kennan of Prentice-Hall initiated the project and saw it through its long development. I would particularly like to thank Dr. Jan Fontein, Director of the Museum of Fine Arts in Boston, and Mr. Rollin van N. Hadley, Director of the Isabella Stewart Gardner Museum, for their generosity in permitting me to use photographs from the collections of their museums. Mr. and Mrs. Philip L. Evans have provided everything from moral support to proofreading. Fred Hanhisalo should be listed as coauthor, editor, quality control engineer, and too many other things to mention.

Judith Evans Hanhisalo
Braintree, Massachusetts

Enjoying Art ————————————————————————————

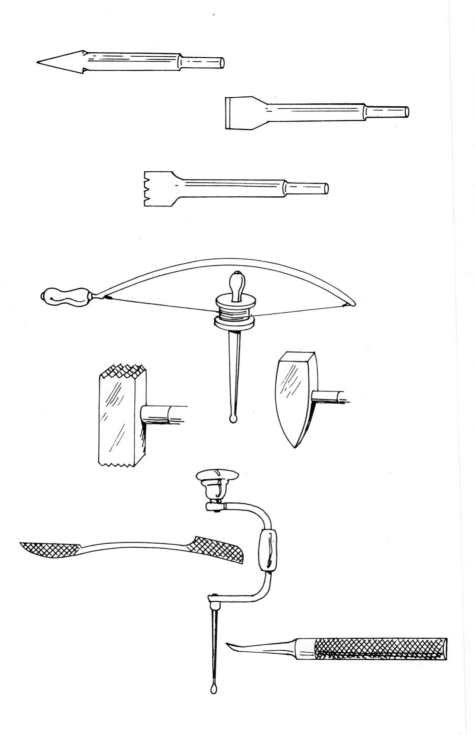

Part One
MATERIALS AND TECHNIQUES

In order to understand a work of art fully, it is necessary to understand how it was done. Throughout history new materials have become available to artists and new processes have been invented. The artists have responded to these changes by exploring their potentials and branching out into previously unknown areas. Technical advances have been responsible for major steps in the history of art. Bronze casting allowed the Greeks to show movement in their statues; oil paints freed artists from the limitations of tempera. The artistic imagination thus achieved more freedom as new materials and techniques were developed.

In this section of the book I explore the various ways in which painters, sculptors, architects, and printmakers have practiced their arts. A short history of each technique is also included. Each section is followed by a series of exercises designed to help the reader identify techniques by looking.

Let the reader beware, though. As the science of laboratory restoration and analysis becomes more and more accurate, new information about techniques, old and new, is becoming available. Assumptions are being questioned and in some cases discarded. Although the information here is as accurate as possible, tomorrow may bring something new.

Painting 1

Fresco

A **fresco** is a painting done on wet plaster. It is usually on a wall or ceiling, but the fresco on a portable backing occasionally does occur. Over the years a combination of gases in the air and the lime in the plaster form a permanent bond betweeen painting and surface. This permanency is the medium's chief virtue and explains its widespread use despite the laborious painting process.

Walls or ceilings, whether of stone, brick, or wood lathe, are never suitable in themselves as a surface for painting. They require special preparation, including the building up of layers of plaster until a properly hard and yet rough surface is obtained. The roughness is necessary to hold the top layer, which takes the actual pigment. As this top layer dries, the paint in it becomes part of the building itself. During various periods in history frescoes have been used for walls and ceilings both inside and out, for homes, temples, public meeting halls, tombs, and churches. They have depicted subjects from the sublime to the grotesque. Botticelli once painted a graceful and delicate fresco of a public hanging.

What all frescoes have in common is the inflexibility of their technique. A contemporary Mexican frescoist works in the same

manner as Giotto or Michelangelo did. Although the Renaissance fresco technique is relatively well understood, far less is known about exactly how frescoes were prepared in early civilizations. They all, however, share the fundamental principle of pigment on wet plaster.

The word "fresco" is Italian for "fresh." It is not interchangeable with **mural**, which simply means a wall painting. The term **true fresco**, actually a redundancy, is frequently used to distinguish the use of actual fresco and *fresco secco*, or dry fresco. The latter is actually inappropriate because a dry fresh is a contradiction in terms. Books and museum labels, however, do misuse "fresco," and it is up to the viewer to decide what he or she is really looking at.

HISTORY

Among the earliest works ever created are the wall paintings in caves, which are 10,000 to 15,000 years old. Deep in low, dark caves, using natural pigments bound with animal fat, artists painted animals and people. Since the animals were often shown as the targets of hunts, representing them was probably a form of magic. To depict a successful end to the hunt may have been a ritual which, it was hoped, would bring food to the community from future hunts. Despite this utilitarian function, the Paleolithic painter showed an interest in making his animals recognizable and, in some instances, beautiful. However, aesthetic fulfillment was not the primary goal. The artist crawled through narrow, twisting passages to the furthest reaches of his cave home to paint where the sun never shone. His audience was clearly not the casual visitor; that his work existed was enough.

Many ancient civilizations made the wall a target for their artistic ambitions. The Egyptians painted the walls of tombs with elaborate murals showing their earthly lives and afterlives. Although there is some evidence that Egyptian artists did know about fresco at a very early period, they did not use it widely. Wall paintings were done with pigments mixed with gum and water and were built up in layers on a dry wall. It is possible that egg or wax was sometimes used to bind the pigments together. For instance a fully dressed woman would first be painted nude, then her clothing, jewelry, wig, and makeup would be added. Interestingly enough, the paintings wear off in exactly the same order, often giving a somewhat false impression of Egyptian morality. Because the Egyptians did not use fresco, much of their mural-painting has faded or worn away, leaving the brilliant color that characterized almost all Egyptian objects largely to the imagination.

On the opposite side of the Mediterranean, a Bronze Age civilization rich in frescoes developed in mainland Greece and the Greek

islands, especially Crete. These cultures had been almost entirely forgotten until the early scientific archaeologists began to excavate their cities in the middle of the last century. The Minoans of Crete, and later the mainland Mycenaeans, built splendid palaces and painted their walls with brilliantly colored representations of their lives, their religion, and the world around them. Fortunately many of their paintings survive and excavations are turning up new ones in good condition even today.

The wall paintings of the Minoans and Mycenaeans were painted on wet stucco and therefore are frescoes. This fact has undoubtedly contributed to their remarkable survival through earthquakes, fires, invasions, and in some cases modern warfare. It is possible, although not proven, that the technique of fresco was learned from the early Egyptians, and its possibilities appreciated by the borrowers as it had not been by the originators. The subject matter and style of Minoan and Mycenaean painting, however, in no way resembles the serious Egyptian preoccupation with the afterlife. The Bronze Age peoples of the Aegean celebrated life; their paintings, with their broad range of color and vivid draftsmanship, bring them alive today (Figure 1).

The Etruscans, a group of people who lived in Italy before the Romans, also painted frescoes. Like the Egyptians, they have left only their tomb paintings, but this seems to be accidental. When the Romans overwhelmed the Etruscans and occupied their cities, they left only the Etruscans' underground tombs to bear witness to this artistic tradition. Much research remains to be done on the techniques of the Etruscans, but it is certain that the application of color to the wall in their paintings was done while the plaster was wet. They incised sketches before painting to offer the artist a guide, and these can often be seen through the finished work. Painting in damp tombs

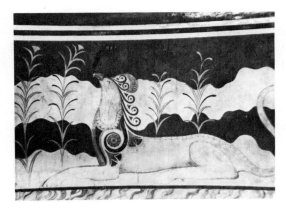

**1 Minoan
Fresco, Crete (reproduction),**
ca. 1500 B.C.
Photo by Fred Hanhisalo

made working in fresco easier than it would have been in a dry climate like that of Egypt; this may have influenced their choice of medium. Other media besides fresco may also have been used in Etruscan tomb-painting, but there is no agreement about this among scholars.

The Greeks, who gave mankind so much in the other arts, left almost no painting. They did paint, so their writings tell us; but what little has survived is far from enough to give us a picture of what Greek murals were like. It is possible that the lost Greek murals were frescoes, since the Greeks were always aware of the finest technologies of their time; but without much more evidence than exists today, nothing really certain can be said.

Fortunately the same situation does not exist for the work of the Romans. Roman wall paintings, both from the capital and from the destroyed cities around Pompeii, abound. As you might expect, a large and sophisticated world such as that of the Roman Empire of the first century A.D. used a wide range of mural-painting techniques. The first-century writer Vitruvius advised that

> colours, when they are carefully laid on stucco still wet, do not fade but are permanent. This is because the lime, having had its moisture burned out in the kiln, becomes porous and loses its strength, and its dryness makes it take up anything that may come into contact with it. On mixing with the seeds or elements that come from other substances, it forms a solid mass with them and, no matter what the constituent parts may then be, it must, obviously, on becoming dry, possess the qualities which are peculiar to its own nature.*

METHODS

In 1968 the Metropolitan Museum of Art in New York held an exhibition called *The Great Age of Fresco*. In the exhibit were seventy Florentine frescoes and, in many cases, the preparatory drawings done for them.† The Great Age was defined as lasting from the time of Giotto, around 1300, to that of Pontormo, in the sixteenth century. It was during those years that hundreds of churches, palaces, and public buildings in Italy were covered with frescoes, both inside and out. Unfortunately no exterior frescoes survive, but those painted on the interior walls are enough to present a picture of variety, ingenuity, and splendor.

It is also largely due to the careful study of fresco technique during the preparation of the 1968 exhibition that the exact methods used in Renaissance frescoes have come to light. Much of the infor-

*Vitruvius, *The Ten Books on Architecture*, trans. Morris H. Morgan. New York: Dover Publications, Inc., 1960, p. 207.
†The Metropolitan Museum of Art, *The Great Age of Fresco*, New York, 1968.

mation discovered then had been known previously from scholarly writings, but they now have been supported by careful examination of the paintings both on and off the walls.

In general, a Renaissance painter worked as part of a studio. He was apprenticed as a youth to a master for whom he could carry out menial tasks as he learned. Over the years he was taught the techniques of his craft and, if he had the talent, eventually became the master of his own studio. Painters belonged to the guild of St. Luke, patron of artists, in their home town and worked in other places with the permission of that town's guild.

Fresco commissions were usually for more than one painting. Often a monastic order would want an entire chapel, dining hall, or chapter house covered with appropriate frescoes. Upon receiving an order, the master artist negotiated a contract and began work with his assistants. While the master painter debated the subject matter for the paintings with the patron, his assistants prepared the walls to be painted. No ordinary wall is suitable for fresco. The wall must be even, although not completely smooth, and all holes, protuberances, and other obstacles must be removed. Doors and windows have to be worked into the painting in such a way that they will not detract from its impact. This was frequently done by incorporating them into the subject matter, and sometimes even having painted figures appear to step out over their frames.

First a foundation layer of plaster, called the *arriccio,* was laid. This was left rough so that it would be able to grip the layer to come above it, but it was consistent over its surface. Then a preparatory drawing was done by the artist. There were several methods available for this during the Renaissance, and their use seems to have been largely a matter of individual preference.

Some artists chose to do a full-size drawing in charcoal directly on the *arriccio.* This had the advantage that all of the problems associated with that particular wall would be evident during the preparatory stages and solutions could be found before any painting was done. It had the disadvantage that it can be difficult to be spontaneous when you are always having to move a ladder. When a final version of the charcoal drawing was decided on it was traced in pale red ochre and the charcoal was rubbed off. The artist was free to redraw a portion of the fresco as many times as necessary, preserving only the final version. The red earth color used in these drawings is called *sinopia,* and the term *sinopie* (plural) has come to refer to the drawings themselves.

Another solution to the problem of the preliminary sketch was to use sheets of paper the size of the wall to be painted. The artist could draw on a flat surface while keeping before him the dimensions

of the final work. The drawing was laid on top of another paper the same size and holes were pricked in it with a needle or other sharp tool along the drawn lines. Then the underneath paper, which now held a copy of the drawing made of holes, was fastened to the walls and charcoal dust was pounded through the holes to make a drawing in dots on the wall itself. This method is called *spolvero* (pouncing or dusting) and is done not on the *arriccio,* but on the layer above it.

A variant on the *spolvero* method was drawing on fairly thin paper and then placing it directly on the wall. Then a sharp instrument was used to trace the drawing into the fresh plaster of the *intonaco,* or top layer of plaster.

Perhaps the easiest way to do a preparatory drawing for a fresco is to draw on a small sheet of paper divided into a grid. Each section of the grid is then enlarged by copying it individually onto a bigger paper which is traced onto the wall. This method has its pitfalls. Often a composition that is successful on the scale of an easel painting works less well on a wall. Small details that can be seen easily close-up are often confusing when they appear at the top of a fifty-foot wall.

Having finished the preparatory sketch by any of the above methods, the artist began to paint. Fresh, fine plaster was laid on top of the *arriccio.* Each day only the amount of plaster that could be painted on before it dried was laid between dawn and dusk of one day. The first plaster was laid on the upper left-hand corner so that drips and spills would go onto the unpainted *arriccio.* The following day another area of plaster was laid next to the first and painted on. This continued until the painting was done. Each day's plaster was called a *giornate,* or day's work, and together the *giornate* formed the *intonaco,* or top layer of the painting. When the plaster dried the paint (which is pigment mixed with lime and water) was bonded to the *intonaco,* and became a permanent part of it.

Fresco color is matte, not shiny and it is deeply luminous. The number of actual pigments that work well with fresco are limited. This leads to a certain uniformity of color, which, rather than detracting from the frescoes lends them an air of dignity and restraint. The artist has to know from experience what the colors will look like when dry because their appearance is different when they are applied.

Touching up a fresco is possible, but it is difficult and the additions are never permanent. Artists and early restorers quite frequently used egg tempera paint to make alterations on frescoes, but with time they flake off. The medium is also difficult to modify and many experiments with modifications have proved disastrous. Leonardo da Vinci was too impatient to work in the immensely slow fresco technique in his famous *Last Supper.* Instead he painted di-

rectly on the dry *intonaco* with a paint of his own composition. The painting began to deteriorate while the artist was still alive and is today undergoing extensive restoration.

Like anything, fresco has advantages and disadvantages. It is slow, tedious, and demanding. Its complicated process is inflexible and does not allow the kind of freedom of expression some artists demand. On the plus side, it produces deep, glowing colors and is extremely durable. The surface of a fresco is even water-resistant to an extent. Fresco is the medium in which many of the great works of western art have been painted. Artists have been attracted to its potential for dignity and monumentality and have found a challenge in working within the framework of architecture. The ideal fresco composition is clear and easily discerned at a distance. Figure 2 shows a fourteenth-century fresco of the Crucifixion by the Master of the Cornonation of Urbino, in which large figures, clearly distinguished and evenly spaced, make the religious message direct and understandable. Fussiness or small details result in a confusing painting. Among the Renaissance artists who painted in fresco are Giotto, Raphael, Michelangelo, Piero della Francesca, Fra Angelico, and Pontormo. Their works are still admired today as some of the finest ever produced in any medium.

2 MASTER OF THE CORONATION OF URBINO
Crucifixion, 14th century
Courtesy Museum of Fine Arts. Boston. Augustus Hemenway Fund.

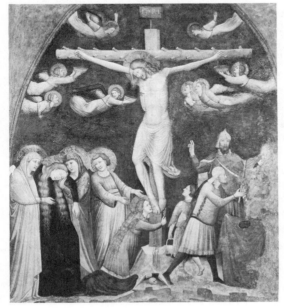

After the sixteenth century fewer painters worked in fresco, largely due to the growing popularity of oil paint and the availability of large canvases. By the nineteenth century hardly any fresco was being done. Today, however, a number of artists, mainly Mexican, have begun to use this ancient medium. The frescoes of such artists as Orozco and Rivera on buildings in Mexico have become a new art for the people. Exterior frescoes, in particular, are not for private viewing; they are available to people who would not go to a museum.

REMOVING FRESCOES

In a very human way, the owners of frescoes have sometimes wanted them in a place other than where they were painted. This presents numerous difficulties, since the fresco is part of the building itself. In the past, entire walls were removed to change the position of a fresco. Chains were then fastened around the wall and it was dragged off to its new location. Fortunately this is no longer necessary, as modern restorers can readily remove frescoes from their walls without damaging them.

The biggest test of the techniques for removing frescoes came in 1966 when the Arno River flooded Florence. Several feet of oily, polluted water poured through the city, flowing into Renaissance buildings and endangering hundreds of frescoes.

There are two ways to remove frescoes, both of which were used in Florence. If the *intonaco* has decayed and shows serious cracking, the thin surface layer which holds the color can be separated and removed. As the fresco deteriorates the color begins to separate naturally and the restorer is actually completing the process that natural forces began. If the surface is in reasonably good condition, the whole *intonaco* will be removed.

In either method a cut is made around all sides of the fresco and a thick layer or two of canvas is attached to the surface with a water-soluble glue. If the *stacco,* or *whole intonaco* method is being used, the painting is gradually loosened by prying and by lightly tapping its edges. Once it is loose, the fresco is snapped off in one piece and the front canvas is removed with water. Traditional *stacco* removal ended at that point. The painting was placed in a heavy frame and its back was cleaned until the surface was even. Today, however, much of the *intonaco* is removed from the back and the fresco is mounted on a fresh support, usually of masonite.

In the *strappo,* or color only, method, the surface to be removed is so thin that it is flexible and can be peeled away from the wall. The canvas glued to the front holds the surface together during the separation and it is removed when the painting is mounted on its per-

manent backing. Both methods were used intensively during the rescue efforts to preserve some of humanity's finest paintings after the Florentine flood.

Tempera

Before the 1400s, a painter involved in works other than fresco used mostly **egg tempera**. This medium, made of egg yolk and pigment, accounts for almost all the nonwall paintings before the 1420s in Northern Europe and before the 1480s or 1490s in Italy. Tempera, like fresco, is a demanding medium whose disadvantages led to its gradual abandonment in the fifteenth century. In the twentieth century a few painters revived the use of tempera and it is now available in a synthetic form. The foremost example of a contemporary tempera painter is Andrew Wyeth, who finds its difficulties challenging and its clarity and definition perfectly suited to his particular style.

Tempera, unlike oil, is a transparent medium. It has to be built up in layers to achieve an opaque appearance. This layering technique results in a thick paint surface that requires a sturdy support, usually a wooden panel. Tempera can be done on canvas, but this requires a good deal of preparation to make the canvas inflexible.

The primary advantage of tempera painting is its durability. An egg tempera painting will fade as much in five hundred years as an oil painting will in thirty years. Since most tempera paintings were done for churches and were regarded as permanent monuments, this was important. Tempera also gives an extremely attractive bright glossy surface. The subjects of a tempera painting do not look as real as those in an oil painting because of the medium's hardness, but the painting has a jewel-like perfection. Most temperas, because of their time period, dealt with realistic subjects, but there are also abstract temperas. The nature of the medium gives these abstracts an almost other-worldly appearance.

However the very permanence of tempera is also a drawback, and may have led to its demise as a major painting medium. Acrylic paint comes off in water; oil in turpentine. Tempera dries almost immediately and does not come off unless it is scraped off, which ruins the painting. This, quite naturally, led to a certain conservatism among tempera painters. If your every brushstroke is for forever, you had better be sure of what you want before you do anything.

METHODS
The best description of the late medieval and Renaissance use of tempera comes from *The Craftsman's Handbook (Libro dell'arte)* by

Cennino Cennini, written around 1440. The twentieth-century notion of speedy production was, fortunately, not yet in existence, since the process of painting with tempera took several years to complete. The use of wood caused problems because wood changes shape as it dries and cures. This expansion and contraction would be disastrous to an already-painted panel. Therefore the artist's first concern was to prepare a perfectly flat, dry panel on which to paint. Cennini recommended that a soft wood be used, the planks should be allowed to dry for a year or two. After this the wood was made into panels which were also cured, preferably in the rafters of a barn or similar open space. The fully cured panels should be kept in the studio for several weeks more, while the artist examines them for warping or other damage.

The panels, which can be of various shapes and sizes, plain or lavishly carved, are then sized and covered with **gesso,** a white, plaster-like substance. Untreated wood absorbs paint and shows its grain, so a smooth, nonabsorbent surface has to be placed on the wood. **Sizing** is a process that fills the pores of the wooden panel and reduces its absorbency. Many different preparations, some using glue and sawdust, vinegar, or honey have been used by painters.

After the size is dry, gesso is applied to the panel to create a smooth surface for the painting. Although its composition varies from artist to artist, gesso is generally a mixture of chalk and glue. Gesso is applied in layers, but all the layers must be applied before the lower layers have dried thoroughly. Gesso can not be added to completely dry gesso without the risk of separating the layers. Many painters applied two types of gesso: *gesso grosso,* thick gesso, followed by *gesso sottile,* thin gesso. Normally you would have twice as many layers of *gesso sottile* as *gesso grosso. Gesso sottile* is so thin that it is almost transparent when it goes on. It is the finest possible ground for painting or gilding; ivory-like in its hardness and regularity. If the panel has a carved frame, it is also coated with gesso. Additional texture can be given to the panel by modelling the gesso. This is sometimes done to suggest the texture of the rich clothing worn by figures in biblical scenes. The process of modelling the gesso to achieve these effects is called working *pastiglia.*

While the panel was being prepared, often by experienced assistants, the artist would do preliminary drawings and make major decisions about composition, color, and detail. As soon as the gesso was dry, the final composition was drawn in ink on the gesso. Changes could be made by rubbing away the ink. The final version of the composition was etched into the gesso with a sharp tool, usually a needle.

Most tempera paintings, particularly those done before the middle of the fifteenth century, include a substantial amount of gold leaf.

Gold leaf is a thin sheet or leaf of beaten gold. It was used on halos, clothes, and entire backgrounds of many paintings. The gold leaf was applied before the paint itself went onto the panel, and could, if necessary be painted over. The effect of this gilding was to make the paintings look as if they were painted on solid gold (Figure 3).

Gilding is a tricky process which requires special tools (Figure 4). The biggest problem is the fragility of the leaf, which has a distressing tendency to turn into gold dust when handled. The gold leaf used in the Renaissance was thicker than that used today but still thin enough to cause problems.

3 NICCOLO DI TOMMASO
Virgin and Child, 14th century
Courtesy Museum of Fine Arts, Boston. Gift of Dr. Eliot Hubbard.

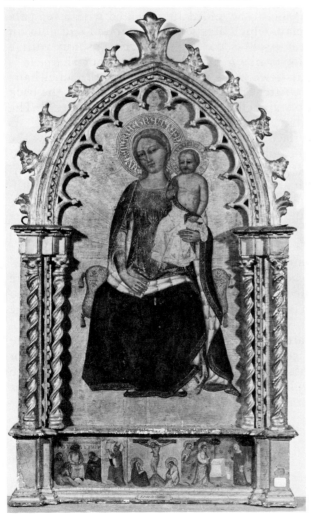

4 Gilder's tools. Gilder's knife (a) and
gilder's tips (b) are used in
the process of tempera painting. (c) shows
the tip in use—picking up gold leaf
on the tip for oil gilding.

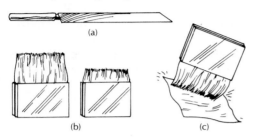

(a)

(b) (c)

The areas of the panel to be gilded are prepared with a red sub-
stance called **gilder's clay,** which acts as both a ground and glue for
the gold. The gold leaf itself is cut on a gilder's cushion with a
gilder's knife, which looks like a table knife and is not sharp. It is
lifted with a gilder's tip—two cards glued together with camel hairs
inserted between them. After brushing the gilder's tip across the back
of the hand to build up static electricity, it is held over the gold. The
gold, caught by the static electricity, adheres to the tip until it is
placed onto another surface. Today many tempera paintings show the
gilder's clay through the gold leaf, giving an unintended reddish cast.

After it has adhered firmly to the panel, the gold leaf is bur-
nished or polished with a variety of tools. It is also worked into cloth-
ing, halos, and lettering. Details are stamped or punched with tools
that look like miniature bookbinder's or leatherworker's tools. Some
artists modelled the entire background of the tempera paintings in
gold leaf to look like a rich brocade drape (Figure 5). Others left the
gold leaf relatively plain, possibly with a geometric border of small
touches around the heads of important figures. Gold leaf details are
also sometimes obtained by painting with gold dust.

Tempera paint is made of pigment and egg yolk. Sometimes egg
white is used, but the yolk is more satisfactory. The colors are ob-
tained from natural earths like iron and manganese ores, which are
treated and mixed to get a variety of hues. Lead white is used for
white. Opaque pigments work better than transparent ones, since the
binder itself (the egg yolk) is transparent. Within these limits, a great
many colors can be obtained.

5 CARLO CRIVELLI
Virgin with Dead Christ, 1485
Courtesy Museum of Fine Arts, Boston.
Anonymous gift and James Fund.

14

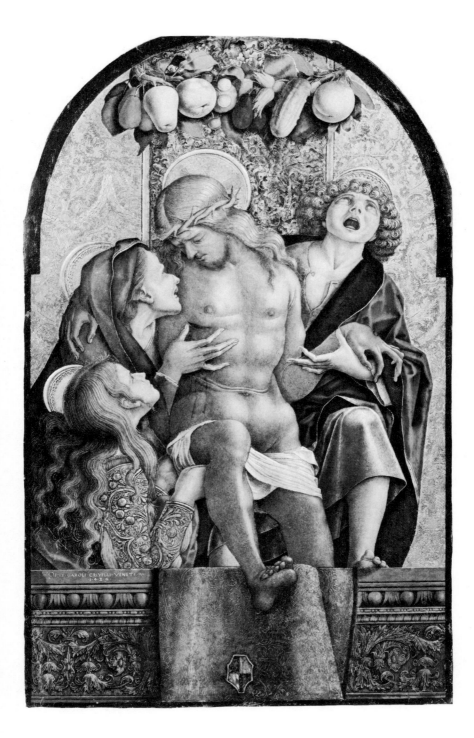

The pigment is finely ground and mixed with egg yolk and water to help the mixture to flow easily. After the egg was broken into the palm of the hand, the white was allowed to run out between the fingers. In the Middle Ages and the Renaissance, small amounts of paint were often kept in sea shells. Because egg yolk was used as a binder, egg tempera could not be stored for future use. It began to rot and smell within two or three days, even if kept in a cool room. New paintings could be a bit odoriferous, as well. Flesh tones were underpainted in *terre verte*, or earth green. When the basically reddish skin colors were added, they were left thin in places where modelling or shadows were desired, allowing the *terre verte* to show through. Since red and green are complements (see Chapter 7, color section), the effect was that of a shadow. Unfortunately, the green has bled through the skin tones in many early temperas, giving the subjects an oddly bilious appearance.

Over the years, tempera paintings have suffered this bleeding through of the *terre verte* as well as from an overall cracking of the surface. But, unless the panel was improperly cured, they are extremely durable, long-lasting paintings. Most of the temperas in museums were done in Italy and date from around 1250 to 1450. An example is a work done in the mid-fourteenth century by Barna da Siena, called *The Marriage of St. Catherine* (Figure 6). This altarpiece, intended originally for a chapel, consists of a large scene with three smaller ones beneath it, all on the same piece of wooden paneling. The principal one is the Mystical Marriage of St. Catherine of Siena to Christ. The major figures are seen against a plain gold background, giving them a feeling of existing in infinite space. Between the figures is a bench on which are seated the Virgin, St. Anne, and the infant Jesus. The figures are stiff and the clothing abounds with elaborate

6 BARNA DA SIENA
The Marriage of St. Catherine,
14th century
Courtesy Museum of Fine Arts, Boston.
Sarah Wyman Whitman Fund.

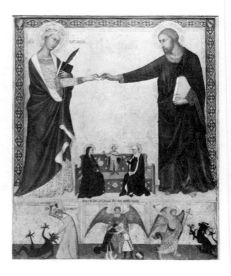

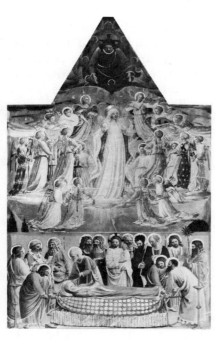

7 FRA ANGELICO
The Death and Assumption of the Virgin
Isabella Stewart Gardner Museum, Boston

patterns. (Tempera is especially suited to small detail and it is diffi-
cult to suggest illusion in the medium.) Catherine, holding a book
and a palm branch, wears a white dress with a complicated design, a
jeweled diadem on her head, and has a halo of concentric circles. Her
name is inscribed on either side of her head. Christ is more simply
dressed in a richly bordered black mantle over a crimson robe. Other
minute details appear on the infant Jesus and on most of the figures
in the small panels below, called *predella* panels.

It is fascinating from a modern viewer's standpoint, that the
medium was not the only restraint inherent in this painting. The
subject is ostensibly the Mystical Marriage, but it was really the set-
tling of a feud between two Sienese families. The two small figures
in the center predella panel are embracing under the eyes of an angel
with golden wings. To the left St. Margaret kills a demon, and on the
right St. Michael scourges a dragon. Evil ends when anger is van-
quished. In the thirteenth century, however, secular painting did not
exist, and a religious simile, a marriage, had to be used. It would be
almost 300 years before secular painting became widely accepted in
Europe.

For sheer craftsmanship it is hard to equal Fra Angelico's *The
Death and Assumption of the Virgin* (Figure 7), painted in Florence
around 1430. This two-part painting shows the Virgin on her death-
bed mourned by Jesus and the apostles. Christ is holding her soul in
His arms. Above, she is lifted into heaven surrounded by angels sing-
ing and playing musical instruments. At the top, Christ receives her

17

into Paradise. This small painting, only about a foot and a half tall, contains an amazing amount of detail. The first thing to catch the eye are the colors. Gold leaf makes up the bed, the halos, the background of the upper scene, and all the details of the costumes. These details were obtained by covering the figural area with gold, then painting over it. When the paint was thoroughly dry, a needle was used to scrape away some of the pigment to allow the complicated designs to show through in gold leaf. No costume design is used more than once. The unfaded blues that provide so much of the rest of the color are made of the gemstone lapis lazuli ground up to powder and mixed with egg yolk. The entire painting glitters with the materials from which it is made. It is not unusual for gems to be used in tempera painting, no expense was too great for a gift to the church.

During the fifteenth century tempera painting was gradually superseded by oil, a more flexible medium. Some paintings were done in a combination of the two media. Sometimes oil was used to achieve subtle effects on faces and clothing in a painting done otherwise in tempera. By 1500, however, almost all nonwall painting was being done in oil, and until the twentieth century tempera was largely a forgotten medium. Artists today use it as a challenge to their skills, or for its particular properties of clarity and brilliance. With the availability of oil and acrylics, however, it is unlikely that tempera will ever again become a dominant medium.

Encaustic

Artists have made many experiments in their search for beauty and permanence. One medium, **encaustic,** or painting in wax, has been used by a small number of artists—both in the remote past and today. The permanence of this method is witnessed by its use for mummy portraits in Roman Egypt. These portraits are still clear today and show the faces of those who have been dead for almost 2000 years with images of haunting beauty.

The method appears to have had some popularity throughout the Roman empire. Pliny, a first-century writer, mentions painting in beeswax. Encaustic was still used in the fifth century, when the physician Aetius recommended varnishing the wax with a drying oil to prevent dust from adhering to the surface.

Despite its permanence, encaustic has never been a leading medium. There was a minor resurgence of its use in the eighteenth century and another in the twentieth, when German artists such as Karl Zerbe worked in this demanding medium.

Perhaps it is the sheer difficulty of the method which explains

its lack of widespread popularity. Encaustic paintings require a firm backing—in the past a wooden panel was used. The preceding section on tempera discusses the difficulties of preparing a wooden panel so that it will not swell and crack the paint. A specially hardened canvas can also be used. Although masonite provides an inflexible foundation for modern encaustics, the method is seldom used.

The procedure for binding pigment to a surface with wax is difficult and frustrating. The surface must be heated so the wax will not congeal too quickly. Ground pigment is mixed with hot liquid wax and resin and applied to the surface before it solidifies from cooling. This wax–paint may be applied with a brush or with metal modeling tools which look like trowels. The finished painting must be bound to its support by *inustion*, passing a heating element over the paint to melt it into the base. The Greeks and Romans used special containers of burning charcoal, but modern artists prefer the control and convenience provided by electric heaters. Once the surface has cooled, it is polished until it has the rich glossiness of an oil painting.

The advantage of permanence does not outweigh the difficulties of using this method. Not only are the mechanics intimidating, it is almost impossible to change the painting after the wax–pigment mixture has been applied. Still, it is thanks to the patience of unknown artists from Egypt with this intractable method that we can see the freshness of faces long-forgotten (Figure 8).

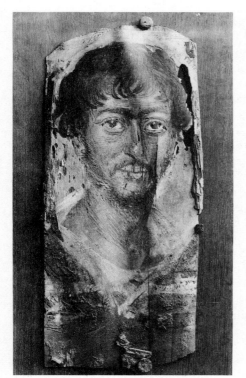

8 Roman Egypt
Head of a Man Painted in Wax,
1st or 2nd century A.D.
Courtesy Museum of Fine Arts, Boston.
Gift of the Egypt Exploration Fund.

Oil Painting

The first written evidence of the use of vegetable oil as a medium for painting comes in manuscripts from the eleventh and twelfth centuries, although the drying qualities of oil and its solubility in turpentine were known as far back as the Roman period. In the sixteenth century Giorgio Vasari, the painter, architect, and biographer, credited Jan van Eyck with the invention of oil paint. Van Eyck, who worked in Flanders in the fifteenth century, was certainly one of the first artists to exploit the capabilities of oil paint, but he did not invent it. Northern Europe had a long tradition of the use of oil before the fifteenth century, but it is during that century that its use expanded and gradually superseded that of tempera.

Venetian painters were the first Italians to explore the new oil medium; their inclination to emphasize color in their work gave them an appreciation of the wide range of pigments that can be used with oil. Such sixteenth-century artists as Titian and Tintoretto painted in the brilliant yet soft and illusionistic manner made possible by oil paint. By the seventeenth century the use of oil had become universal, and such masters as Rembrandt and Rubens thoroughly explored its range of effects. Until the twentieth century and the advent of acrylics, the oil medium dominated the world of painting.

FLEXIBILITY

Flexibility is oil's principal advantage over earlier media such as fresco, tempera, or encaustic. Oil-based paint allows for spontaneity and diversity of expression because it dries so slowly that colors may be blended on the canvas. Oil colors do not change to any noticeable degree when they dry, as paints do in fresco. This stability of oil colors may have prompted Leonardo to his disastrous experiment in combining the two media in his famous *Last Supper*, which immediately began to flake and chip. The slow drying period of oil allows it to be worked over and corrected with ease. It can also be removed with turpentine, a great advantage over tempera and fresco.

The advantage of flexibility overshadows the numerous disadvantages of the medium. Oil shrinks and cracks as it dries, causing great problems for restorers. This is not immediately noticeable because it takes decades or even centuries for oil to dry completely and to crack noticeably. A too-flexible support, drastic changes in temperature and humidity, or simply aging of the dry paint can result in serious cracking, or even crumbling and powdering. Several factors, including the use of too much linseed oil, the yellowing of the protective coat of varnish, or the absorption of the varnish into the paint can cause darkening and yellowing, an effect much admired during

the Victorian period. When one oil painting is done over another or large portions of a painting are redone, a **pentimento** effect can occur, with the bottom layer gradually appearing through the top one. This can create an odd ghostly effect, but not what the artist intended. Finally, oil paint's slow drying time has its own disadvantages. The protective varnish cannot be applied for several months after the completion of the painting. Even after several hundred years, slow chemical changes still take place in the paint.

CANVAS VERSUS WOOD
Before our era, with its accent on disposability, permanence was of great concern to artists who created not just for the contemporary audience but for posterity. Therefore panels continued to be used in preference to canvas in early oil paintings. In the early Renaissance canvas was used for banners but was considered too fragile for more serious applications. Wood is still preferable in some ways, as paintings on wood tend to be better-preserved than those on less-substantial canvas. Cennini describes the treatment of a panel for oil as similar to that for tempera. Several layers of glue were followed by a gesso of plaster of Paris or whiting. Either the gesso was treated so that it would not absorb the oil or a nonabsorbent layer was added to the gesso. Panels were made of different kinds of wood, as they were for tempera. Poplar, oak, and mahogany are the three woods used most often both in the past and today.

If the painting support is a canvas, the ideal is one made from a pure flax fiber with little or no bleaching. In the fifteenth and sixteenth centuries canvases were coated with gesso to provide a stable and pure white undercoat. Unfortunately, if the canvas is rolled, the gesso flakes off, taking the painting with it.

A canvas painting can be thought of as a sandwich, with the visible paint bounded by layers of canvas, size, primer, and varnish. Since canvas is a porous fiber, it allows the paint to be attacked by moisture from behind. To give some protection, a wash of tannic acid or resin and beeswax was used on the back of the canvas. Some contemporary painters recommend backing their canvases with tinfoil to keep them dry and clean.

The front of the canvas is covered with a thin solution of a gluey or resinous substance, both to reduce its absorbency and to make it more receptive to the layers of paint to come. This gluey substance is called **size** and the process is **sizing. Primer,** which is also called **ground,** is applied over the size and consists of a white coating, usually zinc white or titanium white, which gives stability and uniformity of texture to the paint to come. Gesso grounds or primers for oil paintings soon gave way to oil grounds. A canvas prepared in this

way is lighter and more flexible than one primed with gesso, but lacks the high-key whiteness of the earlier primer. A typical oil ground consists of the white pigment and linseed or walnut oil thinned with turpentine. Oil grounds must dry for several months before painting begins. The slow drying rate of oil forces the painter to allow enough drying time between each distinct layer of paint. The alternative is to paint one wet layer on another, but semidry layers cause later deterioration of the work.

COMPOSITION OF OIL PAINTS

The oil in oil paint is usually linseed oil pressed from flax seeds. In the Renaissance walnut oil was popular. Poppy oil has been used by many painters. These oils are called drying oils because, as they dry, they form a resilient film that holds the pigment permanently in place. Today, a typical oil paint contains finely ground pigment, a drying oil, and an inert stabilizing element that prevents the mixture from separating out. The oil may be thinned before use with such mediums as a mixture of varnish and turpentine. Different oils and mixtures have been favored at different periods but it is agreed that one of the finest is Dutch stand oil, a pale, nonyellowing oil which was used by Rembrandt and his contemporaries.

Every painting medium uses pigments appropriate to it. Although few pigments work well with fresco and tempera, oil can use many organic and inorganic pigments to provide a wide range of color effects. Organic pigments come from animal and vegetable sources including dyes obtained from shells. Inorganic pigments result from natural or artificial processes applied to substances which are not of animal or vegetable origin. Black comes from inorganic carbon such as lamp black, charcoal, and ivory black, which is made by heating ivory and bone fragments.

During the Renaissance manufactured paints were not available. Each artist had his apprentices and assistants prepare all his materials. Manufacturing artists' oil paints became a trade in the seventeenth century, when colormen provided pigments for amateur and professional artists. This development was influenced by the breakdown of large studios in favor of more independent artists working without large numbers of assistants. Premixed oil paint was available by the early nineteenth century in a variety of unlikely containers. Pigs' bladders, filled with color then pierced with tacks and squeezed, were tried, as were easily breakable glass tubes. Before the middle of the nineteenth century the appearance of the tin-lined tube signaled the beginning of the modern era in painters' materials. The ease of carrying these tubes contributed greatly to the popularity of painting outdoors.

TECHNIQUES

There are almost as many ways of applying oil paint as there are oil painters; this is the great joy of the medium. An artist can basically work either directly or indirectly, or can combine both methods. **Direct painting** means that the paint is applied in a one-layer process, which gives an immediate and spontaneous effect to the picture. Direct painting is also called *alla prima*, "from the first," and is typical of such modern painters as Cézanne. In the past such painters as Frans Hals and Peter Paul Rubens also painted *alla prima*. Direct painting produces a thick **impasto**, or three-dimensional surface of paint, the texture of which is part of the overall visual effect of the work. Opaque paint consisting of a high ratio of pigment to liquid is used in direct painting, and a white undercoat, if used, gives lightness and sparkle to the picture. Today direct painting is often done by using the paint right from the tube without adding any thinner.

If a painting is done by building up layers of paint, either by painting wet on wet or by allowing sufficient drying time between each layer, it is called **indirect painting.** There are two techniques often used in indirect painting: glazing and scumbling. **Glazing** means applying a transparent layer of very thin color over an undertone, giving a luminous effect. Glazing is a very effective method of creating shadows, among other things, and is part of the secret of Rembrandt's mysterious and haunting lighting effects. Glazing can also give a rich look of suggested color and a strong feeling of atmosphere. **Scumbling** is applying a thin layer of semiopaque color over a dry paint surface without obscuring it. This looser painting method is often used for faces. The artist sometimes uses a rag or his thumb instead of a brush for scumbling, which gives a more general tonal effect than the delicate glazing. It is better, though, to avoid building up too many layers by either glazing or scumbling as they will increase the danger of serious cracking as the painting ages.

Oil paint is applied with a variety of brushes made of either hair or bristle. There are tapered ones, blunt ones, and brushes especially designed to paint with a single stroke. In addition, palette knives and painting knives are used. Palette knives are used to mix paint on the palette and have a flat blade with either a flat or a rounded handle. Painting knives are used to mix colors and to apply paint to the painting and remove it when necessary. They always have rounded handles, although the blades come in many shapes. Heavy globs of paint are sometimes easier to handle with a painting knife than with a brush: some painters, like van Gogh, used it extensively.

Much information about the technique can be gathered from the appearance of the painting's surface. This can be useful in determining the date of the painting because painters from different periods

tended to handle paint in recognizable ways. To illustrate different methods and techniques I have chosen a fifteenth-century Flemish work by Jan van Eyck, a seventeenth-century one by Rembrandt, and a nineteenth-century Impressionist painting by Claude Monet.

Jan van Eyck's *Annunciation* (Figure 9), painted in Flanders in the early fifteenth century, subordinates technique to subject matter.

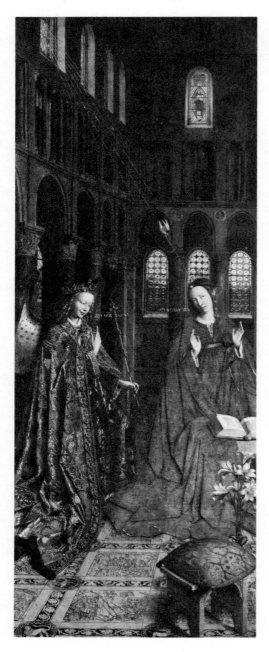

9 JAN VAN EYCK
The Annunciation, ca. 1425–30
National Gallery of Art, Washington.
Andrew W. Mellon Collection.

The painting, a panel 36¾ inches high and 14½ inches wide, was part of a triptych, or three-part altarpiece, for a church. It tells the story of the Archangel Gabriel's announcement to the Virgin Mary that she is to be the mother of Christ. The importance of the angel's message is marked by the way the composition draws the viewer's eye to the angel and to his mouth. The actual text of their remarks is written on the painting, forming a link between them.

This is not a painting that can be grasped quickly; understanding follows long consideration, prayer, or meditation. From a distance, you are aware only of the beauty of the colors. The details come clear only on patient examination. For years scholars thought that the particular color effects achieved by Jan van Eyck and his brother Hubert were the result of painting with oil over tempera. Recent analyses of their paintings have proved otherwise. Pure oil paint was used, built up in many layers over a gesso foundation. The early Flemish painters mixed their oil paint with varnish, giving their colors a quality of technical perfection not found in other oil paints. The varnish came from melted hard resins such as amber or copal, which gives the paint a thick, gluelike, and very flowing quality. The thick paint produces a very even paint surface with almost no visible brush strokes. Details are achieved through careful draftsmanship and the use of tiny brushes, possibly with only one or two bristles. Unfortunately the *Annunciation* was poorly restored in the nineteenth century and much of its clarity is obscured.

The very artificiality of this miniaturism fosters an illusion of reality. No scene in life is this clear to the eyes, but the viewer suspends disbelief as an astonishing range of textures and effects unfolds in this small painting. The angel's jewel-encrusted robe appears to be three-dimensional. Each pearl is carefully drawn in depth and is highlighted with a single brushstroke. Gabriel is believably a visitor from heaven. His skin glows with divine mystery and his hair flows softly and harmoniously. The plain woolen robe of the Virgin, ornamented only with narrow bands of fur and red edging, is an earthly contrast to the angel's celestial grandeur.

The effect of reality is enhanced by convincing perspective and the arrangement of the elements of the painting within a three-dimensional space. The foreground is occupied by lilies, a stool with a red cushion, and a complicated design of floor tiles illustrating scenes from the Old Testament and the signs of the zodiac. The main figures fill the middle ground against a background of the walls of a churchlike building. The eye is directed to faded frescoes on the walls and the bottle-glass window panes.

Although great art does speak through the ages, it is difficult to appreciate this painting in the fullness of its original context. Not

only are the symbols no longer familiar, but we feel uncomfortable when faced with symbols. The intense repetition of triangles with triangles in the composition must have had a specific message for a society that regarded the mystical union of Father, Son, and Holy Ghost in the Trinity as the very foundation of reality. The colors themselves are chosen, not simply for their harmony, but to testify to a long-standing tradition. However, for the viewer willing to expend the necessary amount of time and thought, such a painting has great rewards and opens a window to a past world with its own logic, and perhaps holds a message for today.

By the seventeenth century painters had developed a fuller awareness of the variety of effects made possible by painting in oil. This can be seen in *Lady with a Gold Chain* (Figure 10) commissioned from the Dutch artist Rembrandt. Rembrandt's world was very different from that of van Eyck. The Catholic church no longer held sway in the Netherlands and religious painting competed with the secular. A growing middle class demanded still lifes, genre scenes, landscapes, and especially portraits for the walls of their homes.

People wanted portraits that would be passed down through generations and earn them a kind of immortality. An artist, therefore, had to deliver the most lifelike and specific image possible. The anonymous lady in Rembrandt's portrait benefited from the full range of his technical skill to make her portrait memorable.

The ground, or primer, of this portrait appears to be a light red ochre that gradually changes from light to dark through a series of dark brown or black glazes. This puts the lady in an atmospheric space, full of shifting shadows. Her dress, in contrast, has a relatively thick impasto, and is composed of mostly vertical brushstrokes broken by a wide horizontal stroke which suggests the waist. The visual impression is of a lavish material sewn into a rich and expensive gown.

To further emphasize this richness, the buttons on her dress are painted with an even heavier impasto. The heavy gold chain across her shoulders and chest is so heavily painted as to stand out from the canvas. This three-dimensionality is enhanced by a movement from dark to light in the gold tones of the chain. Various thicknesses of impasto represent the layers of her elaborate lace collar and contrast with the thinner paint on her face. Her face is scumbled, pinkish flesh tones applied loosely over a *terre verte* or gray-green undercoat. Her nose is highlighted with a stroke of lighter paint, and a roughening of her forehead gives variety to the area above her eyes.

The tonal development of the lady's hair is from dark to light, reversing the order of the background. Delicate strokes, widely sepa-

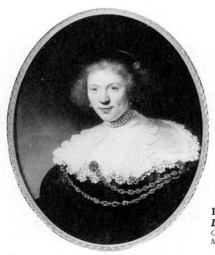

10 REMBRANDT VAN RIJN
Lady with a Gold Chain, 1634
Courtesy Museum of Fine Arts, Boston. Gift of
Mrs. Frederick L. Ames in the name of F.L. Ames.

rated, of the same reddish color as the background highlight her hair, and there are scratches for an added appearance of texture. Her hat is glazed, and the glazes become lighter as the hat gives way to the background. There is no single point of transition between the hat and the background. They seem to fade into one another.

Due to the great variety of methods of painting, Rembrandt's portrait has a tremendous vitality. The lady smiles confidently, secure in her rich costume, surrounded by an ever-changing atmosphere of light and shadow. It was this kind of portrait that made Rembrandt the most sought-after painter in Amsterdam in the 1630s.

Claude Monet, the founder of Impressionism, painted *Flower Beds at Vetheuil* in 1881 (Figure 11). Between Rembrandt's time and Monet's, many changes had taken place in painting. The invention of metal tubes enabled painters to work outdoors, allowing visual effects such as outdoor light and atmosphere to be portrayed convincingly. Painters no longer relied heavily on patrons but painted to please themselves, but they often suffered financially for their independence. Books on color theory had been published, making available to artists concepts that they could translate into new painting effects. In a picture like *Flower Beds at Vetheuil*, the formal aspects of the painting—technique and composition—are at least as important as the subject matter.

The painting is divided into three sections, both visually and physically, by the varying thickness of the paint. The foreground is a bank of flowers. The hills, island, water, and boat make up the central position or middle ground and the background consists of sky. This division of subject matter is emphasized by different techniques used in each section.

In the foreground, heavy impasto has been built with a variety of brushstrokes. In some places the paint stands off the canvas in

thick globs while in others it seems to have been smoothed on with the artist's fingers. Occasionally the impasto gives way to areas of beige, probably the primer, which show the weave of the canvas. Long, skipping vertical strokes punctuate the short, lively strokes used throughout this area. The impasto grows heavier on the left and is lightest in the topmost flowers. The overall effect is of a varied and dancing light penetrating a thin veil of flowers before being absorbed by the bushes below.

The middle ground is marked by a gradual lengthening of the brushstrokes through the water, the island, and the hill or hills in the rear. Where the water is visible through the flowers, the paint is applied in ridges; at no point does the canvas texture show through the water. A long smooth series of indistinguishable brushstrokes, with an indistinct edge, makes up the top ridge of the hill. Therefore, the middle ground, though attractive to the eye, is muted enough not to provide competition for the livelier foreground.

In the background the sky is painted very thinly but is not glazed. Although the texture of the canvas is apparent, you do not actually see the ground through the paint. The paint is more fluid here than it is in the other two sections. The brushstrokes are long and frequently cross one another diagonally. The treatment of the very thin paint surface is the reverse of the foreground in that it is heaviest on the right.

Monet's *Flower Beds at Vetheuil* should be appreciated on two levels. First, there is the astonishing re-creation of the artist's visual experience of a time, place, and atmosphere. The viewer feels the warmth of the sun, the cool breeze gently rustling the flowers. He or she hears the muted sounds of water and voices from the people in

11 CLAUDE MONET
Flower Beds at Vetheuil, 1881
Courtesy Museum of Fine Arts, Boston.
John Pickering Lyman Collection. Gift of
Theodora Lyman.

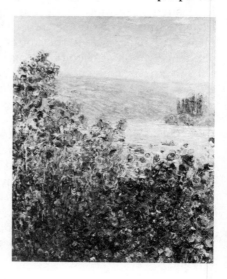

the boat. Monet captures all the details of an experience while only including the physical details visible to the naked eye.

But this is also a painting, and must succeed or fail in formal terms. The variety of brushstrokes, the sure mastery of color, the richness of texture all make this a successful painting. It would not be difficult to think of parts of it, enlarged and framed, hanging in a gallery of contemporary art. Monet and his fellow impressionists, with their superb consciousness of technique, inaugurated the modern era in painting and laid the groundwork for abstraction.

The Impressionist challenge was picked up by oil painters for half a century. Picasso's cubism, Matisse's brilliant dancers, and Dali's fantasies are all expressed in oil. Hans Hofmann painted in oil so thick as to verge on sculpture. Jackson Pollock hurled it skillfully at canvases to create paintings that were both infuriating and irresistible. Until the advent of acrylic paint in the 1940s, the painter's vision found expression mainly through the oil medium. Even today, many painters enjoy exploring the dominant medium of the last 500 years.

Watercolor

Pigment suspended in water with some kind of stabilizer has been used in painting since antiquity. Some of the illustration and ornamentation of medieval manuscripts was done in watercolor. In antiquity, the paper came from the pulp of the papyrus reed which grew on the banks of the river Nile. Vellum, fine-grained lambskin, kidskin, and calfskin came into favor during the middle ages. In the fifteenth century the invention of the printing press caused watercolor to fall into disfavor, only to be revived in the eighteenth century. Modern watercolor, however, has not retained its ancient function of book illustration, as this can be done more cheaply in other ways.

The quality of the paper is important to the appearance of a watercolor. Since the paper shows through the paint, a fine linen rag paper, thick enough not to wrinkle when wet, works the best. Tonal effects can be varied by using different colors of papers and by changing from smooth to rough textures. Since the paper has to be nonabsorbent, medieval artists covered it with starch, a process called **sizing.** Modern paper is treated to be nonabsorbent and needs neither sizing nor priming.

Watercolor paint is a combination of finely ground transparent pigments, gum arabic, and water. It can be applied in several different ways, depending on the artist's intent, and is difficult to use because of its transparency; you cannot cover up your mistakes.

The traditional method of painting in watercolor, as developed

in the nineteenth century, is to build up washes of color until the desired effect is reached. A wash is a very thin solution of watercolor which is allowed to flow onto the paper. Since it is impossible to get exact outlines in a wash technique, watercolors are often done over a pencil sketch. The pencil lines stay visible and give a sense of solidity that the watercolor washes themselves can not provide.

Contemporary watercolorists often use bold, direct methods. The paper is kept wet during the painting process and a combination of washes and dry strokes is used. Emil Nolde's watercolor *Iris* (Figure 12) typifies this bold, modern approach to the medium. The brilliant tones of the stems and petals spring from a gray wash background. Successive washes of yellow, green, and blue form the actual blossoms without drawing or detail. The transparency of watercolor allows the yellow to show through the green and blue, giving a sense of sparkle and variety. The almost oriental handling of the forms of leaves and petals accentuates their fragility, while the brilliance of the colors fills the plants with life and warmth. Nolde's control is such that he can even sign his name in wash in the lower right-hand corner.

A different approach was used by Léon Bakst, a twentieth century Russian painter, in his design for a *Costume for Anna Pavlova* (Figure 13). The details of Pavlova's figure and costume were first drawn carefully in pencil. The colors were then added in watercolor. The effect is more precise and detailed that that of the Nolde, although equally successful. Bakst's drawing suggests not only the appearance of the costume but also its suitability for Pavlova's dancing.

GOUACHE

A variant on the conventional transparent watercolor technique is **gouache.** Gouache is opaque watercolor and is made by increasing the amount of gum arabic binding in the paint and by adding a small amount of an inert pigment like zinc white or chalk. Gouache can be painted on gessoed panels, cardboard, matboard, or heavy watercolor paper. While its physical properties are almost the same as those of watercolor, it has to be handled differently. First of all, gouache has solidity and can be used to paint over and change another color. It can be used in washes or thickly to get a rough, textured surface. Gouache, like tempera, is difficult to blend. If thick layers of gouache are applied, there is a danger that the surface will crack, ruining the painting.

The advantages of gouache are versatility of color effects, the ability to be used in conjunction with other media such as a watercolor or pastel, and the possibility of being used for fine detail. Among the artists who have worked in gouache are John James Audubon, Toulouse-Lautrec, and Rouault.

12 EMIL NOLDE
Iris, 20th century
Courtesy Museum of Fine Arts, Boston.
Seth K. Sweetser Residuary Fund.

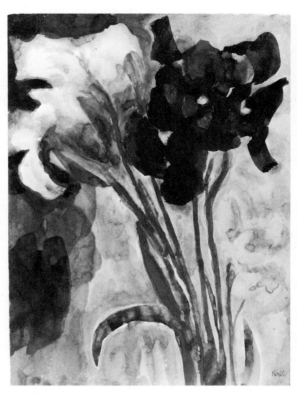

13 LÉON BAKST
Costume for Anna Pavlova, 1913
Isabella Stewart Gardner Museum,
Boston

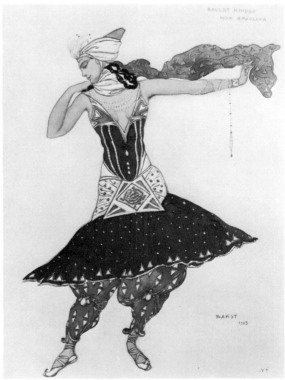

Pastel

The spontaneity of the artist is restricted by the amount of equipment necessary for a particular technique. Even watercolor requires pigment, solvent, and a selection of brushes. For catching a moment in time, most media are too slow to be entirely satisfactory. Edgar Degas stationed himself unobtrusively at the edges of scenes he wanted to paint (Figure 14)—ballet rehearsals or horse races—and worked quickly with pastel on paper.

Pastel is painting in pure color without a binder. The tool is a pastel crayon made of pigment held together with gum and filled out with whiting. Pastel has only been used for about 200 years, although people have been drawing in charcoal and chalk for millennia.

Most papers are suitable for pastel, provided they are soft. It can be successfully combined with watercolor, pastel being used to begin the work on the spot and watercolor providing the finishing touches back in the studio. In a sense pastel is part-way between painting and drawing, but its ability to utilize color gives it a wider range than straight drawing.

The artist either applies pastel directly with crayons, uses a stiff brush, or crumbles the crayons and rubs in the color with his or her

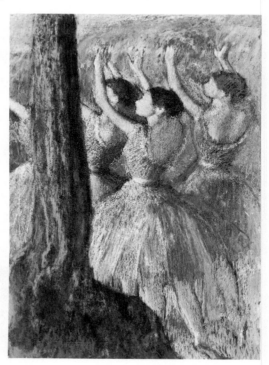

14 EDGAR DEGAS
Danseuses Roses,
late 19th century
Courtesy Museum of Fine Arts, Boston.
Seth K. Sweetser Residuary Fund.

fingers. Textural effects are accomplished by using a rough paper and emphasizing its variation. The overall appearance of pastel is like crayon, but without greasiness. Besides Degas, Pissarro and Toulouse-Lautrec often painted in pastel.

Like any technique, pastel has disadvantages. It is fragile and has to be sprayed with a fixative to hold it to the paper. Glazing is impossible because the crayons are dry and there are a limited number of possible tonal variations. Pastels are usually covered with glass to protect them, but the glass must never touch the paper lest the pastel adhere to it and separate from the painting itself.

Mosaic

Mosaic is not, strictly speaking, a form of painting, since it does not use pigment. However, it serves the same function as painting, and can be regarded as a kind of painting in stone. **Mosaics** are pictures created by laying thousands of small pieces, called **tesserae,** into a bed of plaster or, at times, thick resin. Mosaic has been used on floors, walls, furniture, jewelry, and architectural elements such as columns. The tesserae are made of any hard material, such as stone, glass, marble, wood, or ceramic, depending on the effect desired. Remarkably, this technique can produce pictures that are subtle and sometimes even filled with a strange inner light. The ultimate value of mosaic is that pictures of great meaning and beauty can be preserved so well.

The history of mosaic reaches back to the ancient near east. The Sumerians and Assyrians used mosaic to add color to their mud-brick temples and palaces. Later, Greek and Roman artists created complex paintings in stone for their patrons. One Pompeiian house contained a monumental mosaic depicting the final victory of Alexander the Great over the Persian armies.

Mosaics of gold and glass tesserae, set at angles to catch the light, turned the interiors of Byzantine churches into precious jewels. The plain exterior of such a church gives no hint of the carefully orchestrated arrangement of mosaics covering the interior.

Famous Renaissance painters like Raphael and Titian provided designs for mosaics for churches and palaces, although they did not work in mosaic themselves. After the Renaissance, though, the use of mosaic was eclipsed by the subtle effects derived from painting on canvas or plaster (fresco). In the twentieth century the use of the medium has spread due to its bright bold colors. Particularly in South America, many contemporary buildings are enhanced by the durable beauty of mosaic.

Figure 15 shows a Roman mosaic of the first or second century A.D. Like all Roman mosaics, it was used as a floor. The center shows the head of the gorgon Medusa, who, appropriately enough, turned people to stone before being beheaded by the hero Perseus. Around her is a pattern of delicate leaves and vines, with birds perched at regular intervals. A heavy strip of interlocking links acts as an anchor for an otherwise fragile design, followed by more vines. The overall effect is both pleasant and interesting without being distracting. It is, after all, a floor, and should not be the main focus of a room.

If this mosaic was made on the site, the composition of the mosaic was drawn or painted on a setting bed of plaster. Then the individual tesserae were set into the damp plaster. In a mosaic this size, roughly 16 feet square, the tesserae would be laid in sections to keep the plaster moist. However the Romans also made mosaics in factories, and that may have been the case here.

Throughout the medieval period, most mosaics were assembled piece by piece *in situ*. After that, artists began to assemble mosaics in their shops and transport sections of the mosaic to be put together at the site. One way to do this is to set a section of mosaic in sand and then glue paper or cloth over its surface to hold it together. Each section is transferred to a resin or plaster bed at the site, pressed into it, and the paper or cloth is removed. A variant on this is to glue the tesserae face down on a drawing of a section of the mosaic, and then move each section to the setting bed.

The great advantage of mosaic is, of course, extreme durability. Most of our knowledge of Greek painting and much of Roman painting comes from mosaics. Ancient mosaics have been walked on for thousands of years with little damage. The colors do not fade, and a well-prepared support does not warp or crack. To achieve this permanence, however, portability is sacrificed, except in the case of very

**15 Roman
Mosaic floor pavement,** 2nd century A.D.
Isabella Stewart Gardner Museum, Boston

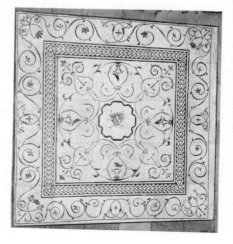

small mosaics. There is, however, an optimism in the human spirit that wants to create beauty forever, an aim to which mosaic is well-suited.

Acrylic

Since the widespread use of oil paint began in the fifteenth century, only one medium suitable for large-scale paintings has been discovered—synthetic acrylic paint. First developed for industry, acrylic paint began to be used by artists in the 1940s. The paint is made of a clear plastic resin suspended in water. As the water evaporates, the paint becomes hard and permanent and cannot be damaged by water.

Twentieth century art has been characterized by variety and experimentation. Artists want to be freed from the restrictions of media in order to use different methods of application and to experiment with combinations of media and techniques. Acrylic is perfect for such situations. It introduced a new freedom to painting not unlike the liberation oil paint gave to tempera artists. There is not a tremendous new range of color effects in acrylic, but it has the range of oil without the drawbacks.

Unlike oil, acrylic does not yellow, crack, or darken (at least in half a century). These plastic paints are fast-drying and permanently flexible. They can be painted either on raw canvas or after a minimum of priming. Acrylic paints can be applied both thickly and thinly; they can be used in glazes or scumbles, or thickened with a gel in a thick impasto. All kinds of inexpensive supports are suitable for acrylic paint, not just fine linen canvas. The only diluting agent necessary is water.

Most contemporary artists like the fast drying time of acrylic paints. In about fifteen minutes a thin layer will be dry enough to paint over, and even a thick layer will be dry to the touch in an hour.

A wide range of pigments is suitable to the acrylic medium, a boon to painters in this color-conscious age. The artist can also work in both oil and acrylic in a single painting, gaining the benefits of both.

The characteristics of acrylic paint encourage the use of large canvases and various unconventional methods of applying paint. The lack of priming frees the artist's time for aesthetic and technical considerations, and the ease of application encourages unorthodox techniques. Throughout the twentieth century artists have been getting away from the traditional painter's brushes and knives. Housepainter's brushes, air brushes, and fingers have all come into play. Paint is splattered on, allowed to flow across the canvas in perfectly con-

16 MORRIS LOUIS
Delta Gamma, ca. 1960
Courtesy Museum of Fine Arts, Boston. Anonymous gift.

trolled sequences, or placed in troughs through which the canvas is pulled. Hundreds of visual effects are possible through these new processes.

Even before acrylic paint was developed, modern artists began to work on a large scale in order to assert the independence of their paintings from their surroundings. A huge painting does not become part of the decor of a room; it dominates its space to the extent that even museums have had to come up with very stark and open galleries for their contemporary art. This makes the painting the determining factor of the environment.

A notable painter in acrylics was Morris Louis. Louis took full advantage of the adaptability of his new medium to explore new methods of application and produced some of the most admired works of the post-war period. His painting *Delta Gamma* (Figure 16), painted around 1960, shows one of Louis' many approaches to painting. *Delta Gamma* is a large canvas, approximately eight by twelve and one half feet. Acrylic paints in soft colors have been allowed to flow across and soak into the raw canvas, carefully guided by the artist into diagonal paths from the upper corners toward the center of the canvas but not reaching the center. The colors themselves are chosen specifically to achieve the visual and spatial dynamics desired by the artist, and they interact strongly with the space between them and the center of the canvas.

In fact, empty space does not really exist, as the tension of color, flowing movement, and a quality of reaching out between left- and right-hand stripes fills the entire canvas. Louis's exact methods are unknown, as he was an extremely private and retiring person, but he did not guide the flow of his paint with tape as some artists do. In-

stead he directed the paint by moving the canvas into different positions as the colors moved across it, sometimes allowing them to touch, sometimes keeping them separate. He avoided the hard edges that would suggest lines and let the qualities of the paint itself speak unhindered.

As yet, acrylic paint seems to have no appreciable drawbacks. However, considering the short period of time that it has been in use, any real evaluation of its weaknesses is impossible. At the present, it seems ideal, and only time can tell whether or not this is the case.

EXERCISES

Plan to spend some time with a few paintings in order to find out just how much you can tell about them by looking. If possible, find a comfortable place to sit where you can see the painting clearly.

1. Does the painting seem to be in good condition?
 a. Is the surface bright and clear or dark and muddy?
 b. Are these cracks on the surface? How bad is the cracking?

 A dull, flat-looking surface indicates that the painting needs cleaning. Clean paint (except for fresco) sparkles, no matter how old it is. Cracking is normal in old age, but spiderweb cracks indicate that the painting has been touched.

2. Is the physical surface flat and smooth or rough and textured?

 To tell this, it's usually good to look up at the painting from the lower corners. The texture of the paint will tell you how it was applied.

3. Can you see the individual brushstrokes or are they carefully blended together?
 a. Is there a lot of detail?
 b. Does the appearance of objects in the painting become unclear as you get close to it?

 The answers to these questions suggest both the artist's concern with detail and his or her interest in displaying technique.

4. Is the paint hard-looking or soft?
 a. Is there any gold leaf?
 b. When the artist goes from one color to another, is the transition abrupt or gradual?
 c. Are the flesh tones turning green?

 The answers to these will indicate what medium has been used. If you are in doubt, recheck the characteristics of each medium in the text.

5. If the painting is a wall painting, are the colors dull or shiny?

True fresco colors are usually dull; and dry wall painting colors are more shiny.

6. Is the painting on plaster, panel, canvas, or paper?
 a. Can you see warping or splitting?
 b. Are there insect holes?
 c. Can you see wood grain or a weave underneath the paint?

Once you've determined the support, it suggests certain time periods and/or certain media.

7. Is there a wide range of colors or did the artist limit his or her palette?

The answer suggests a time frame.

8. If there is canvas showing, does it look primed or raw?
 a. How much canvas shows?
 b. How big is the canvas?

A raw canvas is usually a sign of a contemporary painting.

9. When you look at the painting, are you first aware of the subject matter?
 a. Do you look at people, action, and the like or does color, line, and shape catch your eye?
 b. When you think about the painting after moving away from it, do you think of what it was about or what it looked like?

Whether the artist was principally concerned with subject or technique suggests certain places and times in history. This is subjective but can be useful.

If you can answer all of the above questions you should have a good idea of what medium and technique was used in a painting. Remember, though, that there are always exceptions to the rules and even the experts do not always know what they are looking at. Most of the time, however, you will be right.

2
Drawing

Like painting, drawing is a two-dimensional medium. A painting, however, can rely on a variety of elements for its final effect, including color, texture, size, and various techniques of applying paint. The draftsman relies on **line**. The variety and organization of lines gives a drawing its meaning. There are straight lines, curved lines, thick lines, thin lines, and lines varied by splotches and blobs, particularly in Oriental drawing. The care with which the artist arranges the lines produces the impact of the drawing. With long curving lines, a languid, smooth effect can be produced. Short staccato lines suggest tension and excitement. Lines can give the illusion of space and depth or can remain flat and abstract. They can be drawn with an engineer's precision or be applied with a quick movement of the hand.

It is often said that drawing is more spontaneous than painting. This is only a half-truth, since a fine drawing requires as much planning, at least in the artist's head, as a painting. The detail from a Greek vase in Figure 17 shows a well-planned drawing using a variety of linear effects. This is part of a cup from the fifth century B.C. by the Panaitios Painter, and illustrates a battle of two warriors over the body of a third. The bodies are formed of long curving lines, with little attempt at interior modelling or differentiation. The round shields and the curves of the figures' backs echo the curved edge of the cup and its round base, making the surface and the drawing seem harmonious. Dots of varying sizes are used for emphasis on the helmets, and splotches embellish the shields. The lack of straight lines serves

**17 THE PANAITIOS PAINTER
Greek kylix with a contest of
two warriors,** 5th century B.C.
*Courtesy Museum of Fine Arts, Boston.
H.L. Pierce Fund.*

as another reminder of the drawing's curving ceramic surface. This
drawing required careful composition and execution, yet appears
fresh and lively.

Some drawings are intended to be finished works of art in them-
selves, while others are done in preparation for another work. These
preparatory drawings are called sketches and serve as a beginning—a
planning stage—for a developed work in painting, sculpture, architec-
ture, or the decorative arts. A **sketch** is done all at one time and is
not refined or improved at a later time. Sketches are the most spon-
taneous works of an artist, although they do not necessarily represent
his or her best work, since they are intended to be changed.

Studies, on the other hand, may or may not be sketches. Like
sketches, they are intended for translation into another medium, but
are more finished and can be worked on over a period of time. Por-
trait painters often do one or more studies while a sitter is present
and work from these on the painting itself. Studies are often done
from nature and are translated into a finished work in the studio.
One variety of study is the cartoon, which is a full-size drawing done
in preparation for a painting, usually a fresco. Many studies only
show part of the finished work.

Materials of Drawing

Today most drawings are done on paper. Historically, though, many
surfaces have served as backgrounds for drawings, including Greek
ceramic pottery, Near Eastern mud brick, medieval wooden panels
that have been sized and gessoed, tablets covered with wax which
can be used over and over, and parchment or vellum.

After 1400 paper as we know it today became available and be-

came the principal drawing surface. In China paper had been common since the second century A.D., although some drawings were done on cotton and silk. There are Byzantine drawings on paper from the eleventh century, but these are the exception rather than the rule. Cennini in the fifteenth century still regarded paper as an innovation replacing the parchment, with which he was familiar.

Cloth rags are the traditional source of paper fiber, usually of cotton or linen in the West, and bamboo, rice, or mulberry in the Orient. In the nineteenth century wood-pulp paper was introduced, providing a cheaper source of drawing materials. During the Renaissance paper was expensive and artists often did several sketches on one piece. Today special drawing papers are manufactured, each with qualities making them suitable for either pen and ink, pencil, charcoal, and the like.

A number of different kinds of drawing instruments have been used in the past and are used today. One which is no longer common in drawing, although still used in jewelry making and printmaking, is the **stylus**. The stylus is a smooth, blunt point of metal or other hard material like bone or ivory—which was used to engrave a line into a drawing surface. Roman paintings often show people writing and drawing with styluses on wooden panels covered with wax. Clay tablets and Greek vases were also incised with a stylus.

Contemporary drawings are often done with pencil, which is a relatively recent invention. Graphite in wooden holders began being used in the sixteenth century. Seventeenth-century Dutch artists were among the first to draw in pencil. They appreciated its convenience and delicacy. The modern graphite pencil was invented in 1795 and soon became popular. Today pencil is the preferred drawing medium of many artists.

Before the invention of the pencil, a delicate drawing could only be achieved through **silverpoint**. In a silverpoint drawing the vellum or paper is coated with opaque white pigment. The drawing is done with a silver pointed instrument, either a silver wire set in a wooden holder or a silver stylus 3 to 4 inches long. The silver reacts with the pigment to produce indelible fine lines of a grayish hue that darken as the silver tarnishes. During the Renaissance silverpoint was used for preparatory drawings for paintings on the gessoed panel, as well as for finished drawings. Silverpoint is still used where artists desire its unmatched lightness and delicacy.

Crayon is a generic term for any drawing material in stick form, including charcoal and the wax crayons children use. Artists generally use **conté crayons,** a compound of compressed pigments and binder invented by Nicholas Conté, who also invented the modern lead pencil. Conté crayons, an adaptation of pastel, are grease-free

and are enclosed in a wooden holder. Like pastel, conté crayon needs to be fixed in order to be permanent.

Charcoal, technically a form of crayon, has a long history. Prehistoric cave painters drew on the walls of their caves with twigs burned over a fire. Cartoons for frescoes were commonly done with charcoal, as were finished drawings from many periods and places. Charcoal is black crayon made of charred wood or vine. It is capable of a broad range of effects and is easy to obtain. Today charcoal drawings are usually done on special paper, but charcoal is adaptable to many surfaces and can be manipulated with the fingers for painterly effects. Its only drawbacks are a lack of permanence unless sprayed with a fixative, and the fact that it comes only in black.

Chalk has charcoal's flexibility and provides a wider range of color. The natural chalks are red, derived from ochre earths, and white, derived from gypsum. Artificial writing chalk is too hard to be suitable for serious drawing and it is not generally used. In the sixteenth and seventeenth centuries, artists often made three-color drawings using red and white chalk and charcoal. Both charcoal and chalk give an impression of strength combined with softness and can be used to emphasize the texture of rough paper for interesting and varied effects.

No medium of drawing provides a greater range of effects and flexibility of technique than **ink**. Ink can be applied with pen, brush, or washes. It can be crisply drawn with a fine pen or broadly brushed on. Strong lines and shadowy washes are possible in the same drawing. There are many different kinds of ink. **India ink** is commonly used. It is versatile and resists water when dry. Ink washes and watercolor may be used over India ink. **Chinese ink** is similar to India ink, but it is brilliant and has a wider range of tones. **Japanese ink,** or sumi or Japanese block watercolor, is similar to Chinese ink. Both Chinese and Japanese ink come in little sticks or cakes which are moistened for use.

Dürer's *Study for the Prodigal Son* shows a tightly controlled use of pen and ink drawing (Figure 18). Tone is achieved through parallel- and cross-hatching. The lines are uniformly fine with an economical, almost Oriental, placement. Since the drawing is a study for an engraving, the artist considered the limitations of engraving in his study.

In Tiepolo's *Study for Angels and Clouds* (Figure 19), a preliminary drawing for a painting, painterly effects have been simulated through a combination of free outlines, minimal detail, and ink washes ranging from light to dark gray. The drawing suggests the painterly qualities and tonal range that Tiepolo wanted to achieve in the final painting.

18 ALBRECHT DÜRER
Study for the Prodigal Son,
16th century
Courtesy Museum of Fine Arts, Boston.
Anna Richards Mitchell Fund, 1931 Purchase Fund.

19 GIOVANNI BATTISTA TIEPOLO
Study for Angels and Clouds
(ceiling decoration), 18th century
Courtesy Museum of Fine Arts, Boston.
Gift of Edward Habich.

Methods

Although each artist has his or her own approach to drawing, there are a few basic techniques. One of these is **hatching**—using clusters of lines to achieve an effect of tone. **Parallel hatching** means using groups of parallel lines of any length which look gray from a distance. A denser or darker effect can be achieved through **cross-hatching**—using two sets of parallel lines that cross one another. A series of tonal values using parallel and cross-hatching unifies a drawing and relieves the monotony of isolated lines. Cézanne is particularly noted for his innovative use of different kinds of hatching.

Another way of developing tonal effects in drawing is **wash**. Wash drawings developed after 1500 from pen and ink drawing and can be used alone or in combination with line drawings. A wash is any diluted solution applied to paper. Washes can be brushed on or allowed to flow across the paper. Rembrandt made wash drawings with brushes, as did Goya and Constable. Some artists keep inks mixed with different amounts of water on hand for washes, while others prefer to use a single tone in layers. Different densities of washes give effects varying from a delicate gray to a deep velvety black, which is good for showing shadows.

Chiaroscuro drawing was developed during the Italian Renaissance as yet another method for introducing varied tonal effects to

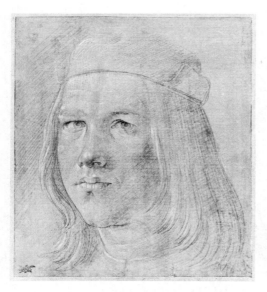

20 LORENZO DI CREDI
Head of a Youth,
15th or 16th century
Courtesy Museum of Fine Arts, Boston.
Gift of Denman W. Ross.

drawing. In chiaroscuro, the artist is creating areas of light and dark rather than individual lines. Leonardo da Vinci and Rembrandt are noted for their use of chiaroscuro drawing. A chiaroscuro drawing is made up of lines placed so closely together that the eye sees them as tonal areas. The artist outlines the figure and then repeats the outline over and over toward the middle of the form, using a lighter line with each repetition. The center of the form is left white on a colored ground so that the eye moves from light to dark. In either one, the effect is strong and painterly rather than linear.

Head of a Youth is a silverpoint drawing on a medium ground with white highlights by the Florentine Renaissance artist Lorenzi di Credi (Figure 20). The head of a young man wearing a soft cloth cap is composed of repeated silverpoint outlines, giving an impression of softness and delicacy. There are white highlights on the face and neck of the boy as well as in his hair. This vivid drawing has a subtle and painterly quality.

EXERCISES

1. Is the drawing primarily made up of lines or are there tonal effects?

2. If there are tonal effects, are they achieved through hatching or wash? In each case, what medium or media does the technique suggest?

3. Is there a combination of techniques? Look particularly for pencil combined with ink wash or charcoal and chalk together.

4. Does the drawing appear finished or is it a sketch? Usually a sketch will have very little detail.

5. If the drawing is linear, are the lines fine or broad? Is there a variety of lines or are they similar throughout? Do the lines look delicate and wispy or firm? In each case, what media are suggested by the appearance of the lines?

6. Are there different, unrelated drawings on the same piece of paper? They are probably studies done before paper became cheap and plentiful.

7. Is there a grid of lines over the drawing? This usually indicates that it is a study for a fresco. Each square of the grid was redrawn separately for transfer onto the wall.

8. Is there a series of related but incomplete drawings by the same artist? They may be preliminary sketches or studies for a finished painting or sculpture.

Sculpture
3

Around 15,000 to 10,000 B.C., artists began to create three-dimensional works of art. These earliest **sculptures** portray exceptionally well-developed women and may reflect a desire for children. The power of these works is obvious, but it is more magical than aesthetic. From the same period there are animal carvings in bone, which may have been made to bring luck in the hunt.

Since that distant time, human history has been marked by an almost universal use of sculpture. There have been amulets smaller than an inch long and statues seventy feet tall. Portraits, historical scenes, religious figures, nudes, heroes, and devils have all found places in sculpture. Sculptures have been used for worship, commemoration, decoration, and political celebration. They have decorated temples, tombs, cathedrals, and private homes, and have even been carved on mountains.

Given this variety, it is surprising that there are only three basic ways to create a sculpture: It can be carved from a block of material, removing excess material until the desired form is revealed (subtractive sculpture); it can be molded from soft elements like clay, stucco, or plaster (additive sculpture); and, in the twentieth century, it can also be assembled or fabricated from just about anything, with welders' tools, screws and nails, wires and glue (direct-metal sculpture).

Subtractive Sculpture

MATERIALS

Traditionally there is a great difference of opinion between carvers and modellers. Michelangelo thought that carving from stone was the noblest art. It requires physical strength and a tremendous effort from the artist. Leonardo found carving the least desirable for the same reasons—you get all sweaty. People have, however, been carving statues for thousands of years and from a variety of materials. The most common material for sculpture is stone, especially marble. The ancient Greeks found a supply of good marble in their own country and developed a sophisticated understanding of what could be done with marble. Many of the tools and techniques of marble sculpture come from the Greeks. Marble is hard, although a good-quality marble is not brittle. This is of the utmost importance, since a brittle marble will severely limit the effects the artist can achieve. Unfortunately, marble is porous, and will absorb water, smoke, and carbon monoxide. In modern cities marble turns black as it absorbs pollution from the air and as the surface of the stone is eaten away by acids in the rain.

The ancient Egyptians preferred hard stones, such as granite or diorite, which would endure. They also used alabaster, a softer but more brittle stone, to fashion everything from larger-than-life-size statues of their kings to delicate unguent vases.

Limestone is a soft stone, and can be used for works that do not have to face the weather. Sandstone is even softer and weathers quite rapidly. The Byzantines were impressed by purple porphyry, a hard stone with a royal purple color.

Various woods are also used for subtractive sculpture. So long as the wood is in good condition, it does not crumble or shatter when worked as stone does. Although contemporary sculptors are much-opposed to the practice, some periods have regarded wood's suitability for gessoing and painting as an advantage. On the minus side, wood comes in logs which must be thoroughly dried or seasoned before being carved. Wood also has a grain that must be followed lest cracking and splitting ruin the work.

Ivory and bone are also available for carving small objects. Ivory, like wood, has a grain that has to be followed, but with the proper care it can produce exquisite effects. Plaster and stucco, while usually associated with modelling, can also be hardened and then carved.

TOOLS

Figure 21 shows the basic tools of the subtractive sculptor. A **point** or **punch** (a) is used with a **mallet** to break off large pieces of stone.

When a sculptor first begins to carve a block of stone, he or she works quickly with the point until the shape emerges.

Various types of chisels are also used in carving. A **flat chisel** (b) is easier to use than the point and can give more detail. The **claw chisel** (c) has teeth that can vary in size and number and is a versatile tool that can be used alone or in conjunction with the flat chisel.

The hammer with pyramidal teeth (d) is properly called a *bouchard* or *boucharde* hammer, but is usually called a bushing hammer or bushhammer in English. Contemporary bushing hammers have a steel head covered with points. These hammers are used both for the rough shaping of a sculpture in hard stone and for finely dressing the surface of a stone by pulverizing the rock and removing it bit by bit. The pointed or trimming hammer (e) is used for finer work. The rasps in (f) and (g) are for use at the very end of the carving process. With the rasps, the sculptor smooths away the marks of the chisels, point, and so on, and begins polishing the surface of the work, a process completed with abrasives. The bow drill or running drill (h) has been used as far back as the ancient Greeks. The drill is used to cut deeply and to work more quickly than you can with the hammer and chisel. At some periods in time, sculptors have felt that working with the drill is too mechanical, but at others it has been very popular. The auger (i), like the drill, is used for boring, but not as deeply.

DIRECT CARVING

Carving can be either direct or indirect. In **direct carving,** a model may be used for guidance by the sculptor, but the finished copy is

21 Sculptor's tools: (a) punch or point; (b) flat edge chisel; (c) claw chisel; (d) square hammer; (e) pointed hammer; (f) and (g) files or rasps; (h) bow drill; (i) auger.

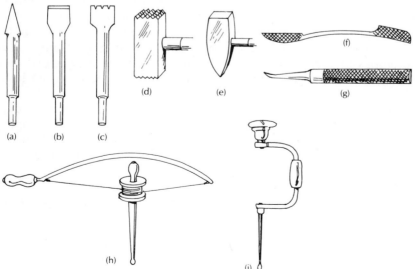

Subtractive Sculpture

MATERIALS

Traditionally there is a great difference of opinion between carvers and modellers. Michelangelo thought that carving from stone was the noblest art. It requires physical strength and a tremendous effort from the artist. Leonardo found carving the least desirable for the same reasons—you get all sweaty. People have, however, been carving statues for thousands of years and from a variety of materials. The most common material for sculpture is stone, especially marble. The ancient Greeks found a supply of good marble in their own country and developed a sophisticated understanding of what could be done with marble. Many of the tools and techniques of marble sculpture come from the Greeks. Marble is hard, although a good-quality marble is not brittle. This is of the utmost importance, since a brittle marble will severely limit the effects the artist can achieve. Unfortunately, marble is porous, and will absorb water, smoke, and carbon monoxide. In modern cities marble turns black as it absorbs pollution from the air and as the surface of the stone is eaten away by acids in the rain.

The ancient Egyptians preferred hard stones, such as granite or diorite, which would endure. They also used alabaster, a softer but more brittle stone, to fashion everything from larger-than-life-size statues of their kings to delicate unguent vases.

Limestone is a soft stone, and can be used for works that do not have to face the weather. Sandstone is even softer and weathers quite rapidly. The Byzantines were impressed by purple porphyry, a hard stone with a royal purple color.

Various woods are also used for subtractive sculpture. So long as the wood is in good condition, it does not crumble or shatter when worked as stone does. Although contemporary sculptors are much-opposed to the practice, some periods have regarded wood's suitability for gessoing and painting as an advantage. On the minus side, wood comes in logs which must be thoroughly dried or seasoned before being carved. Wood also has a grain that must be followed lest cracking and splitting ruin the work.

Ivory and bone are also available for carving small objects. Ivory, like wood, has a grain that has to be followed, but with the proper care it can produce exquisite effects. Plaster and stucco, while usually associated with modelling, can also be hardened and then carved.

TOOLS

Figure 21 shows the basic tools of the subtractive sculptor. A **point** or **punch** (a) is used with a **mallet** to break off large pieces of stone.

When a sculptor first begins to carve a block of stone, he or she works quickly with the point until the shape emerges.

Various types of chisels are also used in carving. A **flat chisel** (b) is easier to use than the point and can give more detail. The **claw chisel** (c) has teeth that can vary in size and number and is a versatile tool that can be used alone or in conjunction with the flat chisel.

The hammer with pyramidal teeth (d) is properly called a *bouchard* or *boucharde* hammer, but is usually called a bushing hammer or bushhammer in English. Contemporary bushing hammers have a steel head covered with points. These hammers are used both for the rough shaping of a sculpture in hard stone and for finely dressing the surface of a stone by pulverizing the rock and removing it bit by bit. The pointed or trimming hammer (e) is used for finer work. The rasps in (f) and (g) are for use at the very end of the carving process. With the rasps, the sculptor smooths away the marks of the chisels, point, and so on, and begins polishing the surface of the work, a process completed with abrasives. The bow drill or running drill (h) has been used as far back as the ancient Greeks. The drill is used to cut deeply and to work more quickly than you can with the hammer and chisel. At some periods in time, sculptors have felt that working with the drill is too mechanical, but at others it has been very popular. The auger (i), like the drill, is used for boring, but not as deeply.

DIRECT CARVING

Carving can be either direct or indirect. In **direct carving,** a model may be used for guidance by the sculptor, but the finished copy is

21 Sculptor's tools: (a) punch or point; (b) flat edge chisel; (c) claw chisel; (d) square hammer; (e) pointed hammer; (f) and (g) files or rasps; (h) bow drill; (i) auger.

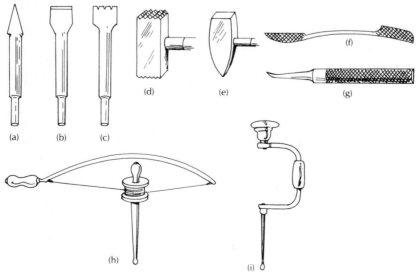

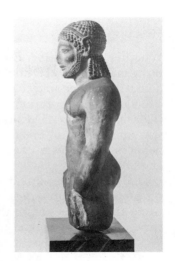

22 Greek
Limestone Figure of a Man,
6th century B.C.
Courtesy Museum of Fine Arts, Boston.
Gift of Denman W. Ross.

never an actual copy of the model. In **indirect carving,** a scale model is made and then is reproduced using a device called a **pointing machine**. Some people feel that the indirect method is less valid because it does not involve the artist as closely with the final creation of the sculpture. Others feel that the original idea is the important thing, not the process through which it is carried out.

In direct carving the sculptor draws on the block, and then cuts away from each of the four sides. The sculptor may or may not have done a model or preparatory sketches beforehand. The Greeks engraved the outline of their sculpture on the stone block and cut around it. Before 500 B.C., sculptors worked almost entirely with the point or punch, as the distinctive marks on their sculptures show. The hair of the Greek statue in Figure 22 is made up of the small lumps that are produced by the point. On other parts of the figure they have been smoothed off with rasps and abrasives like emery or sand. After 500, the Greeks adopted the flat chisel and claw chisel; and by the time of Alexander the Great, the use of the drill became widespread.

The Romans worked a great deal with the drill, and practiced indirect carving on a large scale. This tendency was completely reversed in the medieval period when artists worked with no preparatory sketches and apparently no models. A twelfth-century writer and artist Theophilus wrote:

> When you are going to carve ivory, first shape a tablet of the size you want, put chalk on it and draw figures with a piece of lead according to your fancy. Then mark out the lines with a slender tool so that they are clearly visible. Next cut the grounds with various tools as deeply as you wish and carve figures of anything else you like according to your skill and knowledge.*

*Theophilus, *On Divers Arts*, trans. J.G. Hawthorne and C.S. Smith. Chicago: University of Chicago Press, 1963, p. 187.

Whether or not direct carving is popular at a particular time depends on what is felt to be important in a sculpture. To the Romans, it was a matter of accuracy. They copied Greek sculptures extensively to use as home decorations and wanted them to be as close to the originals as possible. During the Middle Ages, however, the emphasis was spiritual, and mechanical perfection did not mean as much. Paper was always very expensive and was reserved for Bibles rather than sketches.

By the 1400s direct carvers in Germany were beginning to rely on preparatory drawings, both as a guide to carving and to show patrons their plans before the actual works began. In Italy at the same time, three-dimensional models were used.

The foremost believer in the virtue of direct carving in the history of sculpture was Michelangelo. To him, sculpture was the noblest art; the only art worthy of the name. Painting, to him, was for the weak and timid. To attack a block of the finest marble and draw an image from it was his particular genius. Early in his career, Michelangelo used the drill. It is clearly visible in the hair and eyes of his *David*. He also worked over his early sculptures with fine abrasives to achieve a glossy, jewellike finish. The *Pietà* (Figure 23) is an example of this; a work so perfect that it almost seems to be more than could be created by a human being. The fact that it survived the blue lights and garish stage setting that it was subjected to during the New York World's Fair in 1964 is proof of its perfection.

Michelangelo's technique was described by the artist and biographer Giorgio Vasari in his work, *Lives of the Most Eminent Painters, Sculptors and Architects*. Michelangelo did not work equally on all four sides of the block, but concentrated on one, which remains the most satisfactory angle for viewing.

> *The method of proceeding is to take a figure of wax, or other firm material, and lay it in a vessel of water, which is of its nature level at the surface; the figure being then gradually raised, first displays the more salient parts, while the less elevated still lie hidden, until, as the form rises, the whole comes by degrees into view. In the same manner are figures to be extracted by the chisel from the marble, the highest parts being first brought forth, till by degrees all the lowest appear; and this was the method pursued by Michelangelo.* *

Michelangelo also did not use the common Renaissance technique of using drill holes for guides. The holes were then cut along with chisels, resulting in a very clean and linear look.

*Giorgio Vasari, *Lives of the Most Eminent Painters, Sculptors and Architects*, trans. Mrs. Jonathan Foster. 5 vols. London: George Bell & Sons, 1885, p. 337.

23 MICHELANGELO
Pietà, 1498
Courtesy St. Peter's, Rome

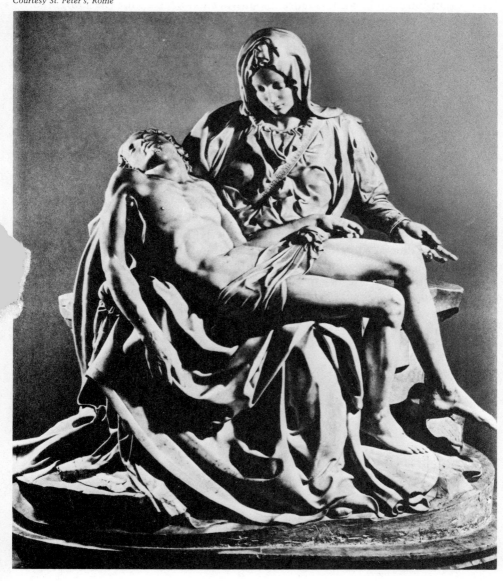

After Michelangelo, most sculptors began to work extensively on preparatory models, or *bozzetti*, in which they thought out all the technical and compositional problems of the work. Such sculptures have multiple views, each worked out in the model, rather than only one. The emphasis in such works was shifted from carving to modelling, and the result was different.

A number of *bozzetti* survive by the Italian baroque sculptor Gian Lorenzo Bernini. Figure 24 shows the *bozzetto* for the *Longinus*, one of the four huge statues at the crossing of St. Peter's basilica in Rome. The finished work is of marble and is about fourteen and one half feet high. The *bozzetto* is made of terracotta (baked clay) and is about six inches high. Although there were changes between the model and the sculpture, the basic idea is there in the model where changes can be made easily. The large *Longinus* is made up of four blocks of marble fastened together, an idea which would have appalled Michelangelo.

Bernini's emphasis on modeling dominated direct carving through the seventeenth, eighteenth, and most of the nineteenth centuries. Much indirect carving was also done during this time, and by 1850 most subtractive sculpture was pretty uninspiring, consisting mainly of large-scale versions of national heroes in various states of classical undress.

Toward the end of the nineteenth century this began to change, largely due to the efforts of the French sculptor Rodin. Rodin wanted to create direct sculpture that could be looked at with equal success from all sides. He began a work by doing preparatory sketches from all sides and visualizing his sculpture in a three-dimensional way right from the start. He stated that:

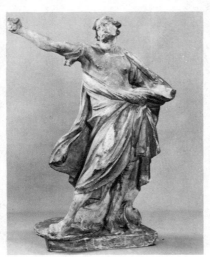

24 GIAN LORENZO BERNINI
St. Longinus, 17th century
Courtesy of the Fogg Art Museum, Harvard University. Purchase—Alpheus Hyatt and Friends of Fogg Funds.

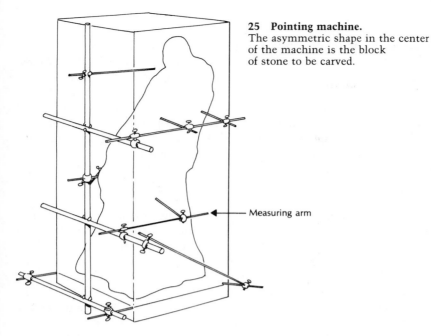

25 Pointing machine.
The asymmetric shape in the center
of the machine is the block
of stone to be carved.

Measuring arm

*In sculpture everything depends on the way in which the modelling is carried out with a constant thought of the main line of the scheme, upon the rendering of the hollows, of the projections and of their connections. . . . To work by the profiles, in depth not by surfaces, always thinking of the few geometrical forms from which all nature proceeds, and to make these eternal forms perceptible in the individual case of the object studied, that is my criterion.**

In the twentieth century direct carving remains popular because of the involvement of the artist in every step of the creative process. Unlike indirect carving or modelling, the artist has complete control and can express himself or herself directly. The British sculptor Barbara Hepworth is one of many twentieth-century artists involved in direct carving.

INDIRECT CARVING
Despite the preference of many leading artists for direct carving, many fine works have also been carved indirectly. The Greeks used clay models made by master sculptors for their great sculptural projects, which were then copied into stone by assistants. The device used for the copying is called a pointing machine (Figure 25). It consists of a platform on wheels with one or more vertical rods on it. Horizontal rods, fastened to the vertical rods on pivots, are placed against various parts of the original to be copied, and then secured.

*C. Mauclair, *The Art of Auguste Rodin,* trans. Clementina Black. London: Duckworth and Co., 1905, p. 62.

The pointing machine is moved to the block of stone intended for the copy, and the stone is carved until the depth indicated by the rods is reached. The ancients used simple versions of the pointing machine and variations on it have been used over the centuries until a fully adjustable model was developed in the nineteenth century.

It is very fortunate that the pointing method existed in Roman times, because Roman copies made this way are the only record we have for most Greek sculpture. The Greeks worked extensively in bronze, and the majority of their bronze sculptures were melted down for reuse during the Renaissance and Baroque periods.

Leon Battista Alberti, the leading theorist of the early Florentine Renaissance, recommended pointing. Alberti regarded correct measurement and delineation (by which he meant the treatment of surface proportions) as extremely important. Therefore a model could be made and worked on until the desired level of perfection was reached and the result transferred into stone. Leonardo da Vinci is recorded as having an interest in a pointing machine, although he never used one. Copies made by indirect sculpture also provided a means for people to own reproductions of originals in stone. Some famous works were copied in stucco, papier mâché, or terracotta, and sold at reasonable prices.

A number of post-Renaissance sculptors worked largely in indirect carving. The early nineteenth-century artist Antonio Canova, for instance, carved directly early in his career but did his later works as plaster casts. The casts were then pointed into marble by skilled craftsmen.

Today very little is done with pointing or indirect carving. Contemporary artists as a rule do not like to hand over any part of the creative process to others, but prefer to work entirely on their own.

SCULPTURE IN THE ROUND
Sculpture in the round is also called **free-standing sculpture**. It is not attached to any kind of background, but can be walked around and looked at from all sides. This does not mean that all angles will be equally effective, only that it is possible to see them. Some sculptures in the round, though, are intended to be placed in niches or against walls, thereby limiting access to them.

Many early free-standing sculptures have geometric shapes, partly because these shapes are easier to carve than a detailed form is. An example is the statue of the Egyptian pharaoh Mycerinus (Figure 26), carved from alabaster around 2500 B.C. The artist worked from each of the four sides of the block until a roughly human shape emerged. Then he did the minimal amount of detail carving to make the form and features recognizable. The beard, arms, and legs were

left attached to the block to minimize the chances of breakage. The chair the king sits on is simply part of the block itself and no further shaping was done in it. Much Egyptian sculpture is even more minimal than this, with the twin benefits of durability and massive dignity.

Stone sculpture continued to be done throughout the classical period in enormous quantities, with a greater emphasis on detail. Herakles (Figure 27) is an approximately three-foot Greco-Roman marble. It is a copy, done by pointing, and shows some of the drawbacks of stone as compared with the bronze the original was cast in. The open stance of the figure with its extended arms was easy to balance in bronze, but in marble requires a heavy base. Herakles's club is attached to his leg by an odd-looking corkscrew-shaped support, and his other arm has a large support in the form of a tree trunk. The heaviness of the stone and the likelihood of breakage are responsible for these unaesthetic changes. As a copy, this was done quickly and drilling was preferable to carving with a chisel. Drill holes are visible in Herakles's hair and beard.

26 Egyptian
Mycerinus, 4th Dynasty, ca. 2500 B.C.
Courtesy Museum of Fine Arts, Boston.
Harvard/MFA Expedition.

27 Roman
Statuette of Herakles,
original (Greek) 5th century B.C.
Courtesy Museum of Fine Arts, Boston.
Francis Bartlett donation of 1912.

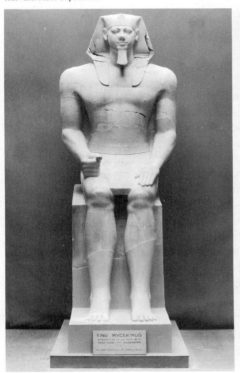

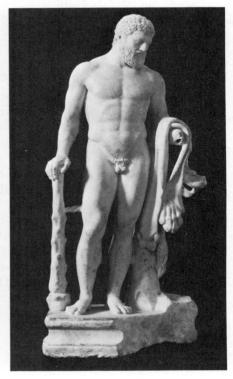

The *Madonna and Child* (Figure 28) is a medieval French limestone sculpture intended for use as an altarpiece. Realistic depiction of a mother and child is subordinated to theological considerations. The queenly Madonna easily supports her marionettelike infant. Statues like this were often gessoed and painted; they provided colorful accents in their churches.

Bernini's *St. Longinus*, the *bozzetto* for which appears in Figure 24, is an example of a free-standing sculpture which pushes the medium of stone to its limit. Although this model is of clay, the stone version reaches out in an equally dramatic way. Sculptors like Bernini were looking for effects that made it impossible for them to be cautious. Outflung arms, widely separated legs, even fingers spread apart, were all part of their vocabulary. No record exists of how many sculptures like this broke during their creation, but this is a chance sculptors like Bernini found worth taking.

Contemporary sculptors, for the most part, do not emulate the illusionism of sculptors like Bernini. To them, there is something dishonest about making stone or wood look like rope or lace. The quality of the material itself is important to such sculptors and they try to emphasize it in their works. John Bergschneider's *Skull* (Figure 29), carved from granite in the early 1960s, is an example. This oval form, thirteen inches in length, is as heavy and massive and elemental as the granite from which it comes. The lightly incised teeth, the roughly hewn cavity, and perhaps an ear, attest to the hardness of the material. This work emphasizes, rather than disguises, the exact nature of its material.

RELIEF SCULPTURE

Relief sculpture, or sculpture attached to a background, is not as popular today as it was in the past, largely because modern architecture does not use relief. There are several different kinds of reliefs: **high relief,** in which at least half the figures project from the background; **low relief** or **bas-relief,** where the figures project slightly; **extremely low relief,** or *relievo stiacciato,* in which the carving scarcely protrudes at all; **sunken** or **intaglio relief,** with the lines of the figures hollowed out of the surface.

The Roman sarcophagus, or coffin, in Figure 30 is an example of high relief. Carved partially with a drill, the frieze of figures appears almost to be free-standing. The arms, in particular, seem to protrude right into the viewer's space. Such high relief makes possible striking effects of light and shadow and makes the subject, in this case a grape harvest by worshippers of the wine god, Dionysus, seem dramatic and motion-filled.

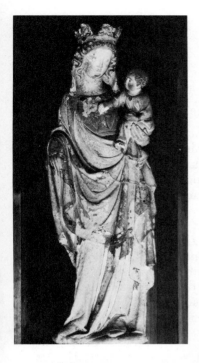

28　French Gothic
Madonna and Child, 14th century
Isabella Stewart Gardner Museum, Boston

29　JOHN BERGSCHNEIDER
Skull, 1961–62
Courtesy Museum of Fine Arts, Boston.
The H.E. Bolles Fund.

30　Roman
Sarcophagus with Satyrs
and Maenads
Gathering Grapes,
3rd century A.D.
Isabella Stewart Gardner Museum,
Boston

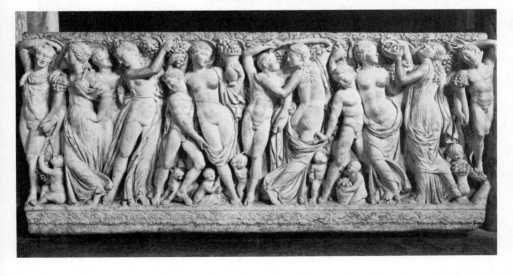

A much quieter effect is presented by a combination of low relief and *relievo stiacciato* in the *Madonna of the Clouds* by Donatello, from about 1435 (Figure 31). The Madonna's head and the infant Christ's arm are in low relief and the rest in *relievo stiacciato*. The highest point of projection is no more than ⅛ of an inch, giving an impression of softness and texture rather than light and shadow. The relief was meant to be appreciated slowly and carefully, with each fine detail noticed separately rather than all at once. The angels in the upper right and left corners are actually incised into the marble, while the *putti* surrounding the Madonna and Child project slightly more.

The Egyptians frequently used sunken or intaglio relief on their architecture. Figure 32 is a column in the shape of a palm tree from a temple. The hieroglyphic inscriptions and scenes of the king are first outlined on the stone and then cut into it. The edges of the figures are cut the most deeply and the centers are left roughly even with the original surface. Like high relief, sunken relief catches light and is easy to see. Even at a distance it is a distinct advantage in architectural situations.

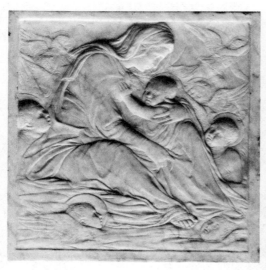

31 DONATELLO
Madonna of the Clouds, ca. 1435
Courtesy Museum of Fine Arts, Boston.
Gift of Quincy A. Shaw, through Quincy A. Shaw, Jr.
and Mrs. Marian Shaw Haughton.

32 Egyptian
Column with palm design capital, 19th Dynasty
(Rameses II), 13th century B.C.
Courtesy Museum of Fine Arts, Boston. Gift of the
Egypt Exploration Fund.

Greek and Roman temples, Renaissance and Baroque churches, the neoclassical architecture of the nineteenth century, all made extensive use of relief sculpture. The simplicity and starkness of modern architecture, however, with its emphasis on poured concrete and glass, do not offer much scope for attached sculpture, and the art of the relief has become little-used in the twentieth century.

Additive Sculpture

The term additive sculpture refers to **modelling**. Modelling can be done with any malleable material and is the opposite of carving in that the sculpture is built up from the inside. The surface is not just the exterior of an untouched block of material, but is the culmination of a process of three-dimensional creation. There is more physical freedom involved than there is in subtractive sculpture. The carver is always limited by the outer limits of the physical block; he or she can transcend it in small ways by additions, but the mass of the sculpture is firmly enclosed by the block. In modelling the sculptor can add material at will, giving spontaneity and directness, both in the process and in the results. The problem of fragility is diminished because most modelled sculptures are small and not subject to the kinds of outside stresses that a large stone work is. Casting into metals is used for large additive sculpture.

MATERIALS

The most common material used in additive sculpture is **clay**. The two types of clay generally available are earth clay and plasticine. Plasticine, the less-used, is a synthetic, nonhardening compound of earth clays, sulphur, and oil or grease. It has to be worked on an armature, or metal skeleton, and is mostly useful for models that are not intended to be permanent.

Earth clays, on the other hand, are made permanent by firing. If fired at a low temperature, the clay becomes terracotta, a term which takes in both earthenware and stoneware. Porcelain is high-quality clay that is fired at a high temperature and produces a fine white or light gray translucent substance. Porcelain was first used by the Chinese during the Tang Dynasty (first millennium A.D.), and was not used in Europe until the eighteenth century, when it was discovered by Johann Friedrich Böttger.

Terracotta is ordinary clay suitable for shaping and firing and has been used for everything from vases to roof tiles. Clays may be painted, waxed, or glazed with vitreous coatings. The glazes can be transparent or opaque, shiny or dull, and come in a wide range of mineral oxide colors.

Another modelling material is **plaster**. Plaster is finely ground dehydrated lime and/or gypsum. When mixed with water, it reconstitutes to form a solid material that is like gypsum but is far more workable. Plaster, like plasticine, has to be worked on an armature, and can be strengthened by the addition of other materials or fibers. Stucco refers to plaster used as a finishing and protective coating on walls. It is usually rough plaster, but smooth stucco with highly polished surfaces was also used for sculpture in the Classical and Renaissance periods. If stuccos are to be used outdoors, they have to be made as densely as possible and be coated heavily with waxes or oils for protection from the weather. The popularity of plaster, or stucco, results from its availability and low cost. It has been used mainly for models, molds, and indoor relief sculpture. Wax can also be used for models, but is unsuitable for finished works of sculpture.

Permanent large-scale additive sculpture needs to be cast into metal. Metal casting was used in ancient Egypt, the Near East, Greece, Rome, pre-Columbian America, and the ancient Orient. Small pieces, including jewelry, are cast in gold and silver. Copper was once used as a casting medium, although now it is used only as a hammered, or *repoussé,* material. Lead and aluminum may also be cast.

Bronze, however, is the most popular material for cast sculpture. Bronze is an alloy of copper and tin and is a durable, strong, and weather-resistant material. The color of bronze when it is newly cast is gold, but as it ages it acquires a patina, or incrustation, of green, due to the oxidation of the copper. Once the patina is complete, the bronze is resistant to further encrustation and is not harmed by exposure to bad weather, making it especially suitable for outdoor sculpture. In some cases though, a damaging corrosive condition, called bronze disease, occurs and eventually eats away the metal entirely. This is almost impossible to stop once it has begun, but can be prevented by keeping the bronze from contact with chlorides.

TECHNIQUES OF MODELLING

Modelling is done either by directly building up pieces of materials such as clay, wax, or plasticine, or by placing them over a metal skeleton or armature. A great deal of work is done with the hands, but there are some tools specifically designed for modelling. There are wooden tools, usually made of boxwood, which come in a variety of shapes. They can be rounded, pointed, flattened, or serrated. Tools with wire loops on one or both ends are also used to carve away and to shape the clay, and may be either rounded or angular. The average size of these tools is from 6 to 8 inches long, although smaller ones for very fine work and larger ones for large-scale projects are also

available. The spontaneity of a modelled work—the direct contact between the artist and his or her material—is a part of its appeal. You can often see the fingerprints of the artist and tell how the work was thought out in his or her mind.

In the sixteenth century Giorgio Vasari gave instructions for modelling in wax or in clay.

> *In order to show how wax is modelled, let us first speak of the working of wax and not of clay. To render it softer a little animal fat and turpentine and black pitch are put into the wax, and of these ingredients it is the fat that makes it more supple . . . And he who would wish to make wax of another color, may easily do so by putting into it red earth, or vermilion or red lead . . . When the mixture has been melted and allowed to go cold, it is made into sticks or rolls. These from the warmth of the hands become, in the working, like dough and are suitable for modelling a figure that is seated or erect as you please . . . Little by little, always adding material, with judgment and manipulation, the artist impresses the wax by means of tools made of bone, iron or wood, and again putting on more he refines till with the fingers the utmost finish is given to the model.**

The process for modelling clay is similar, except that the artist has to keep the clay damp and malleable as he or she works. Vasari recommends adding flour to the clay to keep it from setting too rapidly. Horsehair and cloth fragments also help keep the clay from drying and splitting.

One great advantage of modelling over carving is that the artist can make changes. The clay or wax can be added or removed until the artist gets precisely the desired effect. With carving, however, once a piece of stone or wood has been removed, it is gone forever. The major disadvantage of modelled sculpture is that the materials of modelling are relatively fragile and the works will not last unless they are treated in some way.

The most common way of achieving permanency for small additive sculptures is firing them in a kiln. While not appropriate for wax, this hardens clay by making actual physical and chemical changes in it. If the finished sculpture is not going to be glazed, it is **bisque-fired,** or fired once at a low temperature for hardness. The resulting appearance is of a fine finish without color. If the work is glazed—that is, painted by brushing or other means—it is first bisque fired, then painted, then glost-fired. The glost-firing gives the sculpture a glassy appearance, the bright shiny look, that makes such works as the della Robbia terracottas such vivid additions to Renaissance buildings.

*Giorgio Vasari, *Vasari on Technique,* trans. Louisa S. Maclehose. New York: Dover Publications, Inc., 1960.

HISTORY OF MODELLING

Tiny figurines in terracotta from around 10,000 years ago are among the earliest works of art. The ease of acquiring clay, simplicity of tools, and portability of the results make additive rather than subtractive sculpture suitable both for mobile cultures and for those with little or no access to stone. The walls of Babylon were embellished with baked mud-brick relief sculptures of abstract designs and fantastic animals in the seventh century B.C.

The Greeks used modelling both in preparation for casting and for finished works. Especially notable are the small terracotta figures from the town of Tanagra. These figures were mass-produced from an original model in fired clay. Hollow molds were made of various parts of the model—the front of the body as one; the head, the arms, hats, fans, and other details separately. The back was usually added freehand and was simple and nearly featureless. In this way, the sculptor could vary his figures by using the mold of a head from one model, the body from another, and so on. It brings to mind ordering a new car, picking out suitable options. Different color combinations were even available. Figure 33 shows a typical Tanagra figurine. This diminutive lady in her enveloping cloak seems to turn gracefully, but she is actually only meant to be seen from the front. Her sunhat is made separately.

The Etruscans and Romans used terracotta for portrait sculpture, reliefs, free-standing figures, and burial urns. The Etruscans in particular relied heavily on terracotta, even for large statues. This was not a good idea, and much of their art remains in only fragmentary form. One interesting Roman use for terracotta was for portraits from masks (Figure 34). The subject's face was covered with a mask, probably of straw, and an impression was taken. The negative mask was then filled with clay, which was fired and incorporated into a portrait head. This portrait is the equivalent of a snapshot in that it represents a specific moment in the life of a person.

Medieval sculpture was mostly architectural and subtractive. There were some small additive devotional images, but the great cathedrals were covered with carved, not modelled, statues. The situation changed in the Renaissance, when a new humanism and the growth of secular architecture created a need for interior and exterior sculpture. The della Robbia family of Florence produced hundreds of terracottas, both reliefs and free-standing works. Figure 35 is a typical della Robbia relief. This majolica relief, 20¾ inches high, shows a Madonna and Child in white against a blue and green background. Luca della Robbia discovered a way of using potter's glazes on terracotta reliefs, which gave him a wide range of colors. His works and

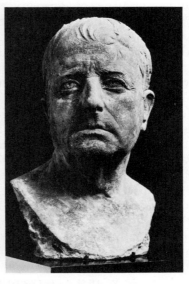

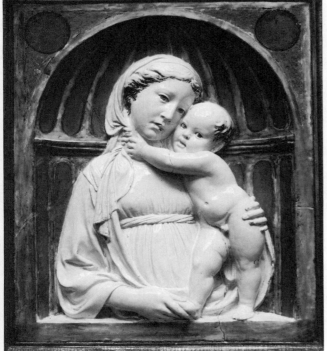

**33 (top left) Greek
Tanagra figurine
(Woman Standing),**
4th century B.C.
*Courtesy Museum of Fine Arts, Boston.
Purchased by contribution.*

**34 (above) Roman
*Man of the Republic,***
1st century B.C.
*Courtesy Museum of Fine Arts, Boston.
Purchased by contribution.*

**35 (left) LUCA DELLA ROBBIA
Madonna of the Niche, ca. 1455**
*Courtesy Museum of Fine Arts, Boston.
Gift of Quincy A. Shaw, through
Quincy A. Shaw, Jr. and
Mrs. Marian Shaw Haughton.*

those of his nephew, Andrea, are particularly memorable for the unique deep blue. Reliefs like this one were used both inside and outside buildings such as the Foundling Hospital in Florence. From the della Robbias in the fifteenth century through the seventeenth century, terracottas were highly regarded as works of art.

There is a tradition of Germanic terracotta sculpture going back to the Middle Ages. Hafner Ware, which originated in the Rhineland in the fourteenth century, is a form of polychromed terracotta used for everything from tiles to portraits. German **faience,** a very similar earth to majolica, was used for statues of up to 4 feet in height. Smaller works were made from Dresden and other porcelains.

Many non-European cultures have used additive sculpture, especially terracotta, extensively. Terracotta figurines of great sophistication and expressiveness were made by the Totonac people of Mexico in the first millennium A.D. Chinese tomb figures from many different dynasties illustrate the diversity of the additive media. The Maya and Inca peoples of South America modelled figurines of warriors and gods in clay and fired them. In Africa the Benin sculptors cast in bronze from terracotta models.

Much European additive sculpture, both because of its size and its frequently functional nature, is classified as decorative art. However an artist making a fine cup or candlestick has the same kind of concern for composition, technique, and expression as the painter or sculptor of full-size works. The twentieth-century idea of separating arts and crafts did not exist throughout much of history.

The flexibility of modelled sculpture has appealed to some twentieth-century artists, although it has not been as popular as carving. An Italian sculptor, Medardo Rosso, worked from 1890–1910 in clay, wax, and bronze, and was as famous in his time as was Rodin for his extremely expressive treatment of the flexible substances he preferred. Most contemporary sculptors, however, cast their works into bronze, thereby combining the malleability of modelling with the permanence of metal.

TECHNIQUES OF CASTING

Metals may be either solid-cast or hollow cast. Small items like jewelry are generally solid-cast, as were sculptures in metal before the Greeks. In **solid-casting** the molten metal is poured into a mold representing part of the sculpture and then allowed to harden. Each mold may comprise up to half the sculpture, depending on its size. When the metal has set, the sections are joined by soldering, usually with an alloy of lead and tin.

Solid-casting is limited to small objects, due to the cost of the metals and the weight of the finished figure. **Hollow-casting,** first

used by the Greeks, enables the sculptor to reproduce a model in metal, usually bronze, with a hollow core. Bronze, an alloy of copper and tin, is the preferred metal for casting because of its durability and resistance to atmospheric corrosion. Bronze is a golden color when it is first cast but acquires a patina, usually a deep green in color, that protects the sculpture from corrosion; it is part of the beauty of the piece. Bronze is used extensively for outdoor sculpture, including fountain sculpture, because of its durability.

One method of hollow-casting metal sculpture is **sand-casting**. The sculptor begins with an additive model of his work, either complete or incomplete, depending on the size of the work. Large works are cast in sections then soldered or welded together. The model is first packed tightly in very fine sand called **foundry sand,** which is kept moist and compact enough to preserve the negative image of the model. The sand is held in place by a frame of heat-resistant material such as steel. The whole unit fits so tightly together that when the model is removed from the middle the sand holds its shape. A core of sand around an armature is fitted into most of the space originally occupied by the model and the entire mold is dried out in an oven. Molten bronze is then poured into the space between the core and the negative mold, both of which are porous enough to let the heat and gases escape. When the bronze has cooled and hardened, the core and frame are removed, leaving a hollow bronze in the shape of the negative space between them. Polishing and fine detail work are done after the casting process has been completed. Sand-casting is frequently used for architectural sculpture, jewelry, drawer pulls, handles, and other applied sculptures.

Most hollow-cast bronze sculpture, however, is done by the *cire perdue,* or lost wax, method. As with sand-casting, lost-wax casting begins with a model, usually made of plaster, which is to be reproduced in bronze. Figure 36 on page 66 shows a model for the head and shoulders of a human figure (a). This model serves as the basis for a negative mold, made in sections (piece-mold), of plaster or today sometimes gelatin. The negative mold is assembled and filled with a thin coating of wax. The center of the hollow wax model is filled with foundry sand, dampened, and tightly packed. Foundry sand has replaced earlier core materials, including those recommended by Vasari—horse dung and hair. Wax rods attached to the wax model lead to the outside of the structure and will become vents (not shown in drawing). A frame of fire-resistant material such as clay goes over the mold and pins of bronze hold frame, mold, wax, and core in place (b). Next, the unit is placed in an oven and the wax runs out, leaving an open space (c). The mold is reversed and molten bronze is poured into the space formerly occupied by the wax, with the heat and gases from

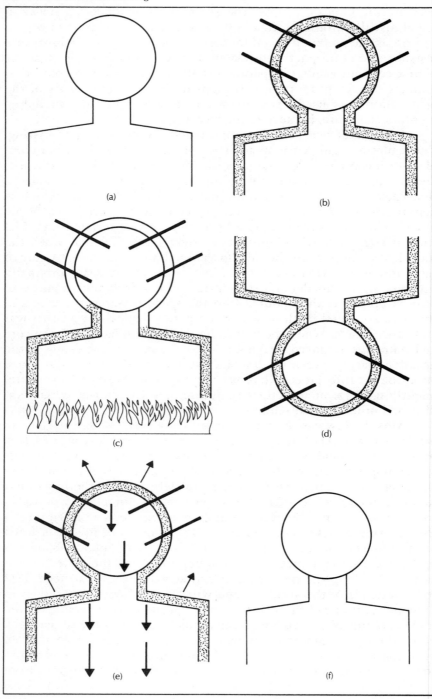

the process escaping through the vents (d). When the unit has cooled, the sand core, mold, and frame are removed (e), leaving a thin bronze shell (f). The mold, made in sections, can be reused. Thus, each casting made from the mold is an original and many versions of famous works in bronze exist. The result of the lost-wax process is a thin skin of bronze, exactly the depth of the original wax coating of the negative mold. This bronze has to be polished, and some details, like the individual hairs in eyebrows, are added by engraving. Finally, in a large sculpture, the various pieces are assembled by soldering or welding and the joints are carefully polished away. Many large bronzes are soldered so that they can be disassembled. For instance, the equestrian statue of the Roman emperor Marcus Aurelius, which crowns Rome's Capitoline hill, was taken apart and placed in a basement for safety during World War II.

HISTORY OF CASTING

Although solid-casting has a long history, it was not until the fifth century B.C. that the Greeks invented hollow-casting. The Greek quest for the illusion of lightness and movement in their human statues had been frustrated by the heaviness of stone. They wanted to make figures reach out and seem to run, walk, and dance. The lost-wax bronze casting method gave them this capability. Bronze Greek gods balanced on the balls of their feet, trident or lightning bolt in hand. Bronze athletes threw the discus, moved easily with their spears, drove chariots. Tragically, the majority of the bronzes are lost to us, melted down and reused during the Renaissance and Baroque periods. There is a great deal of truth in the bitter Roman joke, "what the barbarians did not get, the Barberini did."

The Romans continued the classical tradition of bronze casting, immortalizing their emperors and nobles, making bronze chariot ornaments, faucets, fountains, and garden sculptures. Like the Greek works, much of this has perished, but enough remains to give us an idea of its widespread use.

During the early part of the Middle Ages, bronze casting gradually died out from lack of demand. The technique was so thoroughly lost that when the fourteenth-century Florentine sculptor Andrea Pisano was commissioned to cast bronze doors for the Baptistery in Florence, he could find no one to do the foundry work. Eventually a bell-maker was called in from Venice. Ghiberti, Pisano's successor on the Baptistery doors project, taught bronze workers himself to facilitate casting his work. The other early Florentines, through Donatello, taught one another. After Donatello the technique died out again and Benvenuto Cellini in the sixteenth century had to teach himself how to cast.

37 BENVENUTO CELLINI
Bust of Bindo Altoviti, ca. 1550
Isabella Stewart Gardner Museum, Boston

Cellini's bust of *Bindo Altoviti* (Figure 37) demonstrates the success of his efforts. This work was admired by Michelangelo, who called it a masterpiece for its technical virtuosity. The variety of textures in the highly polished bronze surface give an impression of color, adding to the vivid and lifelike quality of the work. Altoviti's eyes, cast here rather than inlaid as was often done, are bright and interested, his mouth appears about to speak, his head turns as though something has caught his interest. The simpler forms of the bust complement but do not detract from the face. The dark patina of the bronze gives a warmth to Cellini's portrait that would be difficult to duplicate in stone.

After the Renaissance, bronze casting continued to be popular, especially for outdoor sculpture. The public parks of most countries are filled with bronzes of notable persons, providing in some cases both historical and aesthetic satisfaction, and in others at least a resting place for tired pigeons. Nineteenth-century America was especially taken with outdoor bronze sculpture, with a number of American sculptors moving to Italy or France to be closer to the foundries. Their works adorn churches, government buildings, and public parks across America.

Rodin and Degas in the late nineteenth century began to revolutionize bronzes. Degas, although he never cast any of his models himself, exhibited one of them, a small sculpture of a ballerina wearing an actual ballet costume. When it was cast after his death, the bronzes were also dressed in net skirts. This was the beginning of the end of a strict separation of materials in sculpture.

Rodin worked in many sculptural media, both additive and subtractive, and was interested in making both the materials and the sculptural process part of the experience of viewing the work. Therefore he varied the surfaces of his sculptures, sometimes leaving rough

fingerprints in the bronze to remind the viewer of the original buildup of material in the model. He sometimes polished stone to a brilliant gloss, emphasizing its natural hardness. Part of the essence of twentieth-century art is that the process through which the work is created is part of its impact. By emphasizing the effects of different techniques, the act of creation itself is part of the result of that act.

Picasso worked in bronze, adapting styles like Cubism to the sculptural medium and finding satisfaction in the range of physical possibilities offered by a three-dimensional form of art. His *Head of a Woman* (Figure 38) is an example. The planes of the work appear differently as the viewer looks at it from different angles. Light glances off the textured and carefully shaped planes imparting a constant feeling of movement and change. Although very different in appearance from the Cellini, this portrait has the same quality of vivid life as the earlier work. Although it would not have been impossible to achieve these effects in stone, the limitations of the block would have made it more difficult. The deep valleys and sharp ridges of Picasso's head are well suited for bronze.

38 PABLO PICASSO
Head of a Woman, 1909
Courtesy Museum of Fine Arts, Boston.
Gift of D. Gilbert Lehrman.

Among the non-European cultures, the Chinese are particularly noted for their work in bronze casting. There is a tradition of Chinese bronze tomb figures and ritual vessels dating back to the Shang period of the second millennium B.C. The Benin tribe of Africa also worked in cast bronze as have various Indian sculptors. In all three cultures there was a strong sense of the physical qualities of the metal, a sense of volume and highlighting which was not diminished by the fact that the original sculpture was made in another material and then cast into bronze.

Some contemporary sculptors do not like the fact that the artist has to turn over part of the work of creating a bronze to a foundry. This means a lack of direct participation by the artist in that final part of the process. Nonetheless, a number of major contemporary artists work in bronze casting, among them Matisse, the expressionist Lehmbruck, Jacques Lipchitz, and Jacob Epstein.

Assemblage or Fabrication

MATERIALS

Assemblage or fabrication, also called **direct-metal sculpture,** is a product of the twentieth century. Sculptors, like other artists, no longer feel limited by either medium or technique and adapt processes from industry and other sources for their art. The materials used are theoretically limitless, although there is a concentration on steel because of its versatility. Industrial techniques like welding and soldering play a large part in assemblage and no two works are created in exactly the same way. Even energy can play a part in assemblage, as some sculptures are kinetic and are plugged in. This is a reversal of the traditional idea that the viewer should walk around the sculpture. The sculpture itself moves and presents itself sequentially to the viewer, who needs only to participate visually. Since it is impossible to discuss all the materials used by contemporary sculptors, a look at one will give an idea of the possibilities of such materials.

One sculptor who makes interesting use of industrial materials in direct-metal sculpture is Michael Steiner. Steiner frequently works with corten steel, a material which changes in color and texture as it ages, adding to the interest of the work. Like bronze, steel cannot be worked on gradually or experimented with. Steiner replaces the traditional *bozzetto* (preliminary models using terracotta) with a wooden model of his sculpture, although he keeps the possibilities of steel in mind as he works. The model is of the same size as the final work, so that the actual fabricating does not significantly alter his concept. Like a Renaissance sculptor in bronze, Steiner does not do his own

39 MICHAEL STEINER
Flingtime, 1975
*Hirshhorn Museum and Sculpture
Garden. Smithsonian Institution.
Gift of Harry Kahn, New York.*

fabricating, although some direct-metal sculptors do. He does, however, carefully control and oversee the work.

An example of Steiner's work is *Flingtime,* which dates from 1975 (Figure 39). Like many of Steiner's works, *Flingtime* emphasizes the nature of the steel—heavy, raw, and powerful. The curving planes of *Flingtime* appear strong, yet flexible. They reach out into space with assurance. The steel itself, as it changes and ages, continues to interest the viewer. Through the cutting and shaping and welding of the steel, contemporary sculptors can achieve an effect they want—from the most delicate to the most massive. There are no general principles except those imposed by the techniques themselves, and the range of results is limitless.

METHODS

Once again, there is no one method of assemblage or fabrication in sculpture. The only real limit is the imagination of the sculptor. It is possible to invent a new art form, as Alexander Calder did with his mobiles. Calder created mobiles of all sizes, shapes, and colors, freeing sculpture from its traditional association with the ground and giving it a freedom of movement usually unassisted by power sources. One of the grandest of Calder's mobiles was made for the new wing of the National Gallery in Washington (Figure 40). The red and black plates of this untitled mobile are made of honeycombed aluminum, a technique adapted from the aerospace industry. The enormous mobile is held together by a framework of steel and moves by its own weight. Like all of Calder's works, it fills the space it occupies without massiveness or crowding. The building is enlivened and enhanced by the presence of this sculpture.

71

40 ALEXANDER CALDER
Untitled (Mobile), 1976
National Gallery of Art, Washington.
Gift of the Collector's Committee.

One of the points of using industrial materials and methods in contemporary sculpture is to tie it in more closely with everyday life. Such sculptures are best seen, not in museums or galleries, but in parks, playgrounds, and other outdoor spaces. Often they lose their vitality in inappropriate spaces. When they do appear in museums, they must be displayed so that viewers can walk around them and experience them from a variety of angles, and, if possible, under natural lighting conditions. The variety of techniques used by the artists makes it harder for the nonartist to have a clear understanding of how such sculptures were made, but that does not have to limit one's appreciation of them. The important thing is to approach contemporary assembled or fabricated sculpture with an open mind and to get the most from what they are, not to be distressed by the lack of familiar references.

EXERCISES
Looking at sculpture is more physically involving than looking at painting. To appreciate most sculptures, you need to walk around them and look at them from all angles.

1. When viewed from all four sides, does the sculpture seem to have a predominant side? What does this tell you about how it was intended to be displayed?

2. Are there clear distinctions between the sides or do they slide easily into one another? The answer to this will tell you whether the artist conceptualized the work in terms of separate planes or organically.

3. Is there a definite limit beyond which no side of the sculpture reaches? Does any one element reach out further into space than the rest? This tells you whether the sculpture began as a block (subtractive) or was modelled (additive).

4. What is the material of the work? What does this tell you about the probable method of creation?

5. Do you see marks on the sculpture? If so, do they appear to be tool marks or finger marks? What does this tell you about the method of sculpting?

6. If the sculpture is of stone, notice how much help it needs to stand upright. If, in particular, it is a human figure and has a heavy base and a tree trunk as support, it could well be a stone copy of a sculpture originally done in bronze.

7. Does the surface have regular small round holes in some areas? In sculptures of people, these frequently occur on hair and beards. These small holes are drill marks, and give you a clue as to possible times and places of origin of the work.

8. Is the work made of metal? If so, look for seams or mold marks where it was soldered together. The seams in a hollow-cast work usually are not visible.

9. Does the sculpture reach out into space and stand on a small base or no base at all? This usually means it is hollow-cast bronze, which is the lightest material available.

10. When looking at abstract sculpture, try to decide from its appearance what the material is. You can also usually tell how the work was put together by looking closely.

11. Reliefs can be treated more like paintings in that they are meant to be seen from only one side. Decide what the material is and notice the depth of relief.

12. In cases of painted sculpture, you can often tell the technique by deciding whether or not the composition was limited by the form of a block of material. If not, it is probably terracotta or porcelain. If so, then painted stone. Size is also a clue here. Additive sculpture, if not cast, is usually small.

4
Architecture

Architecture is the visual art that has to be functional. Although painting and sculpture can have a religious, political, or funerary function, they can also be purely aesthetic in intent; but a building that could not be used would not be built. Architecture also makes a less direct and intimate statement to the viewer because the architect has to entrust a good deal of the actual creation of his or her idea to others and because buildings are used by many people.

Technique, the method of construction, determines the appearance of a building. The surface details, however pleasing, do not make the building succeed or fail. Only the quality of its conception and construction, and the success with which it fulfills its function are important. Some of the criteria on which a building may be judged are how well it fits into its surroundings, how it affects the viewer from the outside and inside, and how efficiently and pleasantly it serves its function.

Historically, many different systems have been used, with varied success, to construct buildings. Churches, palaces, tombs, houses, office buildings, and factories have all been designed using available technology to meet the needs of changing societies. What technology is available conditions what will be built in some cultures, while others reach out to exciting new solutions to problems.

Since humans have been building for millennia, it is somewhat

surprising that there are only three basic ways to construct a building and that one of them was not used until the late nineteenth century. However most periods did not regard progress and innovation with the fondness that we do and were happy to extend and perfect existing techniques. After all, if there is already a perfectly good way to build a church, why look for another? Because of this overall conservatism, the great leaps of imagination stand out sharply, and are often the work of one person.

The oldest method of construction is the **post and lintel system**. In post and lintel, two vertical elements, the posts, are topped by a horizontal lintel. Stonehenge was built in this way, as are most modern office buildings. The **arch** provided a way of building larger, more open buildings to accommodate growing populations and to create an urban environment. In the late nineteenth century, the American architect Louis Sullivan invented the technique of **cantilevering,** or placing the main weight-bearing area of a building in the middle and hanging the rest of the building from it. A cantilevered building is like a tree with a central trunk from which the branches extend. Entire buildings can be cantilevered or just portions of them, like balconies or canopies.

The Post and Lintel System

Post and lintel architecture is based on vertical supports, variously called posts, columns, piers, or pillars, which carry horizontal superstructures. Most doorways are examples of post and lintel architecture, unless they have curved tops, in which case they are some form of arch. Post and lintel buildings can be constructed of wood, stone, iron, brick, concrete, or steel. With flexible materials like steel, they can rise to great heights and encompass tremendous areas.

The use of post and lintel construction extends back to the prehistoric period. The monoliths at Stonehenge were arranged in a post and lintel form in the second millennium B.C. Even earlier, around 3000 B.C., the ancient Sumerians, in what is now Iraq, built their pyramid-like ziggurats out of mud-brick in post and lintel architecture. The Egyptians, Greeks, and Romans all used post and lintel methods for their temples, refining and improving the system to produce monuments which have commanded people's respect and admiration ever since. Early Christian churches used post and lintel construction in a design that continued into the twentieth century. Renaissance palaces, Baroque churches, the stately homes of the nineteenth century, and most public and private twentieth-century architecture are all variations on post and lintel construction.

With its flexibility, post and lintel has been attractive to architects of many different times and places. Until the twentieth century brought steel beams into common use, however, there was a major drawback. An architect working in wood or stone is limited by the distance the lintel can reach between posts. If the lintel lacked sufficient support, it would collapse and bring the building down with it. This prompted architects to use a large number of posts. Anyone who has ever tried to see a play or movie from behind a post will appreciate the difficulties this presents.

COLUMNS

The majority of posts used in architecture have been **columns**. Columns are cylindrical and usually have a base, a shaft, and a capital (Figure 41). They are round and can be either plain or fluted, which means carved with vertical concavities running their entire length. Although many kinds of columns have been used, some with animal capitals, others with capitals carved into Biblical scenes, still others with the entire column carved with figures and inscriptions, three basic styles, or orders, were established in Greek and Roman antiquity. Figure 42 shows a Doric column from the Hephaisteion in Athens. The Doric column has no base and is fluted. It is rather heavy looking and ends in a simple capital consisting of an echinus that swells out gradually and a block, called the abacus. Below the capital decorative bands called necking are often carved. The Ionic column

**41 The parts
of a column**

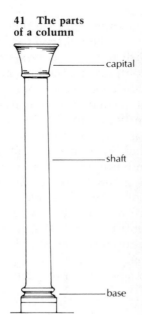

capital

shaft

base

42 Doric column,
the Hephaisteion, Athens,
5th century B.C.
Photo by Fred Hanhisalo

in Figure 43 is from the Erechtheum in Athens. It is more slender and graceful than the Doric and has a curving base that provides a gentle and elegant transition from the floor below the column to its vertical shaft. The Ionic capital has more elaborate necking and is topped by a scroll-like motif.

The Greeks, who used the Doric and Ionic orders extensively, developed a system of proportions based on the columns, which produced buildings that are beautiful and extremely well-proportioned.

The third order, the Corinthian (Figure 44), was used infrequently by the Greeks but extensively by the Romans. Roman architecture is often based on the Corinthian column, which is the most elaborate and grand of the three. The Corinthian capital is made up of acanthus leaves and tendrils and appears to grow from the top of the shaft. Like Ionic columns, Corinthian columns are tall and slender and have a high base.

There are several methods for constructing a column. Perhaps the most impressive is the monolithic column, in which the shaft of the column consists of a single carved stone. The base and capital may be separately made. The difficulty is in finding such great stones, transporting them, and raising them into place. The porch at the Pantheon, a building in Rome from the second century A.D., uses monolithic columns.

It is more common to make the columns of drums (Figure 45), or segments of stone. Each drum has a hole in the top and all but the

Ionic column,
e Erectheum, Athens,
h century B.C.
oto by Fred Hanhisalo

44 Corinthian capital,
the Pantheon, Rome,
2nd century A.D.
Photo by Fred Hanhisalo

45 Column drum
Photo by Fred Hanhisalo

bottom one have a rod, or dowel, sticking out of the bottom. By inserting the dowels into the holes, the drums are assembled into a column. The fluting, if any, is done after the drums are in place. The drums can be lifted into place by means of pulleys and winches. Before such devices were invented, though, columns were erected by filling the building areas they occupied with sand or dirt up to the level of each drum as it was added. When the top was in place, all the sand or dirt was shoveled out again.

The Romans often made their columns from bricks shaped like wedges of pie and covered them with a thin veneer of marble. Wooden columns were used frequently in the nineteenth century, particularly in houses. They are usually made of vertical planks, shaped to form a cylinder, and may be fluted. Some modern columns are made from drums of concrete poured into shaped molds and then cemented or mortared together.

Most American domestic architecture before the second World War was of post and lintel construction. Colonial frame houses were made of heavy timbers lashed or doweled together. Such heavy construction continued into the nineteenth century, often using a mortise and tenon construction, in which the ends of the beams were carved into rods, or tenons, which fit into corresponding holes, or mortises (Figure 46). Around the middle of the nineteenth century a much lighter form of wooden building, called balloon construction, was developed. In balloon construction, pieces of wood only two inches wide are nailed together to make the frames for buildings. Numerous thin, easily lifted pieces of wood were used instead of massive timbers, and nailing replaced mortise and tenon joints. This made construction cheaper, easier, and faster. Today balloon construction is used universally for wooden buildings and wooden interior partitions. The name comes from early detractors who thought that such light construction had as much staying power as a balloon.

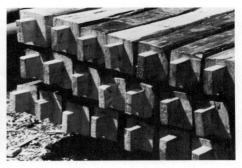

46–47 Mortises and tenons
Photos by Fred Hanhisalo

It would be interesting to know what they would think of today's inflatable buildings.

METAL SKELETON ARCHITECTURE

Wood, however, is not suitable for buildings of great height, and the modern skyscraper age comes from the development of strong yet flexible metals. The idea of **metal skeleton** architecture goes back to the beginning of the nineteenth century, when iron frame buildings like the Royal Pavilion at Brighton, England, were built. Such buildings had a skeleton of iron whose vertical and horizontal members were welded together. The walls, floors, and partitions were hung from the skeleton. The advantage of this method of construction is that the walls can be light, since they bear no weight, and many windows can be used.

Iron is too heavy to be satisfactory, though, and it was not until the introduction of structural steel that the tall buildings that came to be called skyscrapers were possible. By the 1880s, eleven and twelve story buildings with steel frames were being built for use as office buildings, stores, and other public functions. The invention of the elevator in 1857 facilitated this development. The first steel skeleton skyscrapers were heavy and the walls were more massive than was necessary. To make people comfortable with the building's height, the exterior was embellished with familiar motifs—arches, columns, and moldings, and the roof lines projected out like lids. Gradually, people became more familiar with tall buildings and their heights rose to fifty, then eighty, and now over one hundred stories. Many large buildings today appear to be enclosed in a curtain of glass without any solid wall surface. Reflecting glass is sometimes used to make the buildings into giant mirrors for their environment. Both balloon construction and steel skeleton construction show the range of buildings possible with post and lintel architecture.

Arches, Vaults, and Domes

THE ARCH

No one is sure who invented the arch. The Greeks knew about it and an arched gateway from the Etruscans in the first century B.C. survives at Perugia, Italy. The Romans, however, exploited the arch and laid the foundations for hundreds of buildings in following eras. Like post and lintel construction, the arch depends on two uprights. Across the top, instead of a straight lintel, is a curving element made up of specially shaped stones or bricks called **voussoirs** (Figure 48). The voussoirs are sometimes held in place by pressure alone; at other times with the help of mortar. The arch can reach to greater heights than post and lintel construction and can span greater distances. Arcuated buildings (buildings based on the arch) can hold many people in interior spaces unbroken by supports. This made them suitable for cathedrals of the Middle Ages.

Arches gain stability from a balance of tension in opposite directions. The greatest downward tension is at the topmost voussoir, or **keystone,** which locks the arch together. There is also an outward tension at the bottom of the arch, called the **haunch,** where it curves, or springs, away from its supporting verticals. To maintain its integrity, the arch has to have some help. There has to be something exerting pressure inward against the posts, which would otherwise be forced apart by the tension of the arch itself. This opposing pressure can be supplied by a wall, by another arch, or by towers called **but-**

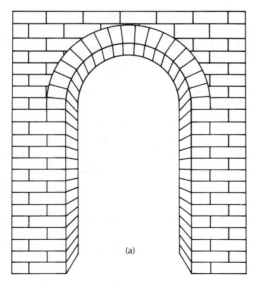

(b)

48 An arch constructed of voussoirs:
(a) voussoirs making up an arch;
(b) individual voussoir.

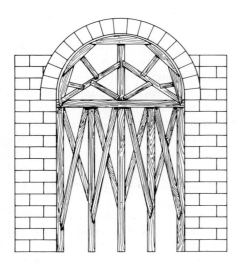

49 **Centering device** for the construction of an arch.

tresses. In buildings like the Colosseum in Rome which used to be a complete oval of arches, the balance has been destroyed by the removal of some arches. An enormous brick wall has been built to try to keep the building standing and to prevent more spreading.

Arches are constructed over a semicircular wooden scaffolding called a **centering device** (Figure 49). The voussoirs are placed on the centering device from the edges towards the middle. The last to go into place is the keystone, which locks the whole arch into place. If the keystone is disturbed at any time, the arch will come down.

The corbeled arch is not an arch at all. Stones are placed in layers with each layer projecting further into space than the previous one. Finally the top stones on each side meet one another. The Mayans in South America and the Mycenaeans, an early Greek culture, used corbeled arches. To build an entire corbeled building, a circle of stones is laid, then another circle on top, projecting towards the middle, then another and so on. Rather than a smooth dome-like roof, there is an almost cone-like effect.

Over the centuries a good many uses for arcuated buildings have been developed, most of them based on Roman ideas. The Colosseum itself is the ancestor of hundreds of modern football stadiums. The Romans spanned hundreds of miles with arched constructions called aqueducts, which brought fresh mountain water to their cities. They built triumphal arches to commemorate great victories, an idea that survives in the Arc de Triomphe in Paris and in many other places. Arched windows appear in buildings from the Renaissance to today, their graceful silhouettes giving interest to the façades they occupy and allowing large window areas. Bridges are often based on arches, as are railroad trestles.

THE VAULT

The vault is a logical development of the arch. A simple vault is really a series of arches, one behind the other, forming a tunnel. In fact, this kind of vault is called a **tunnel** or **barrel vault**. (The Romans used them extensively in their building and they were adapted by the various people of the Middle Ages for churches and castles; they have been used ever since.) Barrel-vaulted halls have been a feature of large buildings since the first century A.D. because of their ability to hold large numbers of people. The disadvantages of barrel vaults are that they require a great deal of buttressing. The pressure on a barrel vault is the same as that on an arch, but multiplied many times because of the length of the vault.

In order to overcome these disadvantages, the Romans continued to experiment with vaulting and developed the **groin vault**. A groin vault is made up of two barrel vaults crossing one another at right angles (Figure 50). A large building could be constructed with one barrel vault running its length and a number of others crossing it, creating a series of segments, or bays. Groin vaults have a number of advantages over barrel vaults. Each of the two vaults making up a groin vault is pressing in a different direction and the pressure meets at the corners of the vault. Heavy buttressing has to be provided at the corners, but the vault can be open on all four sides, allowing light and air into the building. As architects gained experience with groin vaults, they noticed that the tension is the greatest on the arches at the ends of the vault and at the point of crossing. These were then built of heavy stone and the rest of the vault of lighter brick. The Romans also built cast-concrete vaults that needed little or no buttressing.

50 Medieval groin vault construction
Photo by Fred Hanhisalo

82

A twelfth-century Italian church, Sant' Ambrogio in Milan, used heavy ribs along the openings and crossings of its groin vaults. This was widely copied, and for this reason a groin-vaulted ceiling usually looks like a series of X's. Many ancient buildings and the majority of Romanesque and Gothic cathedrals are constructed of groin vaults.

The sexpartite vault is a variant of the groin vault. The ribs that divide a groin vault into four parts led to its also being called a quad-ripartite, or four-part, vault. In some buildings, especially the larger Medieval churches, the groin vault was strengthened by an additional rib running across the middle of the X. This divides the vault into six parts, making it a sexpartite vault. The English continued the prolif-eration of ribs until the vaults of their cathedrals looked like spread fans. The basic structure, however, does not vary.

Until the thirteenth century vaults were constructed using the Roman, or rounded, arch. This limits the architect by requiring ex-tensive buttressing and by restricting ground plans to a combination of squares. A rectangular building with two long sides and two short sides would produce arches of different heights, since the height of an arch is related to the distance between its supports. The development of the Gothic, or pointed, arch solved these problems. By varying the angle of the point of the arch, they can span narrower or wider spaces while remaining at the same height. The pointed arch also permits higher ceilings; the Gothic architect was able to make churches that seemed to reach toward heaven.

Gothic cathedrals are the ultimate in vaulted architecture. Other than modern steel frame constructions, they are the only buildings in which the walls do not support the roof. Gothic cathe-drals are great stone skeletons from which the walls are hung, allow-ing the gloriously multicolored stained-glass windows for which they are famous. The construction of such cathedrals often took centuries of careful work assisted only by the simplest machinery. In a building that depends entirely on the balance of arches and vaults, an improp-erly placed stone could mean disaster.

To support the weight of the vaults, foundations more than 25 feet deep had to be placed in the ground. These foundations were built of stone under the weight-bearing areas of the cathedral. Under the principal vault no foundation was needed, so the space could be used for a crypt to hold the burials of the rich and powerful. When the foundation was in place, work could begin on the elements that would bear the weight of the vaults: piers, buttresses, and flying but-tresses. **Piers** are vertical posts which are more massive than columns and which usually do not have bases or capitals. Huge piers were sometimes carved to resemble a group of columns to make them seem less overpowering.

Buttresses, like piers, are vertical supports. They are used on the exterior of buildings at places where an especially heavy load has to be carried down to the foundations. A **flying buttress** is an arch reaching from the nave pier to the buttress (Figure 51). The flying **buttress** takes some of the pressure off the pier and transfers it to the stronger buttress. Flying buttresses were originally built under the roofs of the side aisles of cathedrals, but were later exposed and decorated with pointed towers and sculpture.

The vaults were constructed by first building their ribs. Each set of ribs was held together by a carefully carved single stone, or keystone. When the ribs were finished the thinner brick or stone skins could be added between them. Each rib leads to a pier which takes some of the weight of the vault, while the rest passes across the flying buttress to the buttress. The cathedral was filled with scaffolding until all the vaulting was in place, since the vaults would not hold their own weight until the ribs were completely finished.

The plan of a Gothic cathedral in Figure 52 shows the appearance of the finished church. The wide central aisle, or nave, is groin-vaulted except at the point where the two arms of the church cross. There, additional ribs had to be added to cover the larger area. The wings, or transepts, are also groin-vaulted. Piers run the length of the nave and transept and are connected to mammoth buttresses by flying buttresses. The entire building has the appearance of lightness and a bold, upward thrust reflecting the confidence and ingenuity of its builders.

Although they were embellished with stained glass and sculpture, the essential beauty of a Gothic cathedral comes from its structure. The soaring ribs of the vaults, the graceful flying buttresses, the majestic processions of piers reaching toward the altar, combine to provide a breathtaking experience for the worshiper or the general visitor.

51 Flying buttresses,
Westminster Abbey, London, 13th century
Photo by Fred Hanhisalo

52 Plan of a Gothic cathedral.
(From Cathedral *by David Macaulay. Copyright © 1973 by David Macaulay. Reprinted by permission of Houghton Mifflin Company.)*

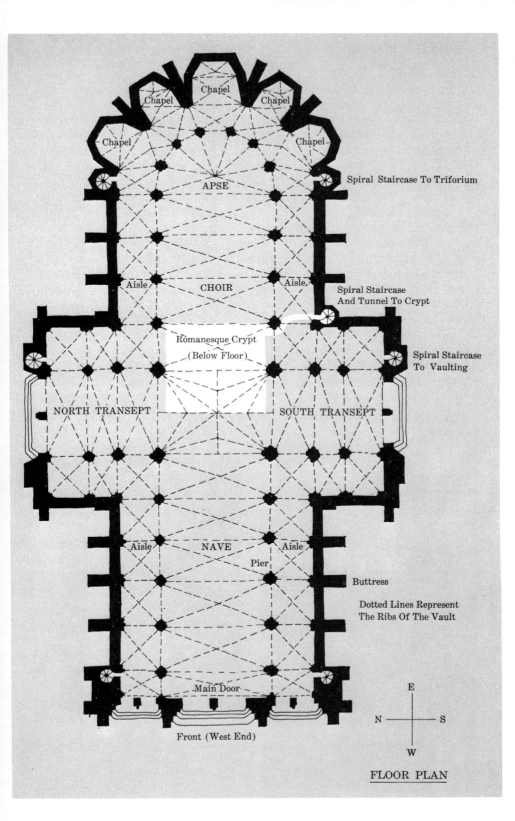

Chapel

Chapel

Chapel

Chapel

Chapel

Spiral Staircase To Triforium

APSE

Aisle

CHOIR

Aisle

Spiral Staircase
And Tunnel To Crypt

Romanesque Crypt

(Below Floor)

Spiral Staircase
To Vaulting

NORTH TRANSEPT

SOUTH TRANSEPT

Aisle

NAVE

Aisle

Pier

Buttress

Dotted Lines Represent
The Ribs Of The Vault

Main Door

E

N ——— S

Front (West End)

W

FLOOR PLAN

THE DOME

The dome was first developed by the Romans. Earlier, some primitive huts had mud domes, and a corbeled dome was used by Mycenaean tomb builders, but these do not qualify as true domes. The Romans and the Early Christians liked the analogy of the dome to the sky and found it an appropriate shape for the roof of their place of worship. Like other vaults, a dome can span large spaces without internal supports and can rise to great heights. The greatest difficulty in building a domed building is in melding the circular dome with a rectangular or square building. The Romans never solved this puzzle and built their domes on circular buildings, or drums, in which there is no need to cover up corners.

The first domed building of note is the Pantheon in Rome, built in the second century A.D. during the reign of the Emperor Hadrian. The Pantheon's dome is low, with three locking rings at the bottom that from the outside look like steps (Figure 53). It ends in a hole, or oculus, which is also surrounded by a locking ring (Figure 54). These rings at the bottom and top of the dome counteract the tension of its arched sides and maintain the dome's stability. The Pantheon dome was made by pouring concrete over a huge, hemispherical wooden form temporarily erected within the concrete and brick drum of the

53 Locking rings on the dome
of the Pantheon, 2nd century A.D.
Photo by Fred Hanhisalo

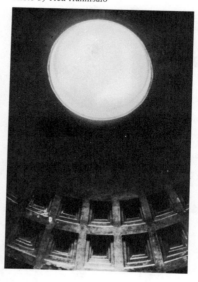

54 Oculus of the Pantheon,
2nd century A.D.
Photo by Fred Hanhisalo

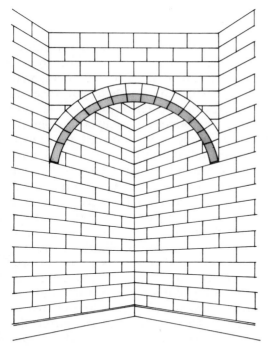

building. The rectangular coffers, or cut-out areas, that cover the interior surface of the dome add visual interest and reduce weight. The drum has a series of arches built into it that catch the weight of the dome and carry it to the foundation.

The problem of placing a round dome in a square building was solved in the sixth century A.D. Hagia Sophia, the Byzantine church at Constantinople, is a square-plan domed building. The basic construction of the dome is the same as that of the Pantheon, but its greater weight is partially borne by a series of half domes, or exedra, placed in steps. **Pendentives** cover the area between the circular bottom of the dome and the rectangular outline of the building. To build pendentives, the architect must erect arches spanning each of the four sides of the building. Between the arches and the bottom of the dome are four curving triangular areas with their points at the corners of the building. These are filled in with rows of stone, and the result is the pendentive. The pendentive is a graceful solution to the problem and provides an interior surface that can be used for paintings or mosaics.

After Hagia Sophia, a number of Eastern buildings were built with domes. In Islamic architecture as well as in some Western buildings, **squinches** were used instead of pendentives. A squinch helps a dome sit directly on its building without intervening arches. A squinch is a curving stone wedge that joins the corners of the building with the bottom of the dome (Figure 55).

The biggest change in dome construction came in the Italian Renaissance. Brunelleschi, a Florentine architect of the fifteenth century, covered the crossing of Florence cathedral with a tall, octagonal, double-shelled ribbed dome (Figure 56). The dome is put together somewhat like an umbrella. The ribs that reach from top to bottom are made of stone, as are the smaller horizontal connectors. The inner and outer walls of the dome are made of stone in the first levels and of brick above. Brunelleschi left the top of the dome open, with a locking ring of stone, but always intended that a lantern be constructed over it. To balance the outward thrust at the bottom, a huge chain of logs was added. Brunelleschi's dome for Florence Cathedral, with its sophisticated engineering, the comparative lightness of the double-shelled construction, and its commanding presence made it the model for many later domes. The dome on St. Peter's in Rome, designed by Michelangelo and Giacomo della Porta, is a copy of Brunelleschi's, as are the domes on St. Paul's in London, and Les Invalides and the Pantheon in Paris. Similar domes are also common in America, such as the dome on the statehouse in Boston and that of the Capitol Building in Washington. The structure of the latter, designed by T.U. Walter, is of cast iron, combining nineteenth-century construction techniques with Renaissance design principles. Contemporary architects like Frank Lloyd Wright and Pier Luigi Nervi have built domes in a twentieth-century idiom, taking advantage of new building materials such as plastic, steel, and reinforced concrete.

56 **Dome of Florence Cathedral,
15th century**
Photo by Hal Siegel

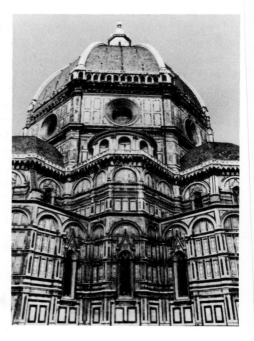

Cantilevering and Beyond

The American architect Louis Sullivan is usually credited with the invention of cantilevering. Sullivan's guiding principle was that architecture should be functional and that its exterior should express the interior configuration. He also sought a uniquely American form of architecture which did not depend on European models. **Cantilevering** is a form of post and lintel in which the main support is an interior core, usually made of steel and concrete. The floors of the building are hung from the core, often with a slanting beam running from the horizontal element to the core for support. Although entire buildings can be cantilevered, the method is more often used for parts of a structure, like porches or balconies, which seem to hang out into space. By cantilevering the second story of a building, the architect can omit the first floor walls and create a large open entrance space for the building (Figure 57).

The most innovative use of cantilevering was made by Frank Lloyd Wright. Wright, a student of Louis Sullivan, was a structural and an aesthetic innovator. Because the only vertical support for a cantilevered building is in the center, there need be no permanent interior walls. This makes for an enormous spatial flexibility which Wright was quick to exploit. His houses were intended to be completely open spaces, which could be divided to suit the occupant. Screens, rather like those in Japanese homes, could be used to change

57 Cantilevering
Photo by Fred Hanhisalo

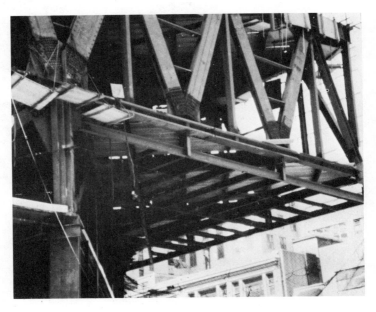

the interior design of the house. Rather than being imprisoned in a series of boxes, the person living in such a home would be free to express his or her changing needs and moods by changing the house. This is really the ultimate in functionalism.

Wright also applied cantilevering to public buildings such as the Solomon R. Guggenheim Museum in New York, finished in 1959 (Figure 58). He believed that the ordinary museum does not present an environment in which a work of art can be properly appreciated. Wright wanted enough space in which to move around and look at the works from all angles. The display area of the Guggenheim consists of a ramp spiraling through the building. Visitors take an elevator to the top and then work slowly down the ramp, stopping to look at the works on display. Objects can be viewed close-up and from a distance on the other side of the ramp. The overall impression is of lightness and freedom. There is a harmonious interaction of building and objects. There are problems, of course. Paintings have to be hung at exactly the angle of the ramp to ensure that the viewer and the viewed are parallel. Special pedestals for sculpture have to be made to compensate for the angle of the floor. Nonetheless, it is a consid-

58 FRANK LLOYD WRIGHT
Interior of The Solomon R. Guggenheim Museum,
1959
Courtesy of The Solomon R. Guggenheim Museum, New York.
Photo by Robert E. Mates and Mary Donlon.

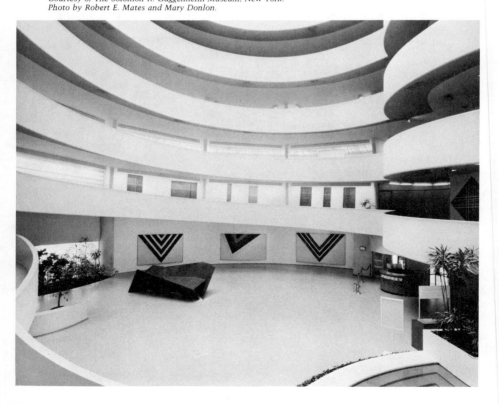

59 BUCKMINSTER FULLER
Geodesic Dome, 1967
Photo by Fred Hanhisalo

erable contribution to the art of museum display; the ideas behind the Guggenheim have influenced other museums.

Other contemporary architects have continued Wright's emphasis on innovation and on the creation of a special architectural vocabulary for the twentieth century. Space-age materials, plastics, fiberglass, aluminum, and others are being worked in entirely new ways to create forms suitable for life in the late 1900s. R. Buckminster Fuller's geodesic dome structures are an example. Figure 59 shows the United States pavilion at Expo 67 in Montreal. Geodesic domes are a web of tetrahedrons, joined in groups to form spheres. The tetrahedron, made up of four triangles, can be joined with others to cover huge volumes of space. Building materials for geodesic domes have included steel, aluminum, plastic, cloth, and waterproofed cardboard. The resulting building is open, airy and infinitely flexible. It takes advantage of solar energy and at night gives off light. The interior can be arranged in a variety of ways to suit the needs of the occupants. Floors need not go all the way across but can be partial, and are connected by escalators. The geodesic dome is an example of the kind of thinking that will eventually free people from the tyranny of rigid architectural schemes and allow them to plan their environments to suit their lifestyles, and to use materials and energy creatively.

EXERCISES

In order to evaluate a work of architecture, it has to be seen from the exterior and the interior. If possible, walk around the building and look at it from all sides. Then go in and see as much of the inside as is feasible.

1. What is the building made of? Wood, brick, stone, and concrete are some possibilities. Certain materials are associated with specific periods and styles.

2. How tall is it? Buildings higher than five or six stories are usually of steel skeleton construction.

3. How much of the exterior is made up of windows? Steel skeleton construction and cantilevering allow for much more window area than do older building methods.

4. What shape are the windows? Modern buildings usually use large rectangular windows. Smaller rectangular windows or arched ones indicate an older building.

5. If the building is a tall one (six or more stories) does it have much carved decoration on it? The more embellishment, the older the building tends to be.

6. Are there areas that don't have any supports under them? Porches, balconies, and second-story exteriors sometimes appear to be suspended in space. This means that they are cantilevered.

7. Are there columns? What order are they? What does their use tell you about the interest of the architect? What kind of architecture from the past do columns recall?

8. If there are arches, notice how they are held up. Are there buttresses, other arches, or walls keeping the arch stable?

9. In domestic architecture, what is the size of the house? What does this tell you about the occupants? This may seem obvious, but it does tell something about people's taste over the years.

10. If the house is American, is it symmetrical-looking from the outside? Are there classical elements (especially columns and arches)? Do heavy beams show from the outside? The answers to these questions suggest certain time periods.

11. Are the windows of a house sash or casement? Casement windows are the earlier type. (Sash windows slide up and down; casements open out, usually by turning a handle.)

12. In older architecture, especially in Europe, look for the presence of piers, columns, arches, and vaults. If there are combinations

of elements, try to decide which are structural and which are only decorative.

13. Go into the building. Is the entrance easy to find? What size is it? Is it straight-topped or curved? Do you feel comfortable going into the building? These questions will tell you both about the construction and the success of the planning of the building.

14. Look at the ceiling. Is it flat or curved? Can you see beams, ribs, vaults, or plaster? Which construction method do you associate with each?

15. Is there much decoration? Does the decoration remind you of buildings from the past? In older buildings, what period does the decoration suggest?

16. Is the function of the building clear? For instance, in a church does the position of the altar make it seem to be the focus of the building? Do you feel a sense of purpose or are you confused?

17. Is the room you enter very large and high-ceilinged? How does this impress you? What impact do you think the architect intended to make? Is it appropriate to the function of the building?

18. Is it dark or full of light? Do you feel shut off from the outside or is there a sense of communication between inside and outside? What do you think this means in terms of the building's fulfilling its function adequately?

19. Is the building confusing? Does it have a lot of rooms that do not relate coherently to one another? This may mean a building that was added to over a period of time, without always taking into account what was already there. This same point can be made with exteriors. If some parts seem discordant, they may be from a different time.

20. Is it noisy? Does this make it less functional?

21. On your way out, evaluate the building in terms of its surroundings. Does it fit in with other buildings in the area? Is it similar to them? Is there landscaping? Does it seem to belong in its location? If the building harmonizes with its surroundings, it is probably part of a planned area. If not, it is an area that was put together piecemeal, and without consideration for the environment as a whole.

5
Prints

Prints are copies of a single original plate or block. The plate is produced by an artist and each impression taken from the plate is considered an original work of art. The word "print" is widely misused today to mean reproduction. Unlike a print, a reproduction is a photomechanical image in which the artist has no part. Reproductions can exist in unlimited quantities, whereas prints are usually produced in limited numbers or editions. A print often has an inscription on the margin with two numbers, for instance 5/75. This means that the particular print is the fifth one made of a total edition of 75. Since the process of printing wears out the block or plate, the lower the number of a print within an edition, the better quality it will be, and the more valuable. When a plate is worn out, it is usually destroyed to prevent prints being made which would not faithfully mirror the artist's original intentions.

Throughout their history, prints have been a way of making inexpensive, original art works available to the public. As early as the ninth century in Asia prints were used to reproduce religious pictures and texts. The same function was served by European prints, which would be used as objects of religious veneration in homes as well as in illustrating books—mostly Bibles and religious stories. Today many people collect prints instead of paintings because of their lower cost, and because some of the finest artists work in printmaking as well as in painting or sculpture.

To be able to appreciate a print, it is important to understand how it is made. Printmaking is a linear art form for the most part, and the way lines are produced determines the overall effect of the work. Since the Renaissance, printmakers have been constantly expanding their range of techniques, with each new process adding possibilities of effect until today combinations of four or five techniques in one print are not uncommon.

One advantage of printmaking is that the artist can check his or her work during the process and make changes as necessary. Often, a working proof is made by printing the plate before it is finished. The artist knows then whether everything is correct and, if not, most processes allow changes. A trial proof is a single print run before an edition is made from a completed plate. It is the final check before the print is made in quantity. Before the print is begun, a preliminary drawing is usually made in which the artist works out the basic idea of the print. This is followed by a preparatory drawing which contains the composition of the print and which is copied onto the block or plate. The finished print will be the reverse of the drawing, and this has to be taken into account in the composition.

There are four basic printmaking processes: relief, intaglio, planographic, and stencil. In **relief printing,** the area to be printed is raised above the background by cutting away the block around the lines. Any page of print is an example of relief printing. The opposite is true of **intaglio printing,** in which the lines are cut out of a metal plate and filled with ink for printing. In **planographic printing,** no cutting takes place. The artist draws on the plate with a variety of special instruments. **Stencil printing,** or **serigraphy** (silk-screen), involves squeezing ink through a screen onto paper. Each method is suitable for certain results, and it is not unusual for artists to work in more than one, or in combinations of, several processes. The appeal of the print comes from the skill with which the techniques are used to carry out the artist's conception.

The Relief Processes

WOODCUT

One of the oldest printmaking techniques is **woodcut.** A woodcut is made from a block of wood cut longitudinally from a tree so that the grain of wood runs the length of the block. Traditionally, hardwoods like apple, pear, beech, or sycamore were used for woodcut, but in the twentieth century softwoods like pine have become popular for large prints. The artist draws his or her composition on the block of wood, and then, with a gouge or burin (Figure 60), cuts away the white areas

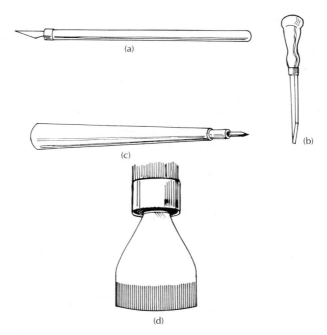

60 Printmaker's tools: (a) woodcutter's knife; (b) burin
or graver; (c) etching needle; (d) mezzotint rocker.

leaving the lines in relief. The block is then inked with a roller and
a sheet of paper is placed over it. Making sure that the paper does not
shift, the artist rubs the surface with a smooth tool of some sort,
often the bowl of a spoon. Block and paper are inserted into a printing
press and an impression is made. Subsequent impressions can be
made by re-inking the block until the number in the edition is
reached or the block is worn out.

The ordinary woodcut is also called a **black-line cut** because the
design is printed in black against a white background. The opposite
of this is **white-line cut,** which gives a very different visual effect.
White-line involves cutting out the lines and leaving the white areas
in relief. The effect is like that of a photographic negative.

Another unusual effect is produced by the **chiaroscuro woodcut**.
Ordinary woodcut has only bold areas of black and white, with no
intermediate tones. Gradations of shade and tone can be suggested
only through combinations of parallel and crossed lines, called hatch-
ing. In chiaroscuro woodcut more than one block is used. Chiaro-
scuro woodcut came into existence around 1500 and became popular
with Italian printmakers who liked to achieve a painterly range of

tones in their prints. The earliest ones are done with two blocks. The first one covers the paper with a single color, leaving some areas white, which will become highlights. The second block is printed in black in the normal way and adds the outlines and shading to the colored background. The finished work looks like black and white lines on a colored surface. Soon some printmakers began to work with additional blocks, up to four, each one of which is printed in a different shade. For instance, one print might contain light green, green, dark green, and black.

Woodcut began to be used around the end of the fourteenth century, originally for playing cards. By the fifteenth century, woodcut illustrations were appearing in books. The great age of woodcut is the High Renaissance in Germany. Sixteenth-century German artists like Albrecht Dürer designed woodcuts of such subtlety and complexity that it is almost impossible to believe that such a demanding and limiting process created them. Although Dürer and others did not always cut their own blocks, often preferring to trust the work to skilled craftsmen, the daring in producing such fine effects in fragile wood is the artist's alone. By the seventeenth century, engraving and etching, media using a durable copper plate rather than the trickier and more fragile wooden block, had largely replaced woodcut. Woodcut was revived at the end of the nineteenth century, when its bold effects suited the work of artists like Gauguin. In the twentieth century a number of artists, in particular the Expressionists, have worked in woodcut. Edvard Munch, the Norwegian Expressionist, cut and printed his own woodcuts and was responsible for much of the contemporary interest in the technique.

One of the German Expressionist artists who worked in woodcut printmaking was Ernst Ludwig Kirchner. *Mountain Landscape with Winding Road* (Figure 61) shows the bold treatment that appealed to the Expressionists. The scene is a bird's-eye view of a mountainous terrain. A curving line of skeletal white trees marches from lower left to upper right, emphasizing the harshness of the scene. A few animals on the mountaintops in the rear are shown as black silhouettes against the white clouds. The elements in *Mountain Landscape* are sharp and jagged; there are no fine lines or soft contours. The treatment of the subject is semiabstract, with strong contrasts of dark and light. The composition is united through the repetition of shapes, the opposition of major curving elements, and the numerous sharp-edged forms indicating trees, bushes, and rocks. The finer shadings and details of other printmaking media would have been less effective in this scene. Woodcut provides the bold contrasts necessary to the stark emptiness of Kirchner's vision.

61 ERNST LUDWIG KIRCHNER
Mountain Landscape
with Winding Road, 20th century
Courtesy Museum of Fine Arts, Boston.
Lee M. Friedman Fund.

LINOLEUM CUT

Linoleum cut, or **linocut,** is a twentieth-century variation on wood-cut. The technique is the same, but the material is battleship lino-leum. The greater suppleness of this material and its lack of grain makes it much easier to handle. There is a heavy, rich tone to lino-cut, which is somewhat different from the appearance of woodcut, although it is often difficult to tell one from the other.

WOOD ENGRAVING

Another variant on woodcut is **wood engraving**. Despite its name, wood engraving is a relief process. The end grain of a wooden block is used rather than the parallel grain of woodcut, and very hard woods are preferred. The area which is cut away in wood engraving are lines of the composition, and the blank areas are left in relief—just the re-verse of woodcut. The result is a print of white lines on a black back-ground. In the nineteenth century wood engraving was used for illus-trating books and magazines, especially in the United States. Today it has been replaced by photoengraving.

METAL CUT

It is also possible to do relief prints with metal plates. **Metal cut** has been in use as long as woodcut, although it has never been as popu-lar. A metal plate, usually copper, is cut using goldsmith's tools. Then the plate is fastened to a wooden block and printed in a wood-

cut printing press. William Blake used metal cut to illustrate his *Songs of Innocence* in the 1790s, and a mechanical version of metal cut is used to make illustrations in periodicals and the like.

METAL RELIEF

Metal relief works the same as metal cut, although the cutting away is done differently. The parts of the plate meant to stand out in relief are covered with an acid-resistant varnish. The plate is then dipped into an acid bath which eats into the unprotected areas and produces the relief.

The Intaglio Processes

In an **intaglio** printmaking technique, the area to be printed is cut from a plate, usually made of copper, and the white areas are left untouched. These processes are therefore precisely the opposite of relief printing and have the advantage of increased flexibility. Something that has been cut out of a plate can be filled back in, whereas once an area of a block has been cut off it cannot be fastened on again. The major intaglio methods are engraving and etching. Often used in conjunction with them, and less frequently alone, are drypoint, mezzotint, and aquatint. Each technique has specific advantages and disadvantages, and artists use them alone or in combination, depending on the effects they want to achieve.

ENGRAVING

The word "engraving" has changed its meaning over the years. Until shortly before 1900, the graphic arts as a whole were called engraving, and the specific technique of engraving was called "line engraving" or "copperplate." Today the terms "line engraving" and "engraving" are interchangeable, both referring to a specific way of making a print. **Engraving** employs a plate, usually copper, which has been polished to a high gloss. A cutting tool called a graver or burin (Figure 60) is pushed along the surface of the plate to make an indentation in the copper. The material that is pushed up from the furrow is wiped away with a scraper, although sometimes some of this material, or burr, is left to attract the ink and make a softer line. The burin is always pushed away from the artist and makes a firm sharp line which can be varied somewhat by increasing or decreasing the pressure on the tool. Further variety comes from using lines that are short, curved, straight, broken, and so on. Tonal effects come from paralleled hatching, using groups of parallel lines, and cross-hatching, or groups of parallel lines crossing one another at an angle.

Engraving was developed in the fifteenth century and is usually thought to derive from metalworking techniques, although some people think that it was developed to capture the effects of paintings more accurately than woodcut. Both in Italy and in Northern Europe, first-rank artists worked in engraving. An early engraver was Martin Schongauer, the son of a goldsmith, followed by Dürer and Cranach. In Italy, Botticelli and Mantegna are among the painters who were also engravers. The sixteenth century was the great period of engraving, and by the seventeenth century it had begun to be superseded by etching—a freer technique which provides a greater range of visual effects.

Albrecht Dürer was the greatest printmaker of the Renaissance. His aesthetic vision was enhanced by an acute sense of the possibilities of each of the media in which he worked. *Saint Jerome in His Study* is an engraving dated 1514 (Figure 62), that uses all the resources of the engraving technique. There is parallel hatching in the ceiling and in the gourd hanging from it. The lion is drawn with a combination of parallel and cross-hatching. Short line segments are used on the dog and the table top. Parts of *Saint Jerome* are so free as to appear to have been etched. The pervasive effect of light throughout the scene is achieved by varying the spacing of the line segments. There is also a distinction between natural and holy light, with the holy light appearing as a blank area. The effect is painterly, with a strong sense of space and atmosphere.

ETCHING

Like engraving, **etching** uses a copper plate. However, instead of the lines being drawn directly into the plate, they are produced by acid. The polished copper plate is first covered with an etching ground—a black substance made of gummy and resinous elements. This mixture is heated and spread over the plate. The density of the ground determines the cleanness of the line. Hard-ground etching produces thin lines, while a soft ground allows the acid to spread more for a softer look. A combination of the two can also be used. An etching needle, a short steel instrument set into a wooden handle, is used to draw in the etching ground. The plate is then dipped into a bath of nitric acid which cuts, or bites, the lines of the design into the copper plate itself. For a light line, the plate is bitten only once and then the line is covered with ground. Darker lines are produced by repeated

bites. This way, everything from a light gray to a velvety black line can be achieved.

Because the lines in etching are not made manually, they can be much more casual and spontaneous than in engraving. An etched line often skips and jumps rather then being firm and regular. The result looks sketchier and more spontaneous than in engraving. A great many artists have expressed themselves through etching, two of the best-known of whom are Rembrandt and Goya. Both these artists pushed etching to its limits, combining it with other techniques and achieving almost the range possible with painting.

Saint Jerome Reading in an Italian Landscape (Figure 63) is an etching with drypoint elements by Rembrandt. Although it is not signed or dated, it is probably from around 1653–54. The lines of this print are less deep and regular than in Dürer's engraving of *Saint Jerome*. Different depths of biting combined with a careful wiping of the plate produce an effect of intense sunlight and shadow. Notice particularly the variety of lines on the body of the lion, the sketchy figure of the saint himself, and the landscape elements in the background. Rembrandt has taken advantage of the freedom of line provided by etching to achieve a looseness of structure that is not seen in Dürer's engraving.

Etching is thought to have developed from the medieval practice of making designs on suits of armor with acid. Daniel Hopfer, a sixteenth-century armor etcher, is credited with being the first to print an etched iron plate. The first dated etching comes from 1513 by the Swiss artist Urs Graf. Dürer, a master of woodcut and engraving, disliked etching, probably because of the iron plates he used. Copper plates were used first in the Netherlands and Italy and became universally used by the seventeenth century. Since then such artists as Whistler, Picasso, Rouault, Chagall, and Edward Hopper have all worked in etching.

AQUATINT

An eighteenth-century process, **aquatint,** was developed to produce tonal effects without lines. The name derived from the fact that aquatints look like drawings done with watercolor washes. Aquatint is usually used in combination with etching or drypoint, except in color prints, where it works quite well alone.

In aquatint the copper plate is placed in a box and coated with a fine layer of powdered resin. The resin can be placed either thickly or thinly, depending on the artist's choice. The thicker the resin, the less it can be penetrated by acid. Then the plate is heated to fasten the resin to the metal during the acid-biting process. When the plate is dipped in acid, the acid bites around the grains of aquatint grain to

63 REMBRANDT VAN RIJN
Saint Jerome Reading in an Italian Landscape,
ca. 1653–54
Courtesy Museum of Fine Arts, Boston.
Harvey D. Parker Collection.

64 FRANCISCO GOYA
Love and Death, 1799
Courtesy Museum of Fine Arts, Boston

produce a pitted area in the plate. This appears as a grainy tone in the final print.

Francisco Goya used aquatint to add atmosphere and shadow to his etchings. In the tenth of his *Los Caprichos* series, *Love and Death* (Figure 64), from 1799, a woman holds the body of her lover, who has been killed in a duel over her. Bands of light and dark aquatint form a backdrop to the two lovers. The aquatint unifies the composition and emphasizes the drama of the subject. The heaviness of the aquatint sky and the dark shadows around the lovers eliminate any suggestion of romance or sentimentality. The foolishness of an unnecessary death is exposed with stark candor.

103

MEZZOTINT

Another tonal process is **mezzotint**. Like aquatint, mezzotint produces areas of gray or black rather than lines, and is used either alone or in combination with other processes. The tool used in mezzotint is a mezzotint rocker, which can be of varying sizes (Figure 60). The rocker is held at right angles to the plate, with the teeth resting on its surface. The artist then rocks the tool back and forth, grinding the teeth into the plate and making a rough area which catches printer's ink and makes a dark tone on the finished print. Mezzotint was first used in the seventeenth century and continued to be popular through the nineteenth. A number of American colonial artists worked in mezzotint, producing prints of incredible fineness. Today mezzotint is not popular and has been largely replaced by other techniques.

DRYPOINT

For an extremely delicate line the printmaker can resort to **drypoint**. Like engraving, drypoint is done by drawing directly on a copper plate. The tool, however, is a long sharp needle and it can be moved in all directions, unlike the burin, which always has to be pushed away from the artist. Drypoint gives an effect similar to pencil and has almost its flexibility. The extremely feathery and delicate lines can be varied by leaving the burr, which is pushed up in place for a soft, velvety, and dense black tone. Because drypoint lines are very shallow and the burr wears away very quickly, only a limited number of prints, about thirty, can be made from a drypoint plate.

In his etching *Saint Jerome Reading in an Italian Landscape* (Figure 63), Rembrandt used drypoint to add rich velvety tones to parts of the print. The lion's mane, for instance, is drypoint, and provides an excellent contrast to the etching of its body. Drypoint is also used in the trees in front of the building, on the two figures diagonally behind the lion, and in details of the tree and grass behind Saint Jerome.

The Planographic Processes

LITHOGRAPHY

No cutting is involved in printmaking by the planographic processes, lithography and monotype. **Lithography** involves drawing on a lithographic stone, usually limestone, with either a lithographic crayon or a water-soluble greasy black liquid called "tusche." The greasy substance sinks into the pores of the stone and is cleaned off of the surface with turpentine. Then the artist treats the surface of the stone with a nitric acid wash that interacts with the greasy lines to make

104

them attract ink. When water is applied to the stone, it is repelled by the greasy lines, sticking only to the plain areas of the stone. Oily printing ink is then rolled over the stone, being rejected by the wet areas (oil and water do not mix) and sticking to the lines. The stone can then be run through a special lithographic printing press with a piece of paper on top of it.

There are several variants on the lithographic drawing technique. One is to lay greasy chalk over the whole stone and scrape away the white areas. This gives a more negative effect, as there are usually more dark areas. Another is the **wash lithograph,** in which the artist works on the stone with a thin ink and a brush. The appearance is very much like that of a watercolor painting.

Lithography was invented in Germany in 1798 by Aloys Senefelder, and was immediately taken up by such artists as Goya, who had previously worked in etching. In the nineteenth century, such artists as Daumier and Delacroix worked with lithography early in the century, and later Degas, Munch, and Toulouse-Lautrec were known for their lithographs. The medium's popularity has continued into the twentieth century with such practitioners as Braque, Miró, and Picasso.

COLOR LITHOGRAPHY

Although the first lithographs were black and white, color lithography was developed in the nineteenth century. In a color lithograph, each color is printed from a separate stone. First a keystone is prepared, with the complete composition drawn on it. Then, using special transfer paper, several proofs are made from the keystone, one for each color. These are traced on each of the color stones, and the area to be in one color is drawn in lithographic crayon on its stone. In other words, a drawing with a red rug, a blue chair, and a green table would require four stones—a keystone and three color stones. The rug would appear on one, the chair on another, and the table on the third. The final printing would be done in colored inks, with successive impressions made from each stone on the same piece of paper. The impressions are kept in line with one another by guiding marks on the side of the keystone that are reproduced on each color stone. Color lithography was first used in the late nineteenth century by Impressionists and has continued to be popular throughout the twentieth century.

Toulouse-Lautrec's *The Jaunting Cart* (Figure 65) is a five-stone lithograph in color. The arrangement and combinations of the colors, though, makes them look more varied. Some areas, such as the road in the foreground, the areas of flesh, the man's hat, and part of the background landscape have been left white. The print has a grainy,

65 HENRI DE TOULOUSE-LAUTREC
La Partie de Campagne (The Jaunting Cart),
late 19th century
Courtesy Museum of Fine Arts, Boston.
The Stephen Bullard Memorial Fund.

crayonlike texture that is appropriate to its sketchy treatment. The movement and casual spontaneity of the subject is well-adapted to the flexibility and speed of lithographic drawing.

OFFSET LITHOGRAPHY

Today large editions of lithographs are produced by **offset lithography,** a photographic process. The work to be printed is transferred to an aluminum plate by a special process. Offset lithography is the only printmaking process except serigraphy in which the finished work is not the reverse of the original. A rubber roller is passed over the inked plate, picks up the impression, and prints it on the paper. The design is reversed once when it is picked up by the roller, and again when it is printed on the paper. Good quality greeting cards are often made this way.

MONOTYPE

Monotype is another planographic process of printmaking. The artist draws directly on a glass or metal plate with any kind of paint or ink that dries slowly. Then the wet drawing is transferred to paper by holding the paper onto the plate and rubbing the back of the paper.

Monotype gives only one good impression, hence its name, although a second faint one can sometimes be obtained. The best known monotype printmaker is Edgar Degas, the French Impressionist.

Serigraphy

Like most twentieth-century artists, printmakers have sought techniques that increase flexibility and allow the imaginative, often abstract, compositions that dominate modern art. **Serigraphy,** or **silkscreen,** is a twentieth-century technique that provides a striking range of color and texture. Silk-screen prints can simulate the appearance of oil painting, watercolor, pastel, and gouache.

To make a serigraph, the artist works with a screen made of silk stretched over an open frame over a paper. A pencil sketch of the composition is drawn onto the screen, and the blank areas are stopped up with chemicals. A separate screen is needed for each color. The colored inks are sponged onto the screen and run through the unblocked areas onto the paper below. There is no reversal of the composition since the original drawing is not run through a press.

The artistic potential of serigraphy was developed in the late 1930s, when the Federal Art Project funded a group of New York artists to experiment with the technique. This group coined the word "serigraph" and began the National Serigraph Society. Today, serigraphy is practiced as much by painters as by printmakers because of the personal contact between the artist and the finished work and the variety of results possible.

Edward Ruscha's 1966 color silkscreen *"Standard" Station* (Figure 66) provides an interesting contrast between the Mondrian-like

66 EDWARD RUSCHA
"Standard" Station, 1966
Courtesy Museum of Fine Arts, Boston.
International Graphic Arts Society Fund.

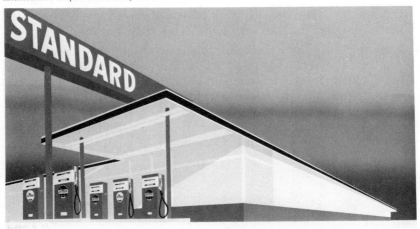

simplicity of the station and the rich colors of the background. The strong perspective of the building draws the eye sharply back from upper left to lower right. The mundane subject is given dignity and presence by its simplified planar treatment. The geometric emphasis of repeated cubes and rectangles is balanced by the hazy flatness of the three horizontal bands of color in the rear. This is a multiple-screen print, using red, gray, blue, and orange inks.

EXERCISES

Exhibitions of prints in museums often stress technique and sometimes include educational displays illustrating the techniques of the works in the show. Take advantage of such displays as well as looking closely at the works themselves.

When looking at prints, the viewer often finds it very difficult to tell one technique from another. It does take a while to learn the visual differences, and it may be quite a while before such identifications come readily. In all fairness, sometimes even the experts are not positive how a print was done, especially if it combines a number of techniques.

1. Does the print have large areas of solid black and white, or solid color and white? If so, it is probably a woodcut or linocut.

2. Are the lines fairly widely spaced and the hatching kept to a minimum? If so, it is probably a relief print.

3. Is the print made up of black and white lines on a colored surface? This is a chiaroscuro woodcut.

4. Are the lines close together and very firm and clear? Do the lines continue for a distance without skipping? Is there a reliance on parallel and cross-hatching for tonal effects? This indicates an engraving.

5. Are the lines in the print freer and looser than those of an engraving? Do they appear to skip? Are there different shades of line, from very dark to very light? This indicates an etching.

6. Is there color? Does the color adhere to the lines of the print or does it flow over the lines? Are the lines themselves sharp or broad? If the lines are broad and the colors reasonably congruent with them, it is probably a colored lithograph. Older prints, however, especially woodcuts, were often hand-painted in watercolor, but the lines will be sharper than lithographic crayon lines. If there is color but no evidence of lines, a serigraph is likely.

7. Are there areas made up completely of tone? Is the tone broken up into a pattern like the cracked mud of a dry stream bed? This is aquatint and can be worked into the composition in interesting ways. The American Impressionist Mary Cassatt used it for the fabric of dresses and the design of wallpaper.

8. Is the tone fine and compact? If so, mezzotint is indicated. Especially with early American portraits, look carefully to see if a very fine mezzotint rocker has been used. From a distance such mezzotints look like engravings.

9. Do the printed lines have a crayon-like appearance? Or do they appear to have been applied with a brush? In both cases it is a lithograph.

10. Check the quality of the print. Is it dull? Do any of the lines seem to be worn away? This is a late number in an impression when the plate or block begins to wear out.

11. Check for signatures. Prints are often signed. Also look for the number in the edition and the number of the individual print. This is particularly important in purchasing a print. The lower the number, the better.

It is really difficult to understand prints without a thorough grounding in technique. If possible, try going to a gallery that specializes in prints. They can often steer you to a workshop where printmakers will allow the public to watch them at work. The person who is really interested in prints would also do very well to take a course in printmaking. Doing something is the best way to learn it.

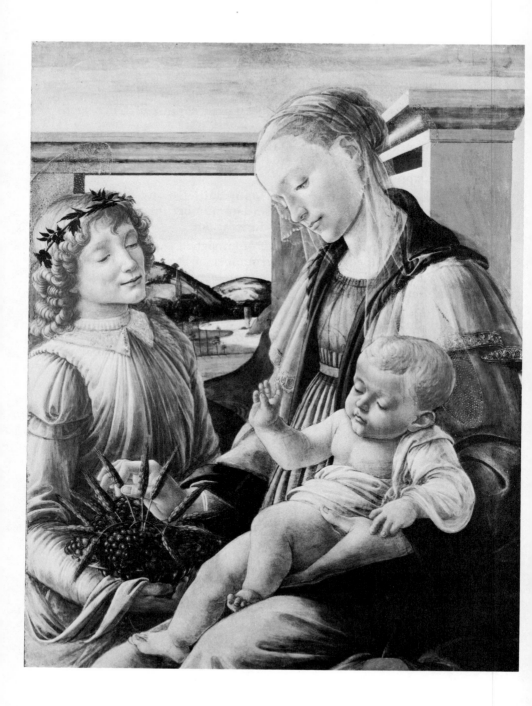

Part Two
ORGANIZATION AND ARRANGEMENT

A work of art is an entity in itself. It has its own logic and rules, its own form and order. The artist is not a copyist, reproducing something on canvas or in stone. In a still-life painting, for instance, an arrangement of fruit and dishes is transformed into a memorable visual experience. The artist sees the objects and interprets them. The expression of this interpretation is the work of art. The form this work takes depends on many factors. Who is commissioning the work? What is its intended setting and function? What audience will it reach? The goals of the work will determine its organization and the artist will use the formal tools of his or her particular field to achieve these goals.

A primary tool of any artist is **composition**. The artist can choose the order in which figures and objects will appear. Color, texture, and light are assigned their roles. Such considerations as spatial relationships, balance, volume, and mass are weighed. Those compositional elements and devices that add to the work are used; others are eliminated. Through a skillful use of the tools or organization and arrangement the artist enhances the meaning of the work, gives it individuality, and reaches the viewer forcefully and memorably.

6
What Is
Composition?

Composition is the formal arrangement of the elements that make up a work of art, such as line, color, and texture. An artist differs from an ordinary observer because he or she presents what is seen in an ordered pattern that has meaning. The strength of this pattern provides much of the impact the work has on the viewer, including its visual appeal.

Almost everyone has constructed a composition at one time or another. When you rearrange a room, you are appealing to your sense of what looks pleasing. Putting all the chairs in a row is too regular—the composition is dull. On the other hand, if the chairs are scattered every which way, the composition is confusing and frustrating. There is a golden mean where everything in the room works together to give a total effect, to welcome the visitor.

Part of this sense of composition may well be innate, a portion of our biological heritage. But a great deal of our ability to compose objects into a pattern is learned. In our daily lives, we are constantly exposed to compositions in visual experiences—in magazines and movies, on television, even when walking up a street.

Consider a typical automobile advertisement. The composition is carefully arranged to enhance the car being sold. The shiny red car is placed in the center of the page, resting on soft, neutral sand. A well-dressed man and his dog are near the car without blocking it. Behind them is an expensive-looking modern home set off against a

brilliant blue sky. The message is clear. Own this car and you will become part of the world of experiences pictured in the ad. However the viewer is not expected to dwell on anything but the car. Its placement, color, and size guarantee that it will be the focus of attention.

Serious works of art usually have complex compositions geared to the lasting message the artist wants to convey. By examining several works from the major visual media—painting, sculpture, and architecture, various compositional types emerge.

Painting

Jean-François Millet's *Young Shepherdess* (Figure 67), painted in 1869–71 in France, shows a young woman seated on a rock in a countryside. She wears a broad-brimmed hat that covers part of her face with shadows and she holds a stick with some wool in one hand. In her other hand she has a smaller stick with which to comb the wool. Millet has planned his composition to convince the viewer that the girl lives a tranquil and natural life because she is at one with her surroundings. The girl is the focal point of the composition and occupies most of the canvas. But, unlike the car in the previous example, she does not dominate her environment. Her costume blends gracefully with the background because both are painted in soft shades of blue and green. As you look past the girl, noting the sheep on her left and the rolling fields behind her, the perspective draws the eye back to a point where the fields disappear behind the figure. Attention then shifts back to the figure, and through her gaze, out of the painting. The soft and similar colors throughout this painting mirror the peaceful expression on the girl's face. Relaxed by the cool colors, the viewer is drawn into the world Millet created by the gently receding perspective. This is an uncomplicated world, a world without tension or strife. Such situations rarely exist; but the powerful order in which Millet presents his view commands belief. It is a refreshing and spiritually reinforcing experience.

Sometimes the subtlety of an artist's composition is a reflection of how much formal training he or she has had and the artist's exposure to other works of art. Erastus Salisbury Field was an American folk painter who painted this portrait of *Joseph Moore and His Family* in 1839 (Figure 68).

Field had some training but was largely self-taught: he worked as a portraitist and later as a religious painter. When he painted the Joseph Moore family in their home, he tried to portray each person accurately and show their possessions. As a report on the Moores, as well as a document of mid-nineteenth century American country life,

67 JEAN FRANÇOIS MILLET
Young Shepherdess, 1869–71
Courtesy Museum of Fine Arts, Boston.
Gift of Samuel Dennis Warren.

the painting is quite successful. However, as a composition, it is confusing. The picture is symmetrical, with three people on either side of the center. Matching windows and curtains add to this regularity. With such an arrangement, the focal point of the work should be in the middle. Instead, there is a blank gray rectangle—a mirror that reflects nothing. The artist saw himself in the mirror but could not include his own image in a portrait of a client and his family. Each family member is shown in a rigidly vertical pose; only the size of the adults makes them more noticeable. The people do not relate to one another but stare out at the viewer. The tools of Mr. Moore's occupations (dentist and hatter) are prominently displayed as is their furniture. The lack of perspective in the brightly colored rug makes it easy to imagine the Moores sliding down the rug and right out of the picture.

68 ERASTUS SALISBURY FIELD
Joseph Moore and His Family, 1839
Courtesy Museum of Fine Arts, Boston.
M. and M. Karolik Collection.

115

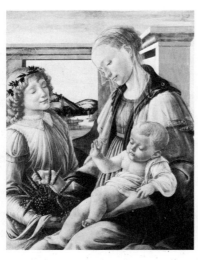

A professional painter shapes his composition to the work. Between 1470 and 1474, Botticelli painted *The Madonna and Child of the Eucharist* (Figure 69 and page 110). In this group of the Virgin Mary, the Infant Jesus and an angel, our eye is drawn to the mother and child on the right, partially because of their size and partly because of the rich yet delicate colors of the Virgin's robes. The Madonna's gentle gaze directs the eye downward to the grapes and wheat, symbolic of the wine and bread of Communion, and to the angel. His look returns the viewer's attention to the Infant Jesus who is blessing the wheat and grapes. The figures are set in a circumscribed space, its borders defined by the architectural elements behind them. To avoid a cramped feeling, however, Botticelli added a landscape in the distance, which gives a feeling of spaciousness without distracting attention from the central group. The interaction of diagonals between the figures ties them together both physically and emotionally. The delicate colors heighten the exquisiteness of the moment. These figures come to life as the Joseph Moores do not. The gentle calmness of each of them is mirrored in the soft colors and the peaceful setting. The clarity of the composition focuses attention on the meaning of the figures and their spirituality. The subject matter blends with the formal elements of composition to provide a visual and emotional experience of lasting value.

Sculpture

One's reaction to works of sculpture is also conditioned by composition. David Smith's *Cubi XVIII,* done in 1964 (Figure 70) uses familiar shapes in unfamiliar ways. Three-dimensional cubes, rectangles, and a cylinder are welded into an open pattern. The eye travels up

the cylinder to the three cubes balanced casually at its spreading top. At first, the cylinder seems almost like a column with a capital; the effect is architectural. Then instead of diminishing, as the eye expects a form to do as it goes upward, *Cubi* grows. The individual segments get bigger and the sculpture looks heavy and almost off-balance. There is an impression of impermanence which comes from the arrangement of forms and from the delicate way in which they are fastened together. The small joints between large shapes make the work dynamic, whereas a more usual attachment could have given it a static effect. The interrelationships of solids and spaces, along with the decorated surfaces that catch the sunlight, make heavy metal into a light and soaring experience.

Naturally, the meaning an artist expresses is partly conditioned by his or her environment and experience. At different times in history, artists have adapted their compositions to serve the prevalent religious or political ideals. During the Middle Ages, all of European life revolved around the church both spiritually and physically. Medieval towns were gathered around huge cathedrals whose construction often took centuries. The arts of painting and sculpture were in the service of the cathedrals, and their compositions reflect this. In the twelfth century an anonymous sculptor in Lombardy, Italy created the limestone *Lombard Madonna* (Figure 71). The artist intended to focus the viewer's attention on the holiness of the figures, not to emphasize their humanity. Although there is a warm, loving intimacy between them, it is symbolically rather than realistically

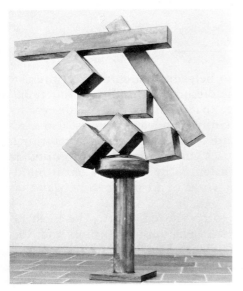

70 DAVID SMITH
Cubi XVIII, 1964
Courtesy Museum of Fine Arts, Boston.
Anonymous Centennial gift.

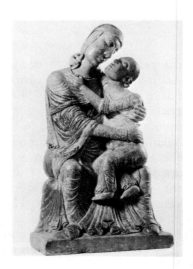

71 Romanesque
Lombard Madonna, late 12th century
Courtesy Museum of Fine Arts, Boston.
Maria Antoinette Evans Fund.

treated. The physical proportions are distorted to express divinity. Their huge heads and the child's enormous body draw the viewer's attention to the special, nonhuman nature of the figures. The figures are flattened and are meant to be seen from the front. The composition consists of a number of diagonals running across the two figures and emphasized by the elaborate folds of the Madonna's drapery. The symmetry of the drapery and the limply hanging feet add to the unreality of the image. To a twentieth-century person, such sculptures may seem unnecessarily unattractive, but their carefully calculated arrangements are an excellent clue to the thoughts of the people who created them. Beauty in this case is not physical but spiritual.

Architecture

The principles of composition also help make architecture interesting. Most people have heard of the dictum "form follows function." This statement, made to emphasize that architecture should serve its designated purpose through a carefully planned design, is also a reaction to some types of architecture in which form was everything. Some over-elaborate Victorian houses come immediately to mind as examples. But function has to be balanced by form. The great buildings, the memorable buildings, are works of art in the same way that paintings and sculptures are.

A Greek temple was meant to be viewed as art. The most famous example is the Parthenon in Athens built by Iktinus and Kallikrates between 547 and 532 B.C. (Figure 72). The building was not meant to be used in our modern sense. It was a home for the goddess Athena and housed a huge gold and ivory statue of her. Most religious

118

ceremonies took place on an altar outside the building. To emphasize even more strongly the visual orientation of the Parthenon, it was placed on the Acropolis so that it could be approached only from the back. The necessity of walking around the building forced the visitor to see it as a three-dimensional sculpture. The Parthenon's exterior was heavily decorated with sculpture, including two friezes that ran around all four sides, one above and one inside the colonnade. Large sculptured figures decorated both pediments (the triangular areas at each end, under the roof).

The dimensions of the building were carefully calculated to make its exterior regular and pleasant. The columns were placed equidistantly except for those at the ends, which were slightly larger and therefore closer. The architects realized that those columns would look farther apart as you looked through them at the sky so they compensated by moving them just the right amount closer. Other modifications of this kind included swelling the columns very slightly in their center (entasis) so that the eye perceives them as straight, and curving the walls and platform to avoid the optical illusion which makes a straight line look curved when viewed from certain angles. These changes result from the knowledge that the eye sees perfectly straight lines as slightly curved. This degree of calculation is unusual, to be sure, but every architect tries to make his or her building interesting to the eye.

The Sydney Opera House in Sydney, Australia provides a con-

72 IKTINUS and KALLIKRATES
The Parthenon, 5th century B.C.
Photo by Fred Hanhisalo

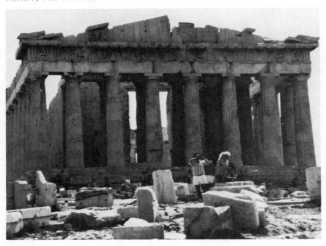

temporary example of a building that makes a striking visual impression through its composition (Figures 73 and 74). The architect, Jørn Utzon, capitalized on the Opera House's spectacular location on a small peninsula sticking right out into the harbor. The building is designed entirely of curves, with the roof giving the impression of a cluster of giant sails. Whether seen from land or water, the building forms a graceful and satisfying silhouette. Unfortunately, financial problems prevented the completion of the Opera House as Utzon intended, and the present interior is not at all as he conceived it. Nonetheless, for a building finished in 1973 to be so obviously concerned with aesthetics demonstrates that the human desire for beauty along with functionalism remains strong.

The interiors of buildings are also composed both according to their use and to the impression the architect intends to make upon the users. Churches, for instance, are usually rectangular or cross-shaped with everything pointed toward the altar; an arrangement that is both practical and visually satisfying. An art gallery will be open and well-lighted to give the works within it maximum exposure. Modern shopping malls are designed to invite shoppers in and part them from their money with the least possible discomfort. All of our lives we are surrounded by compositions, the most successful of which work well enough so that their presence is not obvious.

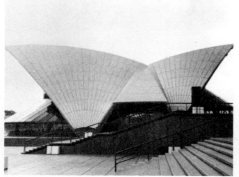

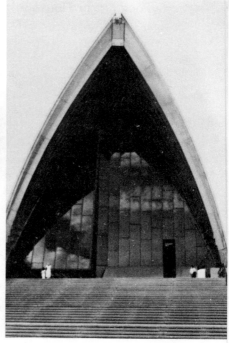

73–74 JØRN UTZON
The Sidney Opera House, 1973
Photos by Mirek Kocandrle

EXERCISES

Taking as much time as possible with the individual object (a print, a drawing, a painting, or a relief sculpture), ask yourself the following questions.

1. What am I looking at? Is there an order in which my eye is drawn to parts of the object?

2. What does the order in which the eye moves tell about the artist's intentions?

3. What kind of color is present here? Is the artist using these colors for a specific effect?

4. Is there any kind of geometric structure evident? If so, how does it affect the content of the work?

5. Is light important? How does it affect the organization and the impact of the work?

6. Is the artist more interested in the subject or in the way in which it is represented? How can you tell?

7. Is there an illusion of three-dimensionality? How is it achieved?

8. Is my eye comfortable with the object? Is there a clear point of entry and exit? If not, is this intentional and what is its effect? Particularly with contemporary works, some confusion is common at first. This challenges the viewer to try harder to understand the work.

7
Elements and Devices of Composition

Very often certain standard devices are used to organize a composition. These devices represent solutions that artists have developed over the years to solve recurrent problems. For instance, if a picture is to give some sort of information as its main purpose, parallelism or triangularity are useful. For a more dramatic, less easily graspable effect, the artist might choose repetition or emphasize color. This is not to say that an artist always sets out to use a specific device, but that the device occurs naturally in certain situations. The critics and art historians have cataloged these commonly used devices because they help viewers understand the intent of the artist.

Color, texture, and light are elements of composition that can also be the devices that pull the work together and give it physical coherence. Each element has certain properties that have to be fully understood by the artist in order to make the most of them. While the viewer who is not also an artist does not understand these elements in the same way, some information about their properties and uses does help in one's grasp of the work of art as a whole.

Color _____

One of the first things that a painter has to learn is the use of color.* It is one of the basic tools. The **color wheel** (Figure 75) displays the

*Author's note: For a fuller discussion of color, see Faber Birren, *Principles of Color*. New York: Van Nostrand Reinhold Company, 1969.

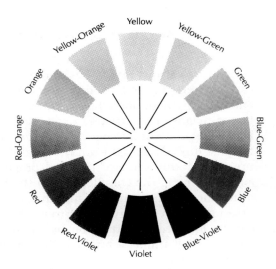

75 The artist's color wheel.
Grey tones shown approximate the value of that color on the color wheel.

various relationships of color in terms of its three basic qualities: hue, value, and saturation. The color wheel was invented by Isaac Newton around 1666 and has been developed and changed by artists and theoreticians since then. This is only one of a number of color wheels in existence today, but it is one commonly used by painters.

PROPERTIES OF COLOR

Hue is the name of the color the eye thinks it is seeing. It is the greenness of green and the redness of red. Today paints are available in a vast number of hues, mostly synthetically manufactured; but in the past artists were restricted to pigments from minerals, charcoal, and shell dyes. In fact one of the principal methods for detecting a forgery today is to determine whether all the hues used in the suspect work were available at the time it was supposedly painted.

Value refers to the darkness or lightness of a color (or hue). The lowest value is black and the highest white. All other pure hues occur somewhere on a scale between the two. For instance, the pure hues in the blue or violet family are closer to black on the scale and those in the yellow or orange group are closer to the white end. Certain colors also achieve full intensity at different values. A fully intense yellow is a higher value than a fully intense violet. The values of a pure hue can be altered in two ways. With opaque oils, the painter can darken a hue by adding black and lighten it by adding white. With thinner oil glazes and transparent paints like watercolor, it works differently. In order to lighten a transparent hue it must be thinned and applied over a layer of white. To darken it, it is applied over a layer of black or another dark ground. A major problem that painters face is trying to reduce the extraordinary range of values in nature to the range of lights and darks comprised by white, grays, and black on a surface. **Saturation,** which is also called brilliance, refers

123

to the intensity of a color. Intensity is the most meaningful when comparing various intensities of the same hue. The intensity of a hue can be strengthened by adding pigment to the paint, changing the balance of a pigment and a liquid binder. Hues can be reduced by a number of means. The artist can add shades based on black or umber or by adding the complement to the original hue. The **complement** is the hue directly across from the original one on the color wheel (Figure 75). Mixing the two in equal proportions will produce gray, but adding some of the complement to the first hue will only dull it. Another method is to underpaint the work with a neutral ground and brush the color thickly over it to produce an optical gray. Some colors can be lowered in saturation by mixing them with analogous earth colors. For example, a bright yellow may be toned with yellow ochre or raw sienna.

Colors also have the property of heat. Reds, yellows, and oranges are called warm colors, and seem to project themselves to the front of a painting. Greens, blues, and violets are cool colors, which recede. It is therefore possible for a painter to place one object in front of another by his choice of color. Of course there are exceptions to this rule, and some artists have been subtle users of effects which are precisely the opposite of the usual. Cézanne, for instance, often toned down reds until they no longer projected but seemed to appear behind a heightened green. The warm and cool properties of colors can also be used to heighten the psychological impact of the painting. Turner and van Gogh are among many artists whose careful use of the emotional qualities of colors add psychological depth to their paintings.

The **color wheel** provides a basic guide to the artist's colors. This is the color wheel of the artist and represents the spectrum of paint, not that of light, which is quite different. The **primary colors** are red, yellow, and blue—colors that cannot be obtained from any combination of other hues. The secondaries are orange, green, and violet. There is an almost even balance between warm and cool colors; the warms ranging from red to yellow and the cools from red-violet to green. Yellow-green can be either warm or cool, depending on the proportion of yellow to green in each combination. For centuries artists have worked with color wheels similar to this one, looking for the combinations and contrasts which are most pleasing and moving to the viewer's senses.

USES OF COLOR
In 1839, Michel Chevreul, the director of the dye works at the Gobelins tapestry works outside Paris, published a book called *De La Loi de Contraste Simultané des Couleurs (The Principles of Harmony and Contrast of Colors)*. In it he set out clear explanations of the use

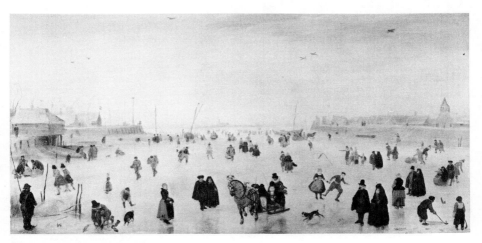

76 HENDRICK AVERCAMP
A Scene on the Ice, 17th century
National Gallery of Art, Washington. Ailsa Mellon Bruce Fund.

of color contrasts and mixtures. Chevreul proposed a series of rules for color harmony which have been in use ever since. His ideas were particularly influential for Impressionist painters, whose works are the beginning of the expressive use of color which is a hallmark of twentieth-century painting. Artists have always used color to tie their compositions together. Consider the painting *A Scene on the Ice* (Figure 76) by the seventeenth-century Dutch artist Avercamp. This scene, full of scattered figures, is given a sense of unity through the repetition of colors, especially red, on people's clothing. The eye moves from red to red, blue to blue, taking in both the individual figures and the painting as a whole. Without this use of color, the picture would seem random and confusing, without clear focus.

Beginning in the nineteenth century, however, painters began to think of color more expressively than narratively. A color did not need to be confined to an object but could stand on its own. Instead of the focal point of a painting being, for instance, a red hat, the hue red with its inherent properties of warmth and brilliance is used separately. One of the first painters to work with color in this revolutionary way was J.M.W. Turner. His painting *The Evening of the Deluge* (Figure 77), illustrates his thinking. The subject of this painting is the last sunset before the great flood of Biblical fame. The ark rides the waves in the center, followed by a dark funnel of birds. An alligator in the lower right corner stares anxiously after it. Through dark clouds and already raging seas, other animals and deserted structures are visible. At first glance, however, the chaotic emotions of the painting are transmitted by the colors and composition.

77 J.M.W. TURNER
The Evening of the Deluge,
19th century
National Gallery of Art, Washington.
Timken Collection.

The eyes are drawn through a maelstrom of dark greens and blues into the muddy yellow vortex behind. The ark is a ghostly shadow in the distance. The colors then pull the viewer around the painting and slowly the other figures are revealed. The sheer horror of the situation is more strongly communicated through Turner's manipulation of color than it could have been in a more conventional painting. The lack of detail makes the universality of loss and danger a more threatening subject than a mere retelling of an ancient story. Nineteenth-century viewers, for the most part, failed to understand Turner because his approach was so radical; but the painters of the time were profoundly influenced.

Claude Monet was influenced both by the developments in color theory and by Turner. His Impressionist paintings explored color in entirely new ways and began the tradition that led to abstract color-field painting. In his painting *Camille and a Child in a Garden* from 1875 (Figure 78) he is exploring color. The floral area is particularly interesting. Brilliant reds are surrounded by greens of a

78 CLAUDE MONET
Camille and a Child in a Garden,
1875
Courtesy Museum of Fine Arts, Boston.
Anonymous gift in memory of Mr. and Mrs.
Edwin S. Webster.

lesser intensity, making the red seem more intense because of the green, and the green, though dull, would seem more intensely green because of the strong action of the red. The juxtaposition of the two forces each color to the complement of the other. Another related effect is that a light makes a dark seem darker and vice versa, an effect which is independent of the intensity shifts of the hues themselves. Chevreul had described the after-image that occurs when the eye shifts from one color to another. The after-image of a color is its complement—after looking at red, the after-image is green and vice-versa. These are, interestingly, the after-images of light rather than those of pigment. The two spectra are different. In pigment, the complement of green is red-purple, but this is an optical, rather than a painterly, effect. With the Impressionist fascination for light, its use in Monet's painting is not surprising. The net result of the juxtaposition of pigments, light, and after-images is a crisp, sparkling appearance to the flowers.

The use of juxtaposed colors is also important. If the colors are applied in relatively broad areas, as in the flowers, the effect is strong and dynamic. In Camille's dress, however, the smaller strokes of blue and white produce a subdued, almost muddy, result. Monet did not apply the broken Impressionist brushstroke to the faces of the figures; he painted them more smoothly and regularly, although without conventional modelling. Along with the color harmonies, there is a great variation in texture and brushstrokes throughout the figures, as though the artist were attempting to solve the problems presented by the human face and form in terms of his new approach to the application of paint to canvas.

Since the period of the Impressionists, painters have become increasingly more sophisticated in their use of color. Seurat, for instance, developed complicated theories on the relationships of colors that greatly influenced later painters. Many modern paintings are based simply on the relationship between various colors. Morris Louis, in paintings like *Delta Gamma* (Figure 16), had an exceptional facility with color. The hues of his flowing stripes were carefully chosen both for their own properties and in relation to the hues of the stripes around them.

The juxtaposition of various hues makes the values and saturations of the colors seem to change as they are viewed in relation to the color on either side of them. In other words, a green stripe seen in relation to a yellow one seems very different from the same green stripe seen with the blue one on its other side. The sizes of the stripes, their saturation, and the amount of space between them all play a role in the continuing interest of such a painting. Nor are the psychological effects of the colors neglected. The hues are arranged

79 REMBRANDT VAN RIJN
Self-Portrait, 1648
Courtesy Museum of Fine Arts, Boston.
Harvey D. Parker Collection.

to arouse specific emotions in the viewer and to leave a lasting impression.

Even when only black and white are used, a composition can still depend upon color for its effectiveness. Rembrandt's etchings went through several stages, or states, as he made changes to improve their impact. Early states of his etching, *Self Portrait,* done in 1648, have sharp contrasts between black and white. The paper on the artist's table, his collar, and particularly the window at the left are all focal points. By the later states (Figure 79) a gray tonality, much softer than before, has become dominant. The paper and collar are less prominent. The window has the suggestion of a landscape in it; not distracting but enough to break up the dominant rectangle of the earlier state. By pulling the various elements together with gray, Rembrandt points the viewer at the psychology of the artist at work.

COLOR IN SCULPTURE

Color can also be an important element in sculpture. Some sculptures that are usually thought of today as being white were originally brilliantly painted. The ancient Greeks, for example, always painted at least parts of their sculptures. The graceful maidens who adorned the Acropolis wore gowns of brilliant blues and greens, accentuated with gold jewelry. Their skin, hair, and eyes were all painted. This is called **polychromy,** literally many colors, and refers to multicolored works, usually sculpture. Egyptian sculpture is another good example of polychromy, some of which still survives. Color was even used to denote sex. Women were painted a yellowish hue and men a reddish brown. Egypt's drier climate has preserved much more polychrome sculpture than survives from the Greeks.

The Romans introduced uncolored sculpture, although they often painted in the eyes of their figures, and the practice continued until the middle ages. Medieval sculpture, especially church carvings

such as altarpieces, was normally painted. Renaissance sculpture varied between uncolored and polychrome, depending on the seriousness of the individual work. Important statues were not colored, as though to emphasize their sober dignity, while folk sculpture and popular works of cheap materials generally appeared in bright colors.

One of the most innovative colorists in sculpture was the seventeenth-century Roman sculptor, Gianlorenzo Bernini. Bernini combined white and colored marbles with bronze, gilt, and real light in his compositions. Although his individual marble figures were never painted, he would place them against colored backdrops or arrange their lighting to give them the effect of polychromy.

The Roman ideal dominated the eighteenth and nineteenth centuries, with the purest of white marbles being especially highly valued. It was partially through ignorance of the Greek polychromy that so much sculpture has been done without color during the past two or three centuries. The ideal of classical perfection was identified with a kind of moral excellence that was best expressed in white.

Contemporary sculpture is often colored, but through the use of colored materials as well as through added polychromy. Twentieth-century sculptors do not feel obliged to be consistent about color, and use it whenever it adds to the impact of an individual work.

Texture

Texture in art can be either that of the objects portrayed within the work (usually in painting) or of the materials and fabric of the work itself. In painting both approaches have been used; but in sculpture and architecture the texture is usually that of the materials used. Sir Anthony van Dyck, in his painting *Philip, Lord Wharton*, probably painted in 1632 (Figure 80), concentrates on textures, mainly those of fabrics, to create a luxurious environment for his aristocratic sitter. The burnished satin of his cloak falls languidly around his body, partially covering a warm velvet tunic. The gleaming wood and burnished metal of Lord Wharton's staff contrast with the youthful softness of his face with its slightly moist lips and large eyes. Behind him is a sweep of green curtain and a softly lit landscape to the left. As Henri Focillon remarked in *Vie des Formes* (1934),

> Here it is that the brilliant flower of his painting comes into play—that precious material, fine and fluid, these shimmering musical notes which compose one of the most delicate luxuries ever made for our eyes.

An entirely different textural emphasis characterizes Hans Hofmann's *Twilight*, painted in 1957 (Figure 81). *Twilight* is so thickly

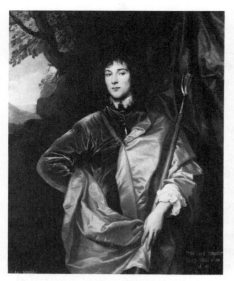

80 SIR ANTHONY VAN DYCK
Philip, Lord Wharton, 1632
National Gallery of Art, Washington.
Andrew W. Mellon Collection.

81 HANS HOFMANN
Twilight, 1957
Courtesy Museum of Fine Arts, Boston.
Gift in the name of Lois Ann Foster.

painted that a canvas was not sufficient support. A wooden panel pro-
vides the backing for this strong and tactile painting. The varying
thicknesses of the oil paint take on the same sort of interest as the
surfaces of a relief sculpture, while at the same time interacting with
the colors. The physical three-dimensionality of the work thrusts it
into the viewer's space, commanding attention.

Older paintings can also take advantage of textures, even in a
three-dimensional manner. Carlo Crivelli's *Virgin with the Dead
Christ* from 1485 (Figure 5) uses texture to enhance the dramatic im-
pact of the scene. The sleeve of Mary Magdalene's gown is modelled
in gesso and then gilded. The gilt was worked to resemble cloth and
to give Mary Magdalene's figure a variety of visual surfaces and to
emphasize her importance to the painting's theme. The rich and ele-
gant nature of the painting is further emphasized by the use of tool-
ing on the gold leaf in the background. A brocade-like effect results
from the designs worked into the leaf. The entire painting is a feast
of textures.

The textures of their materials have long been important to
sculptors. Marble and wood, for instance, have different surfaces
which produce different effects. The grain of wood has a warmer and
rougher appearance than does the smoothness of marble. This often
gives a wooden sculpture an immediacy which marble can lack.
Stone of different kinds has, of course, long been the most popular
material for sculpture, and the treatment of its textures is an inter-
esting study. James Rosati, in his work *Hamadryad* (Figure 82), done
in 1957–58, has celebrated the smoothness and hardness of marble.

82 JAMES ROSATI
Hamadryad, 1957–58
Hirshhorn Museum and Sculpture
Garden, Smithsonian Institution

83 JACQUES LIPCHITZ
Rape of Europa II, 1938
Hirshhorn Museum and Sculpture Garden,
Smithsonian Institution

This roughly 3-foot tall pillar-like form has a monumental, enduring quality. There are rounded forms at the top and two thirds of the way down. The roughly cut base reminds one of the hardness of the material. The essential character of marble is thus reinforced by the manner of carving. The experience is one of strength and permanence, effects which seem natural to the material.

Bronze is considerably lighter than marble and is in a liquid state during its casting. These factors have influenced Jacques Lipchitz in his sculpture *Rape of Europa II* (Figure 83) from 1938. The forms that make up the work are rounded and fluid in appearance, despite the occasional angularity. There is open space beneath the figures and between them at the rear, giving the sculpture a feeling of movement very different from that of *Hamadryad.* The surfaces are shiny and full of wavelike variations, which refer to the molten bronze Lipchitz used. This fidelity to materials is typical of some sculptures, but by no means all. Some sculptors, particularly those working in a representational style, take a great delight in making hard stone look like cloth, skin, or even lace. In such works, however, texture is usually not the basic compositional device.

Light

PAINTING
At different times, all of the visual arts have emphasized light in their compositions. In painting, the seventeenth century marked the

beginning of a new consciousness of the possibilities of light. Caravaggio, an Italian painter of the late sixteenth and early seventeenth centuries, pioneered this new light. His painting, *Supper at Emmaus*, from about 1600 (Figure 84) shows a familiar Biblical scene in an unusual interpretation. The dramatic light coming into the painting from the right leads our eyes to the central figure of the man sitting behind the table. We notice his face and hands, along with the outstretched hands of the man on the right. It is not immediately clear what is happening. The shabby men at either side of the table are jumping up in astonishment, but the standing figure behind seems oblivious to any excitement. He is a witness, as we are, but we have more clues. The seventeenth-century viewer would recognize the story of Christ's meeting with two of the apostles after the Resurrection. The three stopped at an inn, and when Christ broke bread, the others recognized him. Immediately after this moment he vanished. The extremely dramatic story is captured here without any extras. There are no angels, no halos, no heavenly hordes. The mystical and supernatural nature of the event is entirely conveyed through Caravaggio's use of light.

Caravaggio's new compositional use of light became very popular in Northern Europe during the seventeenth century, and variations on it were used by many people, including Rembrandt. In his etching, *Adoration of the Shepherds: A Night Piece* (Figure 85), Rembrandt gives us an extreme example of the effectiveness of light in adding mystery to a work. This reliance entirely on the contrast between dark and light is often called "chiaroscuro," an Italian word meaning light and dark. The scene takes place inside the manger on the night of Christ's birth. A lantern held by one of the shepherds draws the eye into the print and highlights the various members of the group. There is a feeling of stillness and wonder in the velvet darkness of the background. Another light, not that of the lantern, illuminates the faces of Mary and the baby Jesus, while behind them there is a bit of the manger wall. This strong chiaroscuro makes a spiritual statement which would be lost in a stronger light.

The American painter Edward Hopper frequently used light to increase the sense of isolation in his paintings. In *Room in Brooklyn*, 1932 (Figure 86), a woman sits in a rocker before the windows of an upper-story room. Shades are pulled at different levels in the three windows, giving uneven glimpses of the sky beyond. The room is filled with a clear yellow-green light which fills it and appears to push the various objects to the side. Rectangular shapes take on a life of their own because of the light, seeming more vivid than the woman. The sense of aloneness is overwhelming. This kind of light helps make Hopper's social commentary meaningful in many paintings.

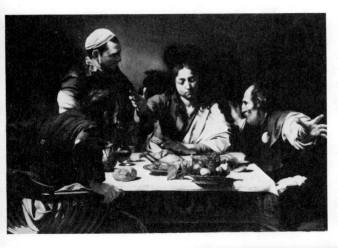

84 CARAVAGGIO
Supper at Emmaus, ca. 1600

85 REMBRANDT VAN RIJN
Adoration of the Shepherds,
A Night Piece, ca. 1652

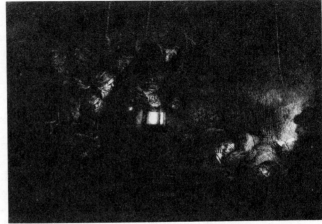

86 EDWARD HOPPER
Room in Brooklyn, 1932

SCULPTURE

Sculptures are often planned to take advantage of a certain kind of light. For instance, many large contemporary sculptures are only successful when seen in sunlight, as they lose their sparkle in an enclosed environment. The Italian Baroque sculptor Bernini, for instance, used natural light to add a feeling of motion and excitement to many of his statues. You are meant to walk around the work, viewing it from different sides and watching the light play on its intricately carved surfaces. Some areas are deeply cut to appear shadowed, while some gleam finely in the sun. Unfortunately, a photograph can never catch the three-dimensional experience of the original.

ARCHITECTURE

Light is also a major consideration in architecture. The character of a building is determined to an extent by the amount and kind of illumination provided. In a Gothic cathedral, the skeletal nature of the building allows for maximum window space. The arches and buttresses bore the weight of the superstructure, allowing large stained glass windows to occupy what would have been solid wall space in earlier buildings (Figure 87). The light entering the church is filtered through color and has a different quality from direct light. The floor sparkles with dancing reds, blues, and greens. The medieval worshiper would have been reminded that the world within the church was different from that outside. Even the ordinary secular light was transformed into a mystical experience of glowing color.

Contemporary architecture has moved in a similar direction. Steel skeleton construction has allowed the use of glass-walled buildings. John Portman's hotels, such as the Hyatt Regency in San Francisco (Figure 88), are built around huge glass-enclosed atriums containing living trees and parklike fountains and pools. Portman's idea

87 Detail of transept, Salisbury Cathedral, England, 13th century
Photo by Fred Hanhisalo

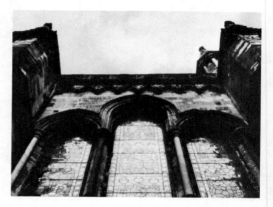

is to minimize the difference between interior and exterior. The inside of a building need not be dark and claustrophobic. By being visually in contact with the outside, you become less isolated, less artificial. A side benefit, of course, is that the uninterrupted light from outside also provides heat, an important consideration in our time.

Sometimes the absence of light is used to establish the personality of a building. In Byzantine churches like San Vitale at Ravenna (Figure 89), the lighting is kept to an absolute minimum. This, along with the extremely plain exterior of the building, makes the transition from exterior to interior abrupt and startling. The walls of the church are covered with gleaming mosaics, and the limited lighting flickers over them, giving the entire building a feeling of mystery and sanctity.

**88 JOHN PORTMAN & ASSOCIATES
Atrium lobby of the
Hyatt Regency,** San Francisco, 1973
Courtesy of the Hyatt Regency. San Francisco

**89 Byzantine
Interior of San Vitale,**
Ravenna, Italy, 6th century
Alinari/Editorial Photocolor Archives

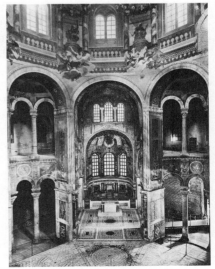

Parallelism _____

Parallelism refers to a composition in which the various elements are arranged symmetrically around a vertical central axis. An example is the panel painting done by Duccio in the thirteenth century for a church altar, called the *Crucifixion* (Figure 90). Duccio intended the picture to be a devotional exercise for the viewer. His parallel organization shows that clarity was his dominant concern. It was important that the worshipers understand the meaning of the story represented before them. The center of attention is the cross in the middle of the painting with the figure of Christ on it and the skull at its foot. Three angels fly toward the cross on each side, emphasizing its importance. Below them are two groups of people. On the left are Christ's followers, bunched tightly together in their grief. Their tight, falling silhouette is balanced by the exuberant arms rising from the group on the right. These are Jesus' enemies, celebrating his punishment. Only Longinus, the furthest to the left in that group, looks pensive, forseeing that he will later become a Christian. There is nothing extraneous here, nothing to detract from the content of the work. The sense of balance, of levels of importance brought about by the parallelism, make a simple and clear composition that enhances the religious message.

Picasso, in his painting *Girl Before a Mirror* (oil on canvas, 64 × 51¼"), done in 1932 (Figure 91), uses the same device in order to achieve balance. The edge of the mirror forms a central axis around which are arranged the figure and her reflection. Though by no means a static painting, the many round and oval forms make a coherent unit. Picasso, like Raphael, is dealing with an extremely complex concept—possibly the Freudian duality of the human personality—and does not want to complicate it further through his composition. Parallelism gives the work the desired intellectual effect, and it is clear that we are to look for its meaning.

An architectural use of parallelism occurs in the Church of Sta. Susanna in Rome (Figure 92). This Baroque church by Carlo Maderno shows that a parallel arrangement does not need to be dull. The central axis is emphasized by the entrance with its columns and triangular pediment on the first level, an elaborately embellished window on the second, and a coat of arms at the roof level. On either side of the door are two columns, a niche with a statue, one column, another niche, and a pilaster. Above are two pilasters, niche with statue, one pilaster, and a volute. The roofline has three vertical ornaments, the central one of which is a cross. Despite the variation in surfaces, light and shadow, and sculptural decoration, the church is self-explana-

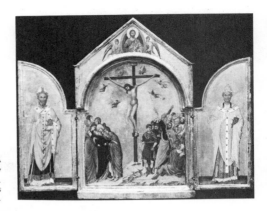

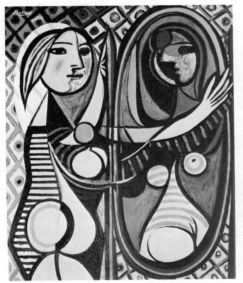

tory. One enters in the center and is given an interesting and varied experience inside, an experience whose variety and meaning is prefigured by the façade.

Triangularity

In painting *Fray Felix Hortensio Paravicino* (Figure 93) around 1609, El Greco sought to arrange the portrait so that the dynamic tension of an energy strong enough to control itself would be expressed by

the static medium of paint on a two-dimensional surface. To express this dynamism, El Greco arranged the figure within two triangles which have one side in common—the line between the thin, nervous hands. The motion of the hands is frozen; the subject does not rest a hand on the arm of the chair, nor does he put down the books he is studying to have his portrait painted. The upper triangle is completed by the head of the subject which is emphasized by the white cowl and becomes the focus of the painting. The lower triangle ends in the white of the robe worn by the sitter—a white which directs us back to the cowl and to the center of the picture. The two triangles create a hierarchy of importance—face, hands, and robe set in a background which constantly directs the eye back to the face. A single triangle might have been static, but the two joined triangles force one's attention to move in a set sequence which always returns to the strength of the face and eyes.

Michelangelo's *Pietà* (Figure 23) in St. Peter's, Rome, uses a triangle to organize a three-dimensional work. The Virgin's head is the peak of a smaller triangle which ends on her outstretched hand and Christ's head, and a larger one which surrounds both figures. The unity of the composition is so successful that we do not notice the physical impossibilities of the situation depicted by Michelangelo. Mary is considerably larger than her full-grown son, yet has no difficulty supporting him with one hand. Christ himself is oddly twisted to turn the greatest possible portion of his body toward the viewer. Yet the sculptural harmony of the two is greater than these awkward factors. The unifying force of the triangular composition compels us to accept the pose despite its impossibility. By imposing order upon the inconceivable, Michelangelo creates a tension which gives the work a strong emotional impact.

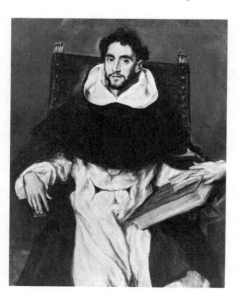

93 EL GRECO
Fray Felix Hortensio Paravicino,
ca. 1609
Courtesy Museum of Fine Arts, Boston.
Purchased. Isaac Sweetser Fund.

Repetition

Many compositions are integrated through the repetition of a single element. This gives unity to the work without necessarily setting up a specific order of viewing. Repetition can occur in different ways. John Singleton Copley used repetition in his portrait of *Mrs. Ezekiel Goldthwaite* (Figure 94), done around 1771. A curving motif, rather than objects themselves, is repeated. We look at Mrs. Goldthwaite's curving hat, her round face, curved shoulders and skirt, the round table, round dish, and round fruit. There is also a subsidiary triangle formed by the lady's face, hands, and fruit, but it is not as clear as the repetition of curving lines. Mrs. Goldthwaite was noted for her very large family and her abundantly productive fruit trees. By emphasizing her roundness and filling her surroundings with curved objects, Copley has made her into a kind of mother goddess, a symbol of fertility in every sense.

Giacomo Balla's *Boccioni's Fist—Lines of Force II* (Figure 95), 1915 (reconstructed 1955–68) utilizes repetition in a three-dimensional format. The sharp yet curving brass shapes tie the work together. The rising curve at the bottom is echoed at the top. Two smaller curves attached to handle-like projections balance one another, surmounted by two sharp, elongated pyramidal elements. This is not parallelism. There is no central axis. But each element in the work appears more than once, sometimes in a slightly different form. A feeling of organic unity, even of anthropomorphism, is achieved by this means.

A multiple repetition of a few shapes is the dynamic of Victor Vasarely's *Orion* (Figure 96), a collage on wood from 1956–62. The work is basically an almost square shape, consisting of twenty small

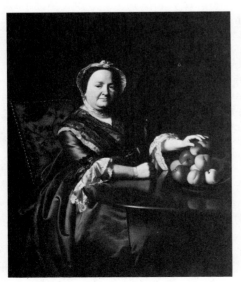

94 JOHN SINGLETON COPLEY
Mrs. Ezekiel Goldthwaite,
ca. 1771
Courtesy Museum of Fine Arts, Boston.
Bequest of John T. Bowen
in memory of Eliza M. Bowen.

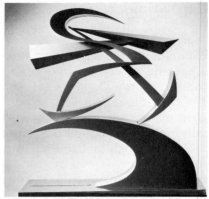

95 (above) GIACOMO BALLA
Boccioni's Fist—Lines of Force II,
1915
Hirshhorn Museum and Sculpture Garden,
Smithsonian Institution

96 (left) VICTOR VASARELY
Orion, 1956–62
Hirshhorn Museum and Sculpture Garden,
Smithsonian Institution

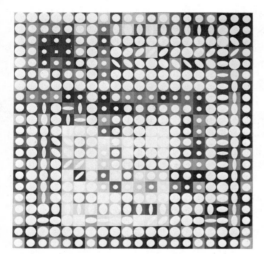

squares on the horizontals and twenty-one on the verticals. Each square contains either a large circle, a medium or a small circle, an ellipse (vertical or horizontal) of slightly different shapes, a small square, or nothing. Every motif is repeated except the small square and the black square, each of which appears only once. A repetition of colors is also present; red, blue, violet, green, yellow-green, orange, and bright pink are all used. This carefully constructed reuse of the geometric elements of the collage give it unity. If a random usage of elements had occurred, the total effect would have been totally different. As it is, there is a strong impression of an orderly diversity.

Space and the Use of Perspective

Creating the illusion of three dimensions on a flat surface challenges the artist. Some cultures ignore the problem and take a symbolic approach to representing reality. Ancient Egyptian art, for instance, was

not usually concerned with perspective or with visual realism in general. Medieval art often takes a similar position, placing theological over physical truth. Twentieth-century artists sometimes avoid perspective because it is a deception, a denial of the two-dimensional properties of a canvas.

Perspective, the creation of a convincing third dimension, has often been of great importance. The Greeks and the Romans employed perspective in paintings on vases and walls. Roman frescoes, in particular, can demonstrate a deep understanding of the problems of perspective.

Systems of perspective were developed during the Renaissance, both in Northern Europe and in Italy. Several approaches were used by Renaissance painters and relief sculptors to capture the effect of natural space and to recreate a scene as it would be viewed from a specific point. The term perspective refers to entire scenes. Perspective applied to a single object within a scene is called **foreshortening.**

Empirical, or **optical,** perspective refers to perspective done by observation. The artist attempts to reproduce a scene as it appears. Figures diminish in size as they recede in space; colors change convincingly; and diagonals are aimed in parallels toward the distance. Early Renaissance paintings from Flanders often use empirical perspective. The result is a generally believable impression of a three-dimensional scene.

An illusion of depth can be established through color, particularly in landscapes. This is **atmospheric** or **aerial perspective,** a method that shows how colors change as they are perceived through increasing amounts of atmosphere. In the background, colors become hazy and gray or cool blue while those in the foreground are sharp. This technique depends on color recession and advance, which was discussed in the section on color. Aerial perspective is generally used in conjunction with empirical or geometric perspective.

The Early Renaissance Florentines developed mathematical procedures for calculating perspective. These techniques are known as **linear, geometric,** or **mathematical** perspective. Much of the theory of geometric perspective was developed by an architect, Filippo Brunelleschi. He worked out a system based on a distant vanishing point that determines the size and placement of objects in the picture. This method was refined by Leon Battista Alberti, whose book *Della Pittura*, written in 1436, became the standard textbook for Renaissance painters and sculptors.

Figure 97 shows a single vanishing point linear perspective system. The surface to be painted was covered by a grid of horizontal and vertical strings. Each of the horizontal strings represent one plane in space. The surface of the painting is the foremost plane and

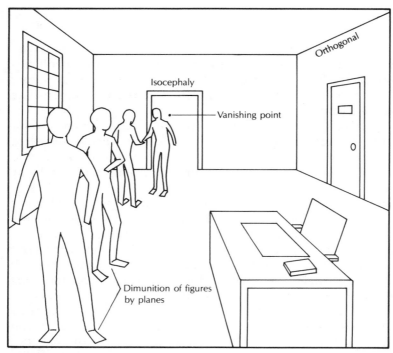

97 Linear perspective

98 ANTONIAZZO ROMANO
The Annunciation, late 15th century
Isabella Stewart Gardner Museum, Boston

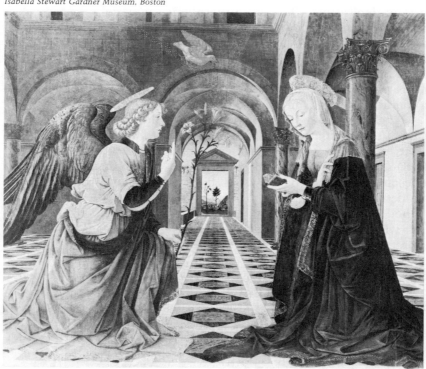

the space behind the surface is divided into a series of planes parallel to the surface. Figures diminish in size by a specified amount on each plane back to the vanishing point. Figures on the same planes have their heads on the same level, a rule called **isocephaly,** literally equal heads, but are smaller than figures closer to the picture plane. This eliminates the problem found in many medieval paintings of indicating distance by placing people higher without decreasing their size.

The vertical strings are used to determine the edges of upright elements, like buildings. Buildings, therefore, have their foundations on horizontal strings and their sides on verticals. A harmonious relation of scale between figures and buildings is also established. Medieval people are often seen trying to get into buildings half their size, which may be symbolic but is hardly realistic.

In linear perspective diagonal lines extend from the picture plane to the vanishing point. These diagonals, called **orthogonals,** often appear in paintings in the form of checkerboard floors or vaulted ceilings. They draw the eye back from the picture plane and are crucial to believable perspective.

One-point perspective was common in the middle of the fifteenth century, but was gradually replaced by two- and three-point perspective, and by systems in which the orthogonals recede to a line rather than to a point. An example of one-point perspective is *The Annunciation* by Antoniazzo Romano (Figure 98), painted between 1475 and 1485. The Archangel Gabriel speaks to Mary in a large vaulted building with a multicolored tile floor. The dove of the Holy Ghost descends on a path of golden light and the scene terminates in a distant landscape seen through a gateway. The figures are calm; their simple dress agrees with the plain, yet monumental, architectural setting. The pattern of the floor and the vaulted ceiling carry the eye toward the vanishing point in the background, which is located in the right-hand tree outside the gateway. In single-point perspective, it is hard not to look at the vanishing point. The subject may be overwhelmed by the technique. The single vanishing point produces a tunnel effect that has to be countered by a strong visual focus in the foreground. The use of multiple vanishing points or perspective to a line eliminates this problem without weakening the impression of depth.

A sculptural example of linear perspective is a limestone relief of a family at prayer done in South Germany in the early seventeenth century (Figure 99). A couple and their children kneel in a small chapel; the males are on one side and the females on the other. Although the relief is shallow, less than 2 inches deep, the viewer seems to look into a deep box. The lines of the floor converge on the cross on the front of the altar and the kneeling figures diminish ap-

99 German
Stone Tablet with a
Patrician Family at Prayer, 17th century
Isabella Stewart Gardner Museum, Boston

propriately as they recede toward that cross. Although the treatment
of the figures is stiff and their placement is awkward, the illusion of
a spacious room is convincing.

The development of perspective, especially linear perspective,
allowed compositions to take on a greater freedom and elasticity, es-
pecially as artists became confident enough not to be dominated by
perspectival theory. Some situations, however, required adjustment
to the normal perspectival arrangement, for instance ceiling paint-
ings. *Sotto in sù*, an Italian phrase meaning "from below upwards,"
describes the kind of foreshortening used in Baroque ceiling paintings
to give the illusion of looking straight up. In *sotto in sù* perspective,
the ceiling of the room is denied and seems to open to a scene in the
sky. The scene is not contained within a picture plane but rises up at
an angle. Obviously, a viewpoint directly under the picture will not
work, as the bottom of most things is not their most informative or
aesthetic view. The angle chosen for foreshortening has to be con-
vincingly steep, yet provide enough of a look at the figure to under-
stand them fully.

Linear perspective dominated painting for centuries. Even works
that seem to have little in common with those of the Renaissance,
such as early paintings by the Impressionist Monet, show an exten-
sive knowledge of Alberti's principles. Before the end of the nine-
teenth century, artists seldom questioned the theory of perspective or
the need for showing a scene from a single point of view. Cézanne,
for instance, thought that the artist should be free of the conventions
of perspective in order to create a world with its own idiosyncratic
order. Unity, he discovered, need not depend on perspective, it can be
achieved through color, brushstroke, or repetition of forms. None of
these devices was new, but they had never been used with such bold-
ness as an alternative to perspective. Gauguin rejected all of western
art and theory and sought to base his spatial relation on flat areas of

color. This challenges the viewer to understand something that is not within a conventional frame of reference, therefore raising questions and defying easy answers.

The Cubists rejected fixed perspective and substituted a series of viewpoints combined by intellectual, rather than visual, guidelines. Cubism, with its revolutionary approach to painting, including its approach to perspective, was the end of 500 years of assuming that a painting was limited by a fixed point of view.

Twentieth-century artists often seek a straightforward approach to their materials. Marble should look like marble, not lace, and a two-dimensional cloth surface should not mimic a three-dimensional box. This is especially true with painters of pure color. Such painters often avoid the use of lines or sharp edges altogether since these suggest the possibility of three-dimensionality. They use methods of painting such as air brushing, flow painting, and splatter painting to produce works that emphasize the flatness of the canvas. As was the case with Egyptian and medieval art, contemporary painting deals with ideas rather than any specific story or realistic representation.

Linear Versus Painterly

In the 1920s Heinrich Wolfflin published *Principles of Art History*, one of the first systematic studies on the dynamics of art history and art appreciation. He developed categories for art objects and analyzed the style and composition of many major works in terms of these categories. While contemporary art historians think Wolfflin was too rigid in his insistence on pigeonholing, they recognize that some of his ideas were valid and that others were the forerunners of more flexible criticism.

Categories provide a convenient summary of the techniques artists have used. If the viewer remembers the enormous variety of works which can be associated with a general category, labels such as linear and painterly can be useful. Wolfflin defines linear style as a work in which

> *the sense and beauty of things is first sought in the outline—interior forms have their outline too—that the eye is led along the boundaries and induced to feel along the edges, while seeing in masses takes place where the attention withdraws from the edges, where the outline has become more or less indifferent to the eye as the path of vision, and the primary element of the impression is things seen as patches.* *

*Heinrich Wolfflin, *Principles of Art History*, trans. M.D. Hottinger. New York: Dover Publications, Inc., 1950, p. 18.

A painterly work, according to Wolfflin, is one in which outline is not stressed; rather, outline is one element of a whole that is based on movement and the interplay of elements such as light and shade.

> Form begins to play; lights and shadows become an independent element, they seek and hold each other from height to height, from depth to depth; the whole takes on a semblance of a movement ceaselessly emanating, never ending. Whether the movement be leaping and vehement, or only a gentle quiver and flicker, it remains for the spectator inexhaustible.*

In more modern language, the linear painter relies heavily on draftsmanship. Forms are clearly outlined and do not surrender their independence to an overall effect, although they contribute to that effect. A painterly composition is first seen as a whole, with the parts acting in such a way as to seem constantly changing, giving a dynamic feeling to the work.

Two of the greatest painters of America's early history worked in distinctly different styles. John Singleton Copley, the renowned eighteenth-century portraitist, drew on his canvas first and then filled in outlines with colors. The effect is one of strength, tangibility, and three-dimensionality, both of the individual objects and of the painting as a whole. Gilbert Stuart, on the other hand, worked in a painterly manner, building his forms with masses of color, working from the inside out, and maintaining a lack of distinctness that is both optically believable and interesting in terms of spontaneity and movement.

Copley's portrait of *Paul Revere*, painted in 1768–70 (Figure 100) is an example of his approach. The goldsmith is shown sitting at his workbench, whose edges are clearly defined. On the table are burins and gravers, the tools of his trade, and a cushion on which Revere rests his arm. In Revere's hand is a pewter teapot, its complicated forms carefully detailed, and its surface reflecting the goldsmith's fingers. The sitter himself is dressed simply, a loose white shirt and green vest contrasting strongly with the usual finery of people sitting for portraits. His right hand is lifted to his chin, as though in contemplation, and he looks out at the viewer with a direct and unwavering gaze. The overall effect of the painting is informational. Revere appears as an unpretentious and straightforward person with no secrets and no hidden motives. He is addressing himself to his work with calmness and poise. There is an overall impression of candor.

This effect is achieved through the extremely real, although static, presentation of the objects in the painting. There is a clarity

*Wolfflin, p. 19.

and order to the painting, with colors used carefully to complement the drawing of individual elements. The white shirt and boldly high-lighted face draw one's attention initially to Revere himself. The broadly rendered face and large dark eyes seem to reflect the person-ality of the sitter. The eye then moves to the teapot, an example of the work of this craftsman, and his large capable hand holding it firmly. The tools and the neat, highly polished surface add to the pic-ture of the sitter's personality. There is nothing mysterious here—no dark shadows, shifting lights, or blurred edges. This is a clear-cut, honest painting, showing both technical expertise and a carefully considered approach to subject. Each of the elements of the painting, sitter, teapot, table, tools, are defined by strong outlines. Color is strictly confined within those outlines, and even the background is defined by a vertical division into two sections. There is stability through careful delineation of forms and attention to detail.

Stuart's approach and intentions are different. The sitter in the portrait in Figure 101 is also Paul Revere. This work, painted about 1813, shows Revere towards the end of his life, no longer the com-petent young craftsman but a man full of experience, the veteran of a long, productive life. Unlike Copley, Stuart does not place Revere in a setting. There is nothing to tell the viewer of the man's profes-sion, or to provide factual information about him. The focus of the painting is Revere's face. His white shirt front and the suggestion of a black coat act as foils for the face and do not distract from it. There

100 JOHN SINGLETON COPLEY
Paul Revere, ca. 1768–70
Courtesy Museum of Fine Arts, Boston.
Gift of Joseph W., William B.,
and Edward H.R. Revere.

101 GILBERT STUART
Paul Revere, ca. 1813
Courtesy Museum of Fine Arts, Boston.
Gift of Joseph W., William B.,
and Edward H.R. Revere.

is no setting, only a believable, atmosphere-filled space. Equally, there is no emphasis on individual details, either of the costume or the face. The impact of the painting comes from the psychology of the individual as it is reflected in his face, his deep-set brown eyes, the hint of a smile. There are no outlines, and shadowing is used heavily at the transitions from one element to another. The figure blends imperceptibly into the background, his features blend into one another. There is a sense of constant movement and change—not physically, but psychologically. A combination of soft transitions, subtle and fluid lighting, and a strong sense of color relationships makes the painting succeed.

Wolfflin's work was done before the majority of twentieth-century abstract art was created, and his categories work less well for them. Although some twentieth-century works rely heavily on line, particularly super-realist paintings by artists like Richard Estes, the tendency overall has been towards painterliness. Also, the relationship between artist and subject that characterizes traditional painting has broken down as subject and form become identical. However, in paintings up through the nineteenth century, concepts like "linear" and "painterly" provide a vocabulary with which to discuss them, and a clue to the intent of the artist.

Volume and Mass

Although mass and volume may be suggested in painting, they exist physically in sculpture. **Mass** is a quantity of matter. In art the term is applied to the weight and density of a form or group of forms. **Volume** refers to size—the amount of three-dimensional space enclosed by a boundary. A balloon has much volume but little mass; but a small iron bar has much mass and little volume.

The exteriors of volumes are called **surfaces,** different kinds of which can be used by the sculptor to achieve different effects. Surfaces that are extensions of a straight line include planar surfaces and those with a single curve. Double curved surfaces are those that have no straight element and are made up entirely of curves. These are usually combined in a single work of sculpture, and it is their interaction that provides much of the visual interest of the piece.

Convex surfaces are the most common in sculpture. Most of the parts of the human body, such as the head, buttocks, and knees, are made up of convex surfaces. Depending on the treatment of these convex surfaces, they can appear light and buoyant or heavy and massive. A convex surface may seem to emerge into the space surrounding it. This gives a sense of movement to the sculpture.

This assertive outward thrust is often balanced by **concave surfaces,** where space penetrates the volume of the sculpture. A combination of convexity and concavity results in interesting light and shadow effects on a sculpture. In the *Pietà* (Figure 23), Michelangelo juxtaposed the convex folds of Mary's headdress with the deep hollows around her face to create the dark shadows on her face which accentuate her grief. Drapery, or clothing, on statues is made of alternating convex and concave surfaces which suggest texture and movement.

The volumes of a sculpture meet at intersections, which can be smooth or abrupt. A smooth transition between volumes integrates their separate identities. The eye glides from one to the other, barely noticing that a transition has taken place. Some Gothic sculptures of figures treat the shoulders as drooping rather than squared to keep the eye moving upward towards the head. An abrupt transition stops the eye by stressing the discontinuity between elements. Most Egyptian sculptures have abrupt transitions. Each part of the figure remains separate although it contributes to the whole.

INTERACTION OF VOLUMES
AND SPACES

The basic composition of a sculpture is determined by the interaction of volumes and spaces. Surfaces and transitions contribute to this interaction. For instance, in a human figure the volumes are head, neck, upper arms, lower arms, hands, chest, pelvis, thighs, calves, and feet. The proportions of these volumes and their relation to one another determines the effect of the figure. An Egyptian sculpture, as mentioned above, is composed of separate volumes joined by distinct transitions. The eye therefore moves slowly around the figure, taking in each part and building up the total image. This slowing down adds to the impressiveness of the figure and invites the viewer to think about its significance. Egyptian art was meant to last for eternity and a hurried treatment by artist or viewer would be inappropriate. One drawback to this volume treatment is that there are sometimes startling discrepancies in proportion.

In the fifth century B.C. a Greek sculptor, Polykleitos, wrote a book called the *Canon* describing a way of showing the human body as a series of interconnected volumes, each one of which is influenced by the position of the others. He illustrated this in a number of cast bronze sculptures showing men and women in positions of repose which suggested the possibility of movement. Prior to this, human figures had been symmetrically arranged around a central axis— the shoulders, hips, and knees were on the same level. Polykleitos rotated the figures about a quarter-turn around the axis and reflected

this movement in each part of the body. This *contrapposto* position involves turning the head in one direction, followed by the torso. The hips and thighs reverse direction and the calves and feet reverse it again. The total effect is of an S-curve in which each movement to one side is balanced by a movement to the other.

Polykleitos' system also takes into account the fact that the parts of the human figure are perceived not only as volumes but also as masses—solid forms with weight. The successful contrast of these compositional masses gives the figure stability. The physical masses of the sculpture are also balanced, although this takes extra weight at the bottom if the sculpture is made of stone. Extra elements such as tree trunks often appear against the legs of sculptured figures to provide that extra weight. They also help visually—when the largest mass is at the bottom, the work looks stable. Since Polykleitos' time the majority of figural sculptors have used variants on his formula. Cyrus E. Dallin's *Samoset*, a hollow cast bronze of an early New England Indian leader, is one of thousands of such Polykleitan statues (Figures 102 and 103).

MODERN SCULPTURE
Modern sculpture, with less emphasis on realistic figures, can manipulate volumes and spaces in new ways. Henry Moore, in his bronze *Reclining Figure No. 4*, 1954–56 (Figure 104), uses volumes with concave and convex surfaces to establish a harmonious relation between mass and space. The figure neither reaches out into space nor is it encroached upon by it. The form and its space seem to be in balance with neither taking precedence. The eye is swept along the figure from head to knees and around the back until the head is reached again. Each part seems to relate to the curvature of the whole, rather than appearing as an independent form. The spaces between the figure, between its legs, and around its perimeter, accentuate the unity of the sculpture and the fluid interplay of three-dimensional curving surfaces.

The transitions between volumes in Moore's *Reclining Figure* add to the sense of fluid completeness. Each of the component volumes of the piece flow smoothly into one another without any interruption of the movement of the viewer's eye. The surface texture is even throughout, with striations, or scratches, following the surface curvature. This adds to the figure's unity.

Constantin Brancusi's *Torso of a Young Man*, a polished bronze sculpture with a stone and wood base, was done in 1924 (Figure 105). Its use of spatial relationships, volumes, and surfaces is totally different from Moore's *Reclining Figure No. 4*. Although the piece has little physical mass, being of hollow cast bronze, it appears heavy and

102–103 CYRUS E. DALLIN
Samoset, Great Sachem of the Massasoits, 1921
Photos by Fred Hanhisalo

104 HENRY MOORE
Reclining Figure No. 4, 1954–56
Hirshhorn Museum and Sculpture Garden,
Smithsonian Institution

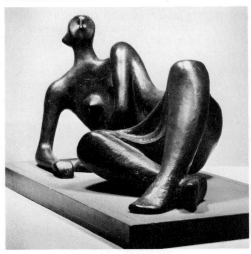

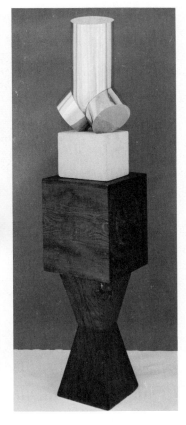

105 CONSTANTIN BRANCUSI
Torso of a Young Man, 1924
Hirshhorn Museum and Sculpture Garden,
Smithsonian Institution

strong. The entirely convex surfaces add to the impression of strength, and the verticality of the main volume suggests an upward thrust. The transition between the three main volumes is abrupt, as is that between the bronze form and the base. Each part retains its own identity while contributing to the whole. The eye takes them in separately and assembles them into a complete sculpture. The only penetration of space into the sculpture comes just above the base. The figure appears to press down on that space and dominate it. At no point is a give-and-take relationship established between the figure and its surrounding space. It is self-contained, dynamic, and tense.

Naum Gabo's *Linear Construction No. 4*, 1959–61 (Figure 106), is a construction of wires and their relationships to the spaces they move within and around. In 1972 Gabo made a statement about how his wire constructions should be approached:

> *The public is prone to find in any abstract work some kind of relationship to what they have seen, may it be in Nature or in their own imagination. In the structure of my work . . . the steel springs or nylon strings may provoke an association with the strings of a musical instrument.*
>
> *This would, of course be totally wrong, and it is most important to tell the public that in these linear structures the strings by themselves have no life of their own. They are important insofar as they are used to create a surface of a particular preconceived shape.*
>
> *I do that for the sake of creating a metallic surface which is transparent, and all the sides of that surface are visible to the observer, a quality which is absent in a solid surface.*

106 NAUM GABO
Linear Construction No. 4,
1959–61
Hirshhorn Museum and Sculpture Garden.
Smithsonian Institution

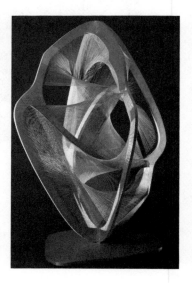

*Knowing that, the observer, I am sure, will conceive the entire image with richer impressions of the work's whole three-dimensional life in space.**

The entire impact of the sculpture is based on the interaction of the aluminum frame, the thin stainless steel wire and the space flowing around and through the wire. The space is not inert, not a negative area, but a positive force which seems to push against the wires and force them into patterns.

TRADITIONAL SCULPTURE
To a lesser extent, this kind of interaction also exists in traditional sculpture. A statue of a figure, for instance, can stand with its legs spread and its arms reaching out into the space around it. This open form as it is called gives a sense of tension and movement to the work. Mannerist sculptors of the Renaissance, Bernini and his followers in the seventeenth century, and the nineteenth-century American Robert Rimmer, are examples of sculptors who took advantage of tension between form and space in their sculptures.

A different kind of spatial tension can be established in a sculpture by suggesting an imbalance of masses. David Smith's *Cubi XVIII* (Figure 70), consists of a slender base with consistently larger cubes and rectangles on top of it. The impression is of a moment frozen in time, the geometric shapes caught for a second as they fall towards the ground. Because the volumes are hollow, the physical mass is small enough so that *Cubi's* balance can be maintained.

UNUSUAL USES
OF VOLUME AND MASS
Some artists heighten the impact of their work through an unusual relationship between volume and mass. Gaston Lachaise is known for his studies of the female figure, mostly in bronze. The women, whether complete or only headless and armless torsos, are filled with a bursting vitality. *Walking Woman,* a polished bronze statue from 1919 (Figure 107), is an example. The figure, entirely composed of great curving volumes, seems to move easily. The impression of weight is balanced by the outward thrust of the volumes, the flowing transitions, the polished metal reflecting its surroundings, and the gracefully moving skirt. Instead of a massive and ponderous figure, *Walking Woman* becomes the epitome of vitality and energy.

Like the painter, then, the sculptor manipulates elements of composition to produce effects. Free-standing sculpture is often

*Quoted in *The Hirshhorn Museum & Sculpture Garden, Smithsonian Institution.* New York: Harry N. Abrams, Inc., 1974, p. 693.

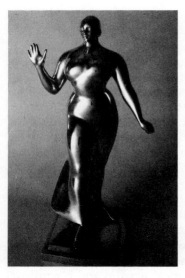

107 GASTON LACHAISE
Walking Woman, 1919
Hirshhorn Museum and Sculpture Garden,
Smithsonian Institution

meant to be seen from a series of viewpoints and the sculptor has to make relationships between his or her volumes to work from several angles. In successful sculpture, the parts relate internally to one another and to the whole. The volumes are perceived as being organically related rather than added to one another.

Entrances and Exits

The contents of a painting are usually arranged so that they will be seen in a particular order. The viewer is drawn to the first focus of the painting, which then directs the eye toward other parts. The artist wants the viewer to be attracted to the painting and to view it in the order that makes the most positive and lasting impression. Whether there is an easy flow through the work profoundly effects the impact of the work, in terms of both subject and form.

Perspective can be used to control the order in which one views a painting. Claude Monet, for instance, in *Rue de la Bavolle, Honfleur* (Figure 108) uses a modified linear perspective to order the composition and attract the eye. The outline of the street moves the eye back to the man walking toward the background. There is a direct line from the man to the woman and child in front of him. The pattern of light then draws the viewer to the figures on the right-hand sidewalk—a woman in a white cap and a small child. By this point, perspective no longer controls the viewer's attention. The green of a vine and the sunlit shop sign are further focal points, as are the figures in the shade. There is another woman sitting on some steps with a black cat near her, and a man's head and hand are seen just emerging from a door. However, perspective resumes control as the colorful

108 CLAUDE MONET
Rue de la Bavolle, Honfleur,
1864
Courtesy Museum of Fine Arts, Boston.
Bequest of John T. Spaulding.

rooftops draw the eye towards the light sky that provides an exit from the painting. The picture is based on four triangles—the street, the sky, and the two sets of buildings. Each occupies the viewer's attention separately.

Renoir used a less geometric composition in *Le Bal à Bougival* (Figure 109). The eye, attracted by the brilliant red of the woman's hat, enters at the level of the dancers' heads. This focuses attention on the faces of the figures and their reaction to one another. The man's eyes are hidden by his hat, keeping his expression hidden; but his interest in the woman is emphasized by the overlapping brims of their two hats. She, however, seems to be pulling back. The gentle-

109 PIERRE AUGUSTE RENOIR
Le Bal à Bougival, 1883
Courtesy Museum of Fine Arts, Boston. Bequest of
Hannah Mercy Edwards in memory of her mother.

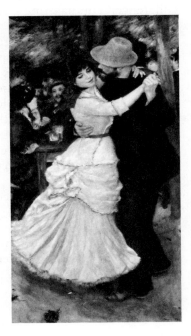

ness of the line of focus allows a slow, leisurely movement through the painting, taking in each portion thoroughly. The figures are the center of attention, due to their size and their central position. The subtle use of color in their clothing tempts the eye back and forth from cool blues and greens on the man to warm pinks and soft whites on the woman. The cigarette butts and matches scattered at their feet distract the eye for a moment, then the sweep of the woman's skirt leads the viewer to the left and up into the middle ground. Cutting the skirt off slightly at the edge of the canvas enhances the movement and lyricism of the painting.

The middle ground enhances the impression of warm conviviality provided by the couple in the foreground. Various details of the group at the table emerge. The woman is tipping her chair forward in order to hear. The man in a top hat bends close to her for the same reason. The open face of the other man suggests that he is dominating their conversation. The three faces in the middle ground form a triangle, as do the two lower faces and the beer glasses. Each triangle is a stopping place, a place for the eye to rest.

Eventually the blurred leaves of the background assert themselves, suggesting a warm summer breeze. Without hesitation, the eye moves across the canvas, drawn by the red flowers on the hats in the upper right-hand corner. The compositional path began with red and ends with red. A leisurely curve has pleasantly encompassed the major elements of the painting. The composition harmonizes the work without dominating it.

Entrances and exits are particularly important in still lifes and landscapes because there is little narrative content to give the work coherence. The painting's ability to hold the viewer's attention depends on the arrangement of its elements. Willem Kalf, a seventeenth-century Dutch painter who specialized in still lifes of richly set tables, arranged his compositions so that each object would be appreciated fully (Figure 110). The eye is directed by light as objects emerge from the rich darkness. Two diagonals are picked up by the light—the first from lower left to center, the second from the center to the upper left. The brightly colored fruit and the delicate blue porcelain bowl are the first focus. The eye then looks to the two tall vertical glasses and continues out of the painting. The dark background allows the individual objects to stand out and is a foil for their brightness.

A similar concern for compositional order characterizes *A View on a High Road* (Figure 111) by Meindert Hobbema, painted in 1665. Hobbema intends a leisurely tour of his painting with frequent stops at points of interest on the way. The painting begins in a sunlit patch at the lower left where three people sit, apparently in conversation.

110 WILLEM KALF
Still Life, ca. 1665
National Gallery of Art,
Washington.
Gift of Chester Dale.

A man's red coat pulls the eye onto the road, which moves the painting's focus slowly to the background, passing a small pond and a stand of trees. At the end of the road one's attention shifts to the cottages, especially the first one with a couple chatting at the door. The eye moves to the trees whose dominant curve leads into the cloudy sky in the upper right and out of the picture. There are few straight lines, no quick changes of focus, and no consistent diagonal emphasis. The order of composition makes the meaning of Hobbema's painting clear and satisfying.

111 MEINDERT HOBBEMA
A View on a High Road, 1665
National Gallery of Art, Washington.
Andrew W. Mellon Collection.

Vincent van Gogh was looking for an entirely different effect in his painting *The Olive Orchard* in 1889 (Figure 112). The scene is divided horizontally into three segments: field, trees, and sky. There is a central triangular focus provided by a stepladder with three women picking olives from the gnarled trees. The eye is first drawn to the central group, then to the different levels of the background. The picture is linked together vertically by the olive trees themselves, which lead the viewer upwards and eventually out of the painting at the top. This is not, however, a peaceful journey. The individual forms and brushstrokes are twisted and knotted, imparting a tension to the canvas. The artist's choice of composition turns a gentle pastoral moment into a tortured exploration of form and feeling.

Often, contemporary painting is less tightly structured than works from the past, but it is not simply random. One of the characteristics of a good painting, whether past or present, is coherence. There are many ways to achieve coherence and there often is not a single entrance and exit, since artists encourage people to look at their works in different ways. The order of the painting, although less obvious, is nonetheless present. Jackson Pollock's *Number 10* (Figure 113), 1949, often seems random to people when they first see it. It is a **drip** or **splatter painting** in which the paint was dribbled or poured onto the canvas. The shape of the canvas suggests an approach. The work is like a frieze, running from side to side. Wherever the eye enters, it is captured by the complicated rhythms of the colors. When enough time has been spent to appreciate the arrangement of colors and textures, either end provides an exit.

Part of an artist's talent is the ability to create order in his or her work. Order may be achieved by intuition rather than calculation, but it is achieved. The viewer responds to this order and shares the experience of the artist.

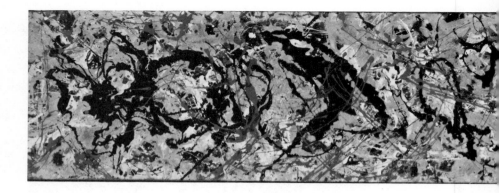

112 VINCENT VAN GOGH
The Olive Orchard, 1889
National Gallery of Art, Washington.
Chester Dale Collection.

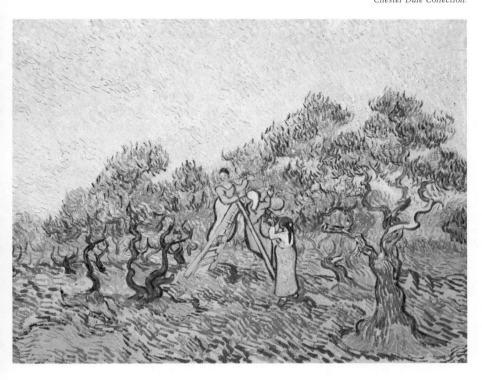

113 JACKSON POLLOCK
Number 10, 1949
Courtesy Museum of Fine Arts, Boston. The
Tompkins Collection and Sophie M. Friedman Fund.

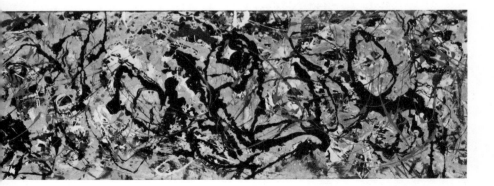

Symmetry and Asymmetry

Part of the effect of a composition depends on balance. There are both symmetrically and asymmetrically balanced compositions, and compositions which derive tension from imbalance. Some modern critics dislike discussing balance because it seems to imply a value judgement. A balanced composition is not necessarily a good one. The use of balance is a factor in determining the impact of some works, and the viewer can understand an object better by being aware of its use.

Symmetrical balance may be the result of parallelism, a compositional device discussed earlier in this chapter. However, a central axis governing the placement of other elements around it is not the only kind of symmetrical composition.

Two large figures that dominate a painting cause symmetry. Degas's *Duke and Duchess of Morbilli,* ca. 1867 (Figure 114), uses this kind of symmetry but avoids a static effect. The painting is divided vertically by the edge of a curtain in the background and by the edge of a tablecloth in the foreground. The diagonal of the Duke's chair suggests depth, as does the highlighting on his hands. A feeling of compartmentalization is avoided by having the Duke reach across the central line and rest his right arm on the table. The Duchess remains within her half but rests her hand on her husband's shoulder to emphasize her connection with his half. The different levels of their heads and their different depths add variety and movement to the painting without destroying its balance.

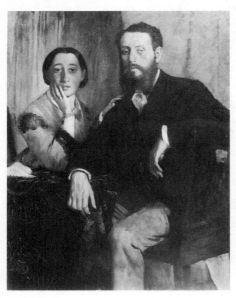

114 EDGAR DEGAS
*Duke and Duchess of Morbilli
(Edmondo and Thérèse),*
ca. 1867
*Courtesy Museum of Fine Arts, Boston.
Gift of Robert Treat Paine, II.*

115 ANTOINE PEVSNER
Column of Peace, 1954
Hirshhorn Museum and Sculpture Garden,
Smithsonian Institution

Antoine Pevsner's bronze sculpture *Column of Peace,* 1954 (Figure 115), uses a similar sort of symmetry. At first the effect of this work is so varied and dynamic that it does not seem symmetrical. But its order is established by two vertical elements which interact with a central space, and like the Morbillis, reach across it to touch. The twisting of the forms and their surface texture fill them with energy and make them look as if they are trying to pull away from each other at the same time as they reach across to one another. The diagonal elements are also symmetrical, beginning together at the base and reversing their angle of movement at the same level. Their peaks are parallel to the verticals, enhancing the sense of unity.

Color can also be used to establish symmetry. Fritz Glarner's *Relational Painting Tondo 20,* 1951–54 (Figure 116), is a round painting, and a more conventional approach would have been to emphasize its shape by using curving forms in the composition. Glarner,

116 FRITZ GLARNER
Relational Painting Tondo 20,
1951–54
Hirshhorn Museum and Sculpture Garden,
Smithsonian Institution

161

however, works with sharp edges and straight flat elements in vivid colors. The center of the painting is the junction of two vertical and two horizontal elements in white and off-whites. There is no sense of a single midpoint, however, because the colors on either side force the eye back and forth across the painting. The colors relate across the center by their repetition, but the left and right sides do not exactly match one another. The two red areas on the upper right relate to the single red on the left. Two yellows on the right are balanced by two yellows on the left. Five black areas on the left recall the four black areas on the right. The two blue patches on the right, however, do not repeat, and keep the work from seeming too precise.

Most architecture, by its functional nature, involves symmetry. Some cultures, like the ancient Greeks, made symmetry a basic principle of their buildings and evolved strict rules of balance and harmony which were rarely broken. At other times, symmetry was less important. A Gothic cathedral provides an interesting example of a variety of approaches to symmetry in one building. The façade of Salisbury Cathedral in England (Figure 117) is basically symmetrical with three major vertical masses, two of which are topped by conical towers and the third by a pediment. The overall effect, however, is not one of clear, symmetrical organization, but of rich variation in shape, texture, and ornament. The entire surface is divided into niches and friezes topped by delicate pointed tracery. Each niche had a sculptured figure. The figures turn, point, gesture, and compete for the viewer's attention. The numerous doorways and windows add to the vibrant busyness. Nor is the façade flat, but is divided into three-dimensional rhythmic spaces by the huge buttresses running from bottom to top. Although Salisbury is one of the most unified of Gothic cathedrals, it is worlds away from the harmony and restrained organization of classical architecture. Each element of the church was prized for itself rather than for its part in symmetrically balanced arrangement.

The lack of emphasis on symmetry at Salisbury was the result of theological considerations. However, asymmetry is sometimes used for art alone. The artist uses unequal balance to achieve certain spatial effects—a sense of movement or tension. Chardin, the eighteenth-century French still-life and genre painter, was a master of composition. Later artists like Picasso collected Chardin's works and

117 Façade of Salisbury Cathedral,
13th century
Photo by Fred Hanhisalo

were influenced by his ideas. In paintings like *The Teapot*, 1764 (Figure 118), Chardin gives life to inanimate subjects by creative use of unequal balance. At first glance *The Teapot* looks simple. A big earthenware teapot, two chestnuts, grapes, and a pear are arranged on a shelf. The light on the teapot makes it the primary focus and an indicator of depth. It is balanced by the smaller vertical of the pear. The chestnuts and the single grape open up the composition to the edges of the canvas. The success of a composition can be tested by trying to remove any one element. In this case, everything contributes to the success of the painting. If even one separate grape were taken out, it would work less satisfactorily.

Seventeenth-century Dutch landscape painters used a similar balance. Jacob van Ruisdael, in his 1670 work, *A Rough Sea* (Figure 119), wanted to fill his canvas with the turmoil of a stormy sea. The wind blows from left to right, filling the sails of the small ships and hurrying them through the whitecaps. The sky is filled with thick dark clouds and only a blue strip running horizontally indicates that the storm is over. Three groups of objects are used to balance one another both horizontally and in depth. The wooden posts in the left foreground, perhaps part of an old pier, are balanced by the highlighted white sail on the ship in the middle ground and the group of vessels behind it. This is precisely the same as Chardin's teapot and pear, except that the depths indicated are far greater. Without the posts, the ships look far closer and the painting seems too cramped and friezelike. The main group of ships on the right are again balanced by the purple and red sails of the smaller group on the left. This left–right, right–left movement draws the eye through the picture without a direct line from one element to another. A more symmetrical arrangement would have been inappropriate to the subject, lessening the openness and atmospheric quality of Ruisdael's painting.

118 JEAN SIMEON CHARDIN
The Teapot, 1764
Courtesy Museum of Fine Arts, Boston.
Gift of Martin Brimmer.

Hans Hofmann used asymmetrical balance in his painting *Oceanic*, 1958 (Figure 120). Colors rather than forms provide the balance. The yellow and green hues on the left foreground give weight to that side of the painting. The blue of the upper right is not enough to balance that weight and the painting could have looked crowded. Hoffmann fills his canvas by adding the yellow, green, and black patch, which seems to hover in the blue. This patch is in the same relationship to the larger mass as the white-sailed boat to the posts or the pear to the teapot. The two elements play off one another, moving the eye back and forth between them and making a physically static art form seem dynamic and full of change.

119 JACOB VAN RUISDAEL
A Rough Sea, ca. 1670
Courtesy Museum of Fine Arts, Boston.
William Francis Warden Fund.

120 HANS HOFMANN
Oceanic, 1958
Hirshhorn Museum and Sculpture Garden,
Smithsonian Institution

121 ALEXANDER CALDER
Mobile-Stabile, 1950
Hirshhorn Museum and Sculpture Garden,
Smithsonian Institution

In sculpture, Alexander Calder based a great many of his mobiles on asymmetrical balance. They were carefully balanced to move without artificial help and to give the viewer a constantly shifting and changing visual experience. *Mobile–Stabile,* a sheet metal and rod construction from 1950 (Figure 121) is an example. This is partially a stabile, resting on the ground, and partly a mobile, hanging in the air. The balance is between the blue plaques on the left and the red one on the right. *Mobile–Stabile* cuts through the air, related to but not tied to the earth beneath it. It seems to fly or dance with an energy supplied by the subtle balance that holds it together.

EXERCISES

Color
To really understand color, you have to experiment. For less than ten dollars, you can get a set of watercolors, a brush, and some paper. An alternative is to buy a set of good-quality marking pens.

1. Start by putting pure color on white paper. How do the various hues look?
2. Next, darken the paper with a wash of black or violet. Marking pen ink can be diluted by dipping the tip of the pen briefly in water. Paint over the darkened area with pure color. How does changing the value of a hue change its appearance?
3. Paint parallel stripes of a hue on white paper and then paint varying amounts of its complement over it. Note the effect of complements on one another.
4. Paint more stripes. Then paint over them with the same color. You have changed the saturation of the colors.
5. Try different combinations and juxtapositions of hues. Decide which ones are pleasing and which are jarring. Notice what combinations seem more natural to the eye than others.

If you are using watercolors and brush, be sure to clean the brush thoroughly between each color and to mix colors on a clean surface.

Sculpture in the Round
Be sure to walk around the object and evaluate it from all sides.

1. What am I looking at? Is there an order in which my eye is drawn to parts of the object?
2. What does the order in which the eye moves tell about the artist's intentions?
3. Is this sculpture meant to be seen from one angle or from all sides? How can you tell?
4. Does it work better inside a room or outside in natural light? Granted, you can not move the object. Evaluate the part lighting plays in its impact.
5. Are the surfaces themselves interesting? Is there a variety of textures? Are the physical elements subordinated to the subject?
6. Is it painted? Does color make a difference? How?
7. What is the size of the sculpture? The mass? The volume? How does this affect its impact on the viewer?
8. How does the eye move from one part to another? Are the transitions abrupt or gentle?
9. What does the appearance of this work tell about its purpose?

Architecture
1. Examine the exterior of a building. Does it tell you what kind of a building it is?
2. Does the exterior tell what the interior will look like?
3. Is the building welcoming? Are the entrances clear and inviting?
4. What size is the building? Is it impressively large or smaller and more intimate in scale?
5. Go inside. Is the interior arrangement clear? Do you know which direction to go in? How do you know this?
6. Is it plain or heavily ornamented? What difference does this make?
7. Does the decoration of the building seem appropriate to its function?
8. What part does light play?

Part Three
IMPACT

The impact of a work of art depends on many variables. The background and personality of the viewer affect all his or her perceptions. Each person has an educational background, experiences, opinions, ideals, and beliefs that effect how he or she perceives reality. No two people will have precisely the same experience of a work of art, although many will react in a similar fashion. The cultural context of the viewer and of the object also makes a difference. A person from a close-knit religious culture will see things differently from someone belonging to a pluralistic, secular society. An object that is closely tied to a specific social situation will not easily reach those in other situations. Conversely, a truly great work of art reaches across cultural and historical barriers.

Innovation is often a barrier to understanding and appreciating a work of art. When Impressionism was new, people reviled it. A newspaper cartoon of the time showed a policeman barring a pregnant woman from an Impressionist exhibition to prevent the paintings from harming the baby. Cubism was equally suspect. In the early 1900s, outraged Philadelphia art lovers hanged a Cubist painter in effigy. Many people react negatively to contemporary abstract art. Its unfamiliarity seems threatening and the effort to understand does not seem worthwhile. Increasingly ingrown and self-indulgent critics have added to the problem, implying that anyone who does not grasp the latest thing is somehow mentally or morally deficient.

Works from the past can also be difficult to understand without knowing their historical situation. Although it is possible to appreciate a work of art without having information about it, some works are far easier to approach through their background. Whole galleries in art museums lie empty except for school groups and art students because the public does not know about the art they contain.

The physical qualities of an art object influence how people react to it. Size is a factor to be taken into consideration. For millennia architects have known that a large building is impressive and hints at important functions inside. A huge sculpture can not be ignored and may gain attention where a small piece would not. Contemporary painters do immense canvases that can not be seen fully without walking back and forth in front of them. Small objects, on the other hand, often seem more accessible and intimate. A miniature painting on ivory can be best appreciated by one person at a time. A tiny carved amulet is for only one wearer. Crowds are discouraged by a small building.

Sometimes a work of art is intended for the ages. The artist works not for the audience of his or her own day, but for audiences who have yet to be born. Materials are chosen for permanence, and features that are too specific are eliminated. Such works, if they are successful, will move a contemporary viewer as much as they did one millennium ago. Ancient Egyptian art, for instance, has maintained its power and reaches audiences separated from it by both time and place. Other works are intended for a specific function peculiar to their culture of origin. When they are appreciated today, it is almost in spite of their original intent. Qualities that may have been peripheral to the artist give the works new interest to later audiences.

Most of twentieth-century art has been abstract. Thus, for many people, abstraction seems a uniquely contemporary feature. Historically, the choice between realism and abstraction has been made by all cultures in terms of their basic goals and needs. Neither type of art represents progress or improvement over the other. Basic problems are repeatedly resolved in similar ways, with differences in detail depending on time and place. Realism and abstraction in art tell a good deal about cultural background, and have to be understood quite differently.

The aesthetic value of a work of art is not established by its historical background, size, specificity, realism, or abstraction. It is relatively easy to tell whether a work is technically good, but some of the finest technical works fall flat. Sometimes an object works despite obvious technical failings. People talk about inspiration and genius; Michelangelo and Rembrandt are universally respected, even by

people who do not like their works. The most common question in contemporary galleries is "What is *that* doing in a museum?"

There is no definitive answer. Everyone will appreciate some works but not others. However, works which have survived the test of time can be used as a benchmark for evaluating contemporary art and as a means for educating one's taste in art.

8
Concrete
Qualities
of a Work

Familiarity and Innovation _____

The historical and cultural context of a work of art influences its impact on twentieth-century viewers. A truly great work overcomes these factors and appeals directly to our very humanity. However many good works fail to speak to us because their cultural context differs too greatly from today's. Much of the art of the past was religious; in today's secular society its pertinence is somewhat lessened.

The bronze statuette of *Hermes Kriophoros* in Figure 122 was cast in the Archaic period. It is a small piece, about 8 inches high, showing the messenger god with a small figure of a ram under his left arm. At one time he held a staff in his right hand. To an ancient Greek this statue would have brought to mind numerous stories about Hermes. His significance as a shepherd and protector of flocks is stressed here, but people would also remember his association with commerce, persuasiveness, and trickery. Most modern people, however, would not be able to identify the god as represented here without the familiar attributes of winged hat and sandals. The skill with which the *Hermes* was executed makes it attractive to modern eyes, as does its charming face with large eyes and a gentle smile. It is impossible today, though, to experience it in the same way that the ancient Greek observer did.

122 Greek
Hermes Kriophoros,
Archaic Period, 520–10 B.C.
Courtesy Museum of Fine Arts, Boston.
H.L. Pierce Fund.

RELIGIOUS ART

Westerners find it difficult to appreciate Asiatic art without having some background in the subject. Many people today are attracted by the culture and art of the Far East and make it a point to study them; but without such study, a work like the *Batō Kannon* (Figure 123), a twelfth-century Japanese painting in ink, colors, and gold on silk is mysterious although intriguing. At first, one is attracted by the complicated draftsmanship and skillful use of color in this finely crafted painting. However, to a non-Buddhist, the significance of the multi-headed and armed figure, of his throne, and of the canopy of flowers over him, is not obvious. It helps to discover that the figure is a bodhisattva, a spiritual being who has given up salvation to work for the enlightenment of all living beings. This particular bodhisattva is assigned to the realm of animals, as the horse's head in the center of his halo indicates. To really understand the *Batō Kannon*, however, it would be necessary to make an extensive study of Buddhism.

Even Christian art, although in general more familiar to western viewers, is not always self-explanatory. The Roman Catholic church, in particular, has been aware of this problem and has attempted in various ways to make religious art more relevant to viewers. One custom that often puzzles modern observers is that of showing religious personalities in the clothing and backgrounds of the time of the painting or sculpture, as in Rogier van der Weyden's *St. George and the Dragon* (Figure 124) from fifteenth-century Flanders. Factual information about St. George is scarce, but the most reliable records indicate that he was martyred in Palestine in the fourth century A.D. Van der Weyden's version, however, is a medieval fantasy of St. George in full armor, astride a white charger, pinning the dragon with his spear. Off to the left, a lady in an elaborate court gown and head-dress kneels in prayer. She is a princess who was to be sacrificed to the dragon. Their setting has nothing to do with Palestine. Behind a series of low green hills, a walled town on a seacoast is overlooked by

123 Japanese
Batō Kannon, 12th century
Courtesy Museum of Fine Arts, Boston.
Fenollosa-Weld Collection.

124
ROGIER VAN DER WEYDEN
St. George and the Dragon,
ca. 1432
National Gallery of Art, Washington.
Ailsa Mellon Bruce Fund.

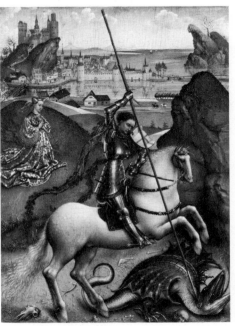

a Disneylike castle on a mountaintop. The buildings are done with the utmost clarity and attention to detail, and scores of tiny people inhabit the sun-drenched, magical town.

Today's viewer may well be troubled by this mixture of fact and fantasy. We know something about the historical settings of religious stories and expect them to be accurately represented in paintings. In the fifteenth century, however, archaeology did not exist and historical knowledge was scanty. Furthermore, it probably would not have mattered if they had known more about the factual St. George. Van der Weyden was painting for a sophisticated audience at the Burgundian court and wanted the painting to reach people who thought that a hero was a knight in armor and that a princess looked like one of them. A factual rendering would have made the story remote and irrelevant. Van der Weyden's point was his content. It would not have been a successful painting, no matter how fine it was in aesthetic terms, if it had not communicated the religious subject forcefully to its audience. By giving them a world they understood, he made the story memorable and significant.

The sixteenth-century Roman Catholic Council of Trent dealt directly with the problem of the religious content of works of art. It declared that religious art should be done in a way that would make it immediately accessible to the worshiper. The council forbade grandeur for its own sake, irrelevant detail, additions to stories, distortions, and individual interpretations. The person confronted with a religious work should become part of the incident portrayed and have his or her faith strengthened from this contact. The Italian Baroque painter Caravaggio, who was discussed on p. 132 (Figure 84), was the first to follow Trent's directions, but others followed his lead. Particularly in northern Europe, French painters like Louis and Matthieu Le Nain, and Dutch artists like Rembrandt, Terbrugghen, and van Honthorst created small-scale scenes whose intimacy encouraged a sense of participation in viewers.

SECULAR ART
Secular art can also be difficult to understand if it portrays people and events that are no longer common knowledge. Scenes of battles that were once of great importance are often meaningless to later people. Portraits can be lessened by anonymity unless they are of the first order of quality. However, a lot of such art can still be a fascinating and worthwhile experience to the person who makes the effort to understand. Adult education courses in art appreciation, lecture series at museums, libraries, and historical societies are good sources of the kind of information that makes unfamiliar works of art come alive.

DISTRUST OF THE NEW

Some works of art are difficult to appreciate because of remoteness, whether of time or of culture. Others are equally enigmatic because they are new. People are usually slow to appreciate innovations in the arts. The works of the recent past are comfortable and offer nothing unexpected. Artists who rebel and who startle the public with totally unfamiliar concepts are rejected by the majority of art lovers. This is by no means a new phenomenon; to suspect the unfamiliar is a human characteristic.

In the first century B.C. the Roman writer Vitruvius bemoaned the decadence of painting. The new art was corrupting the Roman youth and did not look like anything he had ever seen.

> But these subjects which were copied from actual realities are scorned in these days of bad taste. We now have fresco paintings of monstrosities, rather than truthful representations of definite things. For instance, reeds are put in the place of columns, fluted appendages with curly leaves and volutes, instead of pediments, candelabra supporting representations of shrines, and on top of their pediments numerous tender stalks and volutes growing up from the roots and having human figures senselessly seated upon them; sometimes stalks having only half-length figures, some with human heads, others with the heads of animals.
>
> Such things do not exist and cannot exist and never have existed.*

With but a few changes that passage could have come from the reactions of modern viewers to works of contemporary abstract painting.

Distrust of innovation is usually based on taste, on having comfortable assumptions challenged; but at one point in history it was the result of catastrophe. The early 1300s were a time of great experimentation and discovery in Italy. The artists of Siena and Florence were producing works of originality, expressiveness, and technical innovation. The rigid symbolic patterns of the Middle Ages were being abandoned as the first stirrings of Renaissance humanism made themselves felt. Giotto was the leader and the most revolutionary of these artists. His panel painting, *The Presentation of the Infant Jesus in the Temple* (Figure 125), painted in the early 1300s, shows his originality. Instead of the floating insubstantial figures of medieval painting, Giotto's people are heavy and three-dimensional. They do not hang in space, but walk confidently through their world. St. Simeon and the prophetess Anna, on the right, are handing the Infant Jesus to Mary and Joseph on the left. The mosaic floor and the temple build-

*Vitruvius, *The Ten Books on Architecture,* trans. Morris Hicky Morgan. New York: Dover Publications, Inc., 1960, p. 211.

125 GIOTTO
The Presentation of the Infant Jesus in the Temple, early 14th century
Isabella Stewart Gardner Museum, Boston

ing are in perspective, although it is not a consistent or completely convincing three-dimensional effect. The major imbalance in the painting is the relative proportions of people and architecture. The temple is merely suggested by a skeletal framework and its size prohibits any believable movement within it. Despite this, the realism of the figures, their interaction with one another, and the feeling of movement are all revolutionary departures from the works of previous centuries.

The experiments of early trecento (fourteenth-century) art were brought to an abrupt and terrible end by the bubonic plague of 1348.

> *There is no accurate way of measuring the human toll; estimates vary from a conservative fifty-eight percent mortality in (Florence and Siena) to seventy-five or even eighty percent of the population, all swept away in one hot, terrible summer.* *

Most of the major artists of the time died in that three-month period; those who survived rejected the new ways for being a possible cause of the disaster.

> *The demands for works of art seem also to have changed radically. In the general wave of self-castigation which follows catastrophe, religion offered an explanation in terms of divine wrath, as well as a refuge from the consequences of that wrath. On all counts the ground was prepared for the growth of a new style, which rejected as perilous the deep humanity and explorative naturalism of the early Trecento and turned toward both the supernatural and the Italo-Byzantine past, surviving from an era that must have seemed to many more secure, because less adventurous.* †

*Frederick Hartt, *History of Italian Renaissance Art.* New York: Harry N. Abrams, Inc., 1974, p. 94.
†*Ibid.*

The bubonic plague of 1348 probably postponed the Italian Renaissance for half a century because people feared doing anything that might trigger its return.

Today radical departures from the norm may bring negative critical reaction; in the past innovation could be dangerous to the artist. In the sixteenth century, the Venetian painter Paolo Veronese was called before the Inquisition to answer for unacceptable elements in a version of the Last Supper he had painted for a church. The inquisitors were particularly enraged about the inclusion of figures that do not appear in the Biblical descriptions of the Last Supper.

> **Q.** *Does it seem fitting at the Last Supper of the Lord to paint buffoons, drunkards, Germans, dwarfs and similar vulgarities?*
>
> **A.** *No, milords.*
>
> **Q.** *Do you not know that in Germany and in other places infected with heresy it is customary with various pictures full of scurrilousness and similar inventions to mock, vituperate, and scorn the things of the Holy Catholic Church in order to teach bad doctrines to foolish and ignorant people?* *

A work of art that violates established conventions is a work of art that corrupts the viewer and weakens society. As Vitruvius objected to abstraction, so the inquisitors oppose artistic exploration as a threat to religion. Veronese, in a slightly earlier part of his trial, answered this argument briefly and succinctly.

> **Q.** *Are not the decorations which you painters are accustomed to add to paintings or pictures supposed to be suitable and proper to the subject and the principal figures or are they for pleasure—simply what comes to your imagination without any discretion or judiciousness?*
>
> **A.** *I paint pictures as I see fit and as well as my talent permits.†*

Veronese's answer provides the key to the difference between the artist's and the layman's approach to change. The artist pushes his talent to its limits; if the results are not what the public expects, it is too bad for them. Throughout history there has been a tension between the expectations of patrons and the public and the creative direction of artists. Despite social strictures, critical denigration, and even threats, artists have pursued their own vision. The challenge to the viewer is to understand that vision and benefit from it to the greatest possible extent.

*Elizabeth Gilmore Holt, ed., *Documentary History of Art*, Vols. 1 and 2. Copyright 1947, © 1958 by Princeton University Press. Selection from Vol. 2 (p. 69) reprinted by permission of Princeton University Press.

†*Ibid.*, p. 69.

The rapid changes in the visual arts in the nineteenth century met with considerable critical resistance. Impressionism was thought to be trivial, sloppy, and corrupt. The Post-Impressionists suffered from the same reaction, causing Gauguin to strike back. In a letter written in 1901, Gauguin compared himself to a traditional painter named Puvis de Chavannes.

> *Without going into detail, there is a world of difference between Puvis and me. Puvis as a painter is a scholar, but not literary; whereas I am not a scholar, but maybe I am literary.*
>
> *Why, when he looks a painting, does a critic have to have points for comparison with the old ideas of other painters? When he doesn't find what he thinks ought to be there, he stops understanding and isn't moved.**

Gauguin's point, that a critic rejects something because it does not contain what he or she expects, is important. A person tends to bring everything to a work of art except openness to its individual meaning. When something is not what was expected or wanted, it is unacceptable.

Most movements of twentieth-century art have met with considerable resistance. Jackson Pollock's free use of paint in a splatter technique earned him the title "Jack the Dripper." Cartoonists have had a splendid time with everyone from Picasso to Henry Moore. It is, however, a lot easier to satirize something than it is to understand it. There is no doubt that a lot of art that is being done today will not be highly regarded in the future. Much of it, intentionally and unintentionally, will not survive the present day. The difficulty is that no one alive today will get the benefit of long-range judgments. It is to our benefit to be as open as possible.

While it is important for everyone who is interested in art to try to respond intelligently to contemporary activity, it is especially important for the collector. Great collections of French Impressionist art were acquired by Americans in the years before Impressionism became popular. Such collectors relied upon the advice of experts, but they also trusted their own instincts. I am not urging people to join in with the latest fashions of the New York art scene. On the contrary, it is up to every intelligent viewer to see as much as possible, read the applicable literature, listen to the experts, and then evaluate the success of an individual object.

*Letter from Paul Gauguin to Charles Morice, July, 1901. In the collection of the Museum of Fine Arts, Boston.

Large and Small Scale

The size of an object influences its impact on the viewer. Certain psychological responses to size are natural. People are impressed, even awed, by the gigantic. Small objects, on the other hand, have an intimacy which invites close contemplation by small numbers, preferably by one person.

Architects use the human tendency to equate size with importance. From the outside, the pyramids of the ancient Egyptians look big enough to hold all the wealth of Pharaoh's kingdom. Actually, they are mostly solid stone with a few interior chambers connected by corridors and a single underground treasury. The same amount of useful space could have been enclosed in a considerably smaller building, but it would have lacked grandeur and authority. The pyramid is a symbol of the greatness of the king far more than it is a useful building.

Palaces have usually been huge—suitable for the occupation of the select few who would be at home in such surroundings. The gap between ruler and subject is made tangible by the differing sizes of their homes. Temples and cathedrals were built in vast dimensions to honor the deities to whom they were dedicated and to give satisfaction to their mortal builders. Government buildings are big, and status is measured in some corporations by the size of one's office or even by the extent of one's desk top.

SCULPTURE

In sculpture, the choice of material limits size. The best material for colossi is hollow metal. The legendary Colossus of Rhodes would have been a hollow-cast bronze, and the American Statue of Liberty is made of sheet copper. Giant stone statues are too heavy to be stable and can fall very easily. A marble of the fourth-century Roman Emperor Constantine stood at least 40 feet in height. Today, only the head, an elbow, a knee, and one hand remain of its mammoth glory.

Bernini, the leading sculptor of the Italian Baroque, was more successful in his large stone sculptures. His marble Longinus (*bozzetto*, Figure 24) carved for the crossing of St. Peter's in Rome, is 14½ feet tall. The saint is shown at the moment of his conversion to Christianity, throwing his arms out in a dramatic recognition of Christ's divinity. The size of the work presented some interesting problems. Because the head is so far from the viewer, it would appear to be small if it were in proportion to the rest of the body. Therefore, it is exaggeratedly large and cants forward on the neck so that the

face is clear from below. The flesh and cloth surfaces are given texture by parallel striations dug into the stone. Otherwise, they would be characterless expanses of marble. The carving on the hair and beard is very deep, as is that of the nostrils, causing striking contrasts of light and shadow which can be seen from floor level. Bernini also created the enormous Baldacchino and Cathedra, the canopy over the altar and bishop's throne for St. Peter's, but these are almost architectural and are not meant to be viewed in a strictly sculptural way. Bernini's oversized works were done to harmonize with their surroundings and to represent the majesty of the Roman Catholic Church.

PAINTINGS

In the past, large-scale paintings were mostly frescoes and were found on the walls of churches and palaces. Their compositions were simplified to be comprehensible from a distance, and their main purpose was the education and enlightenment of the viewer. Today many painters choose to paint on canvases so large that they would not fit in any but the grandest homes. Unlike artists in the past, these painters do not feel an obligation to fit their works into the environments of their patrons.

A large contemporary painting is an integral part of the space it occupies. It is not a decoration or part of an ensemble. There are sometimes newspaper ads for paintings in all sizes and shapes, one to match every sofa. This is precisely what the serious painter wants to avoid. To appreciate such monumental canvases, the viewer has to take time to walk in front of it and look at it sequentially. Standing back far enough to grasp the whole obscures the details. Moving enough to examine the painting both closely and from a distance is necessary for a full understanding. The best environment for such paintings is a museum gallery with little or no furniture and a good source of natural light.

Smallness, on the other hand, suggests intimacy, manageability, and a one-to-one relationship between object and viewer. It does not imply triviality any more than bigness guarantees importance. A small object is not as immediately arresting as a large one. Very often museum visitors miss some of the finest works because they are not looking for the miniature.

JEWELRY

Fine works of jewelry sometimes achieve the rank of sculpture. The ancient Greeks, with their perfectionism in all things, saw no reason not to apply the same standards to an earring cast in gold that they would to a large bronze. An example is *Nike Driving a Biga* from the fourth century B.C. (Figure 126). The earring was probably intended

126 Greek
Nike Driving a Biga, 4th century B.C.
Courtesy Museum of Fine Arts, Boston.
H.L. Pierce Fund.

to be worn by a statue of the goddess Athena and was originally one of a pair. The goddess of victory is shown in her golden chariot, urging the horses upward into the heavens. The detail on the figure of the goddess, the delicate feathers of her wings, the concentrated expression on her face are remarkable. The horses are similarly fine and the chariot is equipped with a functional axle. The horses are harnessed with gold reigns held lightly by their driver. Both in its technical perfection and in its energy and vividness, this is a memorable work of sculpture.

SMALL WORKS
It is also possible for a small work to achieve a monumental sense of dignity. The ivory snake goddess in Figure 127 was carved around 1500 B.C. on the island of Crete. She is 6½ inches tall, wears a long skirt trimmed with gold, and a bolero jacket; two golden snakes twine around her arms. Her graceful silhouette is clean and simple as she leans forward to meet the upward gaze of her worshipers. At one

127 Minoan
Snake Goddess, ca. 1600–1500 B.C.
Courtesy Museum of Fine Arts, Boston.
Gift of Mrs. W. Scott Fitz.

time, the snake goddess wore a golden crown, the holes for which still remain. She was probably part of a shrine, and there is an indication that she was fastened to some sort of backing. When she is shown in reproduction, particularly as a slide, the only clue to her size is the material. Her personality is that of a large-scale figure and the artist gave her as much impact as any large sculpture.

In the medieval world small objects were frequently made for religious usage. Reliquaries (boxes to hold holy objects), amulets, aquamaniles (holy water pitchers), crosses, book covers, and the like were crafted with the utmost care and skill. Bibles themselves were hand-painted or illuminated with single letters turned into magnificent flights of fancy. The Early Middle Ages were once called the Dark Ages in art history because of a lack of large-scale art, with the exception of some architecture. Today scholars realize that the sculptors worked in gold, silver and enamel rather than marble and bronze. The painters illuminated scrolls and bound books rather than painting on walls or panels. The nomadic life of many groups of the time made it vital that their objects of art be portable.

More recently, miniature painting on ivory or metal has been fashionable. Although tempera and other media have been used, most miniatures have been watercolors since the eighteenth century. They are usually encased in gold frames and protected by glass. Portraits were the most popular subjects for miniatures, but landscapes and still lifes were also painted.

The ivory miniature of *Joel Barlow* (Figure 128), painted by the early-nineteenth-century painter William Dunlap, is typical. This tiny oval painting, done in watercolor, shows Barlow in a bust-length

128 WILLIAM DUNLAP
Joel Barlow, ca. 1805–11
National Portrait Gallery,
Smithsonian Institution, Washington, D.C.

pose against a hazy background. The facial features and ruffles at his throat are done in painstaking detail. The work was meant to be held closely by the observer and examined minutely. An artist working under such circumstances has to think in an entirely different way than one who is working on a large scale. He or she must assume that the miniature will be examined frequently, so it has to maintain its integrity over a period of time. A large painting can make a bold, immediate statement, but a miniature must sustain the interest and appreciation of numerous individuals because such paintings were passed down through generations and treasured as part of the family's past.

The size of a work affects the artist's approach and the viewer's reaction. The best works make their size an asset by using techniques suitable to that size.

General and Specific Aspects

The artist's choice of materials is partly determined by their durability. Some works are meant to last for centuries; others, for only a short time. The intended audience for many artists of the past was the generations to come. Today works are often intended to address immediate concerns. Any relevance the work may have to future viewers is fortuitous, if not undesirable.

The sculpture and architecture of antiquity were often designed for permanence; their survival today is proof of success. Egyptian sculptors worked in granite, slate, schist, and other stones which are almost indestructible, though difficult to carve. Some Egyptian sculptures have endured fire, vandalism, robbery, and floods. The sculptors took few chances with their carving and left figures' hands clenched in unbreakable fists or attached to the body. Sculptures were usually left partly in the form of the stone block with nothing unncessarily exposed to breakage. Duplicating sculptures in quantity was another bid for immortality. Even if some were lost or destroyed, some would survive. The artists of ancient Egypt were also careful to give their work universal appeal. Although much of Egyptian art is related to their religious beliefs, it reaches beyond their beliefs to fascinate people today. In addition, it is an awe-inspiring experience to stand in front of an object that was in existence four millennia ago. The twentieth-century viewer takes the place of the ancient one, and in a way, time is compressed and the tremendously old seems more accessible.

The Greeks and Romans used durable stone for their sculpture, especially the wide variety of marbles available in both countries.

Their architecture was built for stability and a great deal of it remains today.

Churches are dedicated to the eternal and must endure as testimony to the validity of faith. The cathedrals of the Middle Ages survived the centuries, proof of the skill and optimism of their builders. Religious painting in the Renaissance was done in the lasting tempera and fresco media. Only gradually did artists accept the more perishable oil paints.

In the nineteenth century, artistic emphasis shifted to the transitory. With the coming of realism and then Impressionism, art became concerned with immediacy and spontaneity rather than with permanence. The public was slow to accept this change. Manet's *Olympia* shocked the mid-nineteenth-century French audiences, not because it was a nude, but because it was a specific woman, looking directly at the viewer. A nude that represented the ideal of beauty was acceptable because it was impersonal. A real woman without her clothes on was shocking and obscene.

Today not only the ideas but even the materials of art are often of short duration and limited appeal. Sculptures of cardboard, dirt, and even ice are created. Paintings are done on unprimed canvases and denied the protection of varnish. The hectic pace of the second half of the twentieth century and the pervasive uncertainty about the future make eternity a doubtful concept. Much modern art aims at a momentary effect or speaks to a specific issue rather than trying to survive to a doubtful future.

Nowhere is the contrast between a general and a specific approach to art more obvious than in portraiture. Many works that are called portraits are actually not intended to accurately depict a specific individual. Instead, they are aimed at impressing the viewer with the status, wealth, or importance of the subject. Court painters, like Velazquez, beautified their subjects, deleting any details that would detract from their lordly mien. Society portraitists have always idealized their subjects for practical reasons. Few wealthy patrons would recommend an artist who exposed his or her failings.

Figure 129 shows an idealized portrait in marble of Augustus, the first Emperor of Rome. This head was done in the second century A.D., more than a hundred years after Augustus' death, when the Roman people had given him the symbolic importance that George Washington has for Americans. The artist tried to show this idealized concept, yet it is not like a statue of an Egyptian pharaoh, so general that it needs a label to identify it. Augustus' features remain, but with no suggestion of human fallibility. His face is smooth and serene, his hair elegantly curled, his features strong. This portrait

shows a mature person, although of no specific age, whose forceful yet beautiful face is perfect for a respected leader.

Jacques-Louis David sought a similar effect in his painting, *Napoleon in His Study*, 1812 (Figure 130). The portrayal of Napoleon is reasonably factual, although his pose makes him appear taller than he was. His face, while idealized, is recognizable, and his thinning hair and chunky body are revealed.

The emperor's power and grandeur are suggested by his surroundings rather than by his person. The desk, chair, lamp, and clock are all of expensive, lavish materials. The hands of the clock point to four; the guttering candle suggests that it is morning. The documents on Napoleon's desk show that the emperor has worked through the night for the good of France. Always the soldier, he has his sword close at hand. Despite the detailed setting, Napoleon dominates the painting. Warm light picks out the details of his figure. The painting is a superb mixture of realistic observation and carefully contrived imagery.

129 Roman
Augustus from Arriccia,
2nd century A.D.
Courtesy Musuem of Fine Arts, Boston.
H.L. Pierce Fund.

130 JACQUES-LOUIS DAVID
Napoleon in His Study, 1812
National Gallery of Art, Washington.
Samuel H. Kress Collection.

131 ANDREA DEL VERROCCHIO
Lorenzo de'Medici, 15th century
National Gallery of Art, Washington,
Samuel H. Kress Collection.

The opposite approach concentrates on the personality of the sitter and derives its impact from psychological analysis and detailed observations. Verrocchio's fifteenth-century portrait of Lorenzo de Medici (Figure 131) is a startlingly precise depiction of the great Florentine patron of the arts. Lorenzo was called "The Magnificent," and was the richest, most influential man of his time; yet Verrocchio shows him without a trace of idealism. The bust-length bronze shows Lorenzo dressed simply and without jewels, furs, or other status symbols. His face is plain, even homely, with its large twisted nose, squinting eyes, and jutting chin. That Lorenzo de Medici permitted such a portrait is very revealing. Verrocchio has shown a man of such supreme self-confidence that he needs neither trappings nor beauty.

Few artists have delved as deeply into portraiture as Rembrandt. For Rembrandt, facial expression had to reveal the personality of the sitter. Lighting, color, and brushwork work together to emphasize the face and delineate the personality. In his *Self-Portrait* from 1659 (Figure 132 and page 168), Rembrandt caught the essence of his struggle to understand human nature. The artist was fifty-three and past the peak of his popularity. He had decided to sacrifice popular acclaim to pursue his own truth. There is no setting in the painting, only a softly shadowed ambiguous space which seems to flow around the indistinct figure of the artist. His hands are dimly lit and provide a secondary focus to the detail on the face. As one critic put it,

132 REMBRANDT VAN RIJN
Self-Portrait, 1659
National Gallery of Art, Washington.
Andrew W. Mellon Collection.

*In this self-portrait we are shown both his flesh and his spirit, yet Rembrandt eludes our grasp, for his personality is stronger than our capacity to apprehend. He who looks into this face of Rembrandt will have an uneasy sense that he is judged in return.**

Printed and sculpted portraits have been replaced to a large extent by the photographic portrait. Most major contemporary artists avoid portraiture, preferring to use the human figure in symbolic or abstract ways.

Another way in which art tries to move beyond the specific is through revival movements in architecture. When an architect builds in a manner that brings to mind other cultures and time, he or she is tying the present to the past. Today, this approach is in disfavor, being regarded as derivative and unimaginative. Revival architecture assumes an educated public to whom the historical references would be clear. Much of the contemporary dislike of such buildings originates with people's lack of information.

Although there have been architectural revivals all through history, the nineteenth century stands out as completely revival-oriented. This was a time of transition from the agricultural past to the industrialized future. Change was happening more swiftly than in any previous era, and people were insecure in their lifestyles. The

*Thomas P. Baird, *Dutch Painting in the National Gallery of Art.* Washington, D.C.: National Gallery of Art, 1960, p. 14.

French and American revolutions undermined the hierarchy of privilege and overthrew the political order that had stood for centuries. In such a situation, revivals of architecture give validity to the new order by tying it to positive values from the past.

The predominant revival was classicism. Thomas Jefferson traveled to Greece and Italy, and found in their ruins a reflection of mankind's noblest aspirations. The clean lines and elegant proportions of ancient architecture contrasted favorably with the lavish buildings of the prerevolutionary aristocrats of Europe and America. With little regard for actual history, Jefferson and others copied ancient architectural styles and individual buildings as symbols of the replacement of the old aristocracy with new, more democratic societies. There are few European or American cities that lack churches, libraries, government buildings, or universities that look like Greek and Roman temples. Washington, D.C. is a neoclassical city. It is only within the last few decades that the U.S. capitol has had public architecture that was not derived from the classical past.

Medieval church architecture, particularly the Gothic, was also revived. To inhabitants of the industrial age, the unquestioning faith of the middle ages seemed admirable and they emulated it in their churches. Few Gothic revival buildings are actually based on Gothic structural techniques, but they have the outward appearance of the originals.

Twentieth-century architecture concentrates on innovation rather than revival. There has been a self-absorption and a lack of interest in the past that is expressed in the glass and steel towers of today. Newness is valued for its own sake, and the fashions of the moment dominate. Much of America's own past has been sacrificed to the bulldozer. Recently, a few groups have organized to help preserve older architecture, and perhaps the future can find some sort of balance between preservation and innovation.

EXERCISES
The most important thing to remember when you are to judge the impact or the quality of a work is to keep asking why. Do not simply say that you like something. Ask yourself why you like it. It is even more important with things you do not like. What is it that you do not like about them?

1. Do you understand what the work is about? What was or is it used for, if anything? Does it seem very foreign or unfamiliar? What are its unfamiliar elements? Take advantage of museum

publications and gallery talks to become familiar with local collections.

2. How big is the object? Does this affect how you approach it and what you see in it? Do you want to linger with it or can you take it in quickly? The answers to these questions tell something of the artist's intent.

3. With a building, what are your reactions to its size and shape? Was it intended to impress? Does the architecture suggest that something special and noteworthy goes on in the building?

9

Aesthetic Qualities of a Work

Realistic and Abstract _____

Much of twentieth-century art has been abstract. It has dealt with forms, concepts and ideas, colors, textures, and spaces, rather than with recognizable subjects. Many people find it very difficult to deal with abstract art since there are no familiar forms with which to identify. This explains the common tendency to identify objects where there actually are none. It is easier to deal with something concrete and physical than with an idea. Many cultures, however, have used their art to express ideas. Abstraction is not original to the twentieth century and an understanding of its historical context makes the contemporary version easier to appreciate.

ART BEFORE ANCIENT GREECE
Prehistoric art dealt with concepts that were probably related to magic. The lack of documents makes proof impossible, but the objects themselves point to a nonrepresentational intent. Abstract female figures are common, ranging from one inch to about a foot in height, and representing the female body with exaggerated breasts, hips, thighs, and genitals. Facial features are often ignored. They can not be mistaken for portraits or even for attempts to recreate the general appearance of a woman. They symbolize the reproductive principle. In order for the human race to survive, children were needed.

Since the creators had no information about biology, they tried to encourage the mysterious process of childbirth by magic. Some contemporary sculptors represent the female form in a similar way when they want to express their opinions about the basic nature of the feminine, using the same abstraction with a more complex symbolism.

Early historic civilizations in the West, such as the Sumerian and Egyptian, also produced abstract art. Sumerian votive figures for temples were cone-shaped with huge staring eyes and clenched hands. They represent the awe and fear that a person feels when confronted with the majesty of a deity. The statues do not represent participants in a ceremony; their attitude suggest an eternal state rather than a transitory one. They represent a universal truth, not a situation.

The Egyptians also cared about eternity. Their block-like statues, expressionless and grand, defy attempts to analyze their human traits. Each Pharaoh is a god on earth, a manifestation of the greatness of Egypt that would endure forever. Who are we to say that they will not? Some of them have already lasted over four millennia. Similarly, Egyptian painting scorns storytelling. Themes of importance are treated in a hieratic manner, and the idea of visual fidelity does not exist. A shorthand or symbol for something does as well as the thing itself. A work of art is, after all, something different from the world outside of itself. There is no reason why a painted person should look like one on the street.

With a few exceptions, most cultures before the Greeks preferred abstract art. The Assyrians and Persians injected some realism into their painting and sculpture, but they were not observers translating observation into art. The Minoans and Mycenaeans, pre-Greek civilizations, were equally ambivalent about representation. A sense of joy in life combines with a regularity of design and a total disregard for natural coloration.

GREECE

The Greeks carefully observed the world and attempted to produce an idealized version in their art. It is important to note that they were not interested in trivia. Greek art, however realistic, always strives for perfection. A work of art had to represent the best.

Unfortunately, many people equate the Greek movement toward a type of realism as progress. In the world of the visual arts, progress is an indefensible idea. It means that everything that has come before was leading up to what exists now and that today's art is the best ever. This attitude makes understanding of art, whether past or present, almost impossible. Change is inevitable, progress is not. The history of art is one of constant repetition—not exact dupli-

cation because of the changing contexts—but repetition nonetheless. The Greeks made it possible to translate visual reality into art. They did not make what came before them primitive or less worthwhile.

Throughout the classical world, the idea of realism grew. The Romans wanted an exactitude in their art, preferring their painted and sculpted portraits to duplicate as closely as possible what existed in life. This concrete orientation extended to architecture, where engineering and aesthetics were equally regarded. The narrative element is also strong in Roman art. Roman art tells stories. Some Greek art does, too, especially vase paintings, but the stories are religious and are continually repeated for their inspirational content. The Romans would have liked the printing press and camera. They wanted to record life, to keep a visual diary of details of their existence.

THE MIDDLE AGES

The late Roman world saw the beginning of a swing back toward abstraction. Religion has been the basis of much abstract art, and the growth of religious cults that stressed the soul and salvation, rather than ritual observance, produced an abstract art to express their theology. Christianity, Judaism, and Islam are three major religions whose basic doctrines forbid representational art. While the latter two have remained faithful to this ideal, the Christian church was too firmly rooted in the Greco-Roman world to do without art.

There is a slow change from realistic classical art to abstract medieval art. The process begins in late Roman portraits with their staring, upturned eyes, rigid faces, and wiglike hair. Byzantine figures are flat and weightless, floating in limitless golden spaces symbolizing heaven. The flesh and blood feeling, the identification that one feels with Greek and Roman faces, is gone, replaced by ideas of goodness and faith, of obedience and punishment. In the ninth century Charlemagne tried to recapture some of the spirit of the classical world, but he was too late. His artists could only copy outward forms without understanding the inward spirit that enlivened these forms.

Medieval art is abstract. To exist at all in a church that historically banned images, art had to dedicate itself to faith rather than to chronicling events. The twelfth-century *Madonna* from Lombardy, Italy, discussed earlier (pp. 117–18, Figure 71), emphasizes the spiritual characteristics of the figures and avoids their human qualities. As an abstract representation of love, divine tenderness, and caring, the work has emotional impact. However, the figures are not believable as individuals. If the viewer approaches the work without expecting realism, it succeeds on its own merits. It is always important, especially in dealing with abstractions, to judge the object for what it is, rather than for what it isn't.

Later medieval art shows signs of a renewed interest in realism, superimposed on the need to represent abstract religious principles. Giuliano da Rimini's *Madonna and Child, with SS. Francis and Clare and Other Saints* (Figure 133), was painted early in the fourteenth century. The center group, the Madonna and Child, is a compromise between older abstract concepts and the new realism. The Madonna is not as flat as in earlier versions; the artist has attempted, with limited success, to make her look as if she were seated on her throne. The baby is a small man striding across her lap, but it will be some time before the Christ child is allowed to have the ordinary features of a human infant. The two small groups of worshipers at Mary's knees are somewhat three-dimensional and occupy real space, although their expressions and gestures are almost identical. Probably the most nonrepresentational aspect is the lack of scale. Because of her religious importance, the Madonna is enormous, taking up most of the panel. The saints and angels are reduced to Lilliputan proportions, as befits their lower rank. Despite this, there is an attempt at perspective, and the figures are not isolated but relate to one another. By this time the humanism of the Renaissance—its interest in earthly values and accomplishments—is tempering the abstract spirituality of the middle ages.

133 GUILIANO DA RIMINI
Madonna and Child with SS. Francis and Clare
and Other Saints (detail), 1307
Isabella Stewart Gardner Museum, Boston

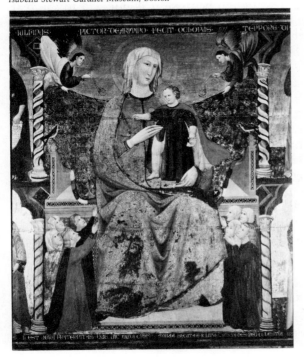

The Gothic cathedrals are among the greatest works of abstract art. Their size, their soaring upwards design, and their sculptural decoration are all aimed at the expression of a religious ideal. The great cathedrals built at the end of the medieval period marked the end and perhaps the culmination of medieval theological abstraction.

THE RENAISSANCE
The ideals of the Renaissance are quite different. The study of perspective, the emphasis on understanding Biblical stories rather than symbolic interpretation, a renewed interest in anatomy, botany, history, and astronomy, all pointed the way toward realism. The mainstream of the visual arts in the West from 1400 to 1850 was representational. Techniques varied, as did the styles of individuals, nations, and periods. Artists grew in confidence and individuality, and approached subjects that had been unpopular since antiquity, such as still lifes, genre paintings, and landscapes. The focus was on objects, stories, places, and people.

THE IMPRESSIONISTS
Contemporary abstraction arises, like earlier abstract schools, from a lack of concern with concrete subject matter. With Impressionism the emphasis of painting began to shift from realism to the accomplishments of the work of art itself. An Impressionist painting says much more about the visual experience of its subject than it does about the subject itself. The approach is not informational. People today relate readily to Impressionism because it is not tied to the reality of the late nineteenth century. The reflection of experiences that are little different in the twentieth century from what they were in the nineteenth make the works of Monet, Renoir, and their peers immediately interesting.

MODERN ART
Since the Impressionists, artists have become increasingly concerned with expanding the range of the arts. Rather than wanting to faithfully reproduce something in nature, artists want to work with symbols, to externalize their emotions, and to discuss philosophical concepts in their painting and sculpture. Technically, this means an abandonment of conventional perspective and of some of the methods that were developed especially for representational art. Cézanne, the father of modern art, rejected Impressionism. For him, visual appearances, being transitory, were of little importance. Instead he analyzed objects and scenes and reduced their outward forms to geometric structures. In this way, the distractions of detail could be

eliminated, leaving the artist and the viewer free to concentrate on fundamentals.

At the same time, around the turn of the twentieth century, Gauguin rejected the entire tradition of western art and left Europe to search for innocence and simplicity. His art was intended to challenge the viewer's mind, to be interpreted rather than visually experienced. He thought that people who were not willing to make the interpretive effort were not worth his time. Art should not be easy. It should be part of an individual struggle to come to grips with basic problems of good and evil, life and death, gods and devils.

In the 1880s Vincent van Gogh moved quickly from Dutch traditional painting through Impressionism to an individual style. His personal torments are revealed in his paintings, turning sunflowers and cornfields into titanic struggles of emotion. The subjects in van Gogh's paintings do not animate them. His own personality gives them vividness, the ability to move people, and lasting impact.

Many trends in twentieth-century art were founded on the ideas of Cézanne, Gauguin, and van Gogh. Cubism is an extension of Cézanne's simplification and analysis, carried much further than Cézanne could have imagined. In all its variations and influences, Cubism has been a dominant force in the art of this century. Gauguin's legacy includes the many forms of primitivism in twentieth-century art such as Fauvism, as well as the symbolic movements like Surrealism. From van Gogh's emotional emphasis came Expressionism and Abstract Expressionism.

In approaching a contemporary abstract work, the viewer needs to be aware of the factors that contribute to its creation. The artist works with an idea, a philosophical concept, an emotion, a theory, a symbol, a metaphor, or something similarly nonconcrete. The techniques of painting, sculpture, or even architecture are the means of expressing that concept. The viewer can approach the work on two levels. First, the actual properties of the work should be analyzed. The second level, interpretation, will vary from person to person. A symbol can be understood in many different ways.

Adolph Gottlieb's *Two Discs,* painted in 1963 (Figure 134) is a 7½ foot by 9 foot canvas that contains no recognizable images. The colors are black, white, blue, yellow, red, and pink. The entire canvas is painted pink with variations in tint throughout. Just below the horizontal center there are two discs, one red and one yellow, each with a red aureole behind it. Along the bottom are patches and splotches of black, blue, red, and white. The painting bursts with energy and vitality. The discs seem somehow suspended in a space through which they are capable of moving. The upper half of the can-

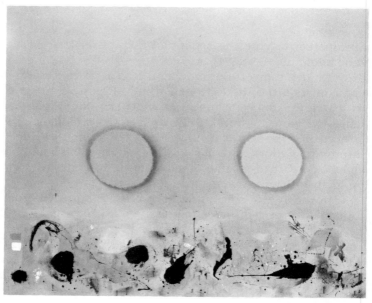

134 ADOLPH GOTTLIEB
Two Discs, 1963
Hirshhorn Museum and Sculpture Garden,
Smithsonian Institution

vas is a potential space for them. The blotches and splashes below seem to dance, jump, twist, and turn randomly. The eye is attracted by the yellow disc, then by the red, and finally by the bottom area. While it is tempting to identify the discs as suns and the regions below them as earth, this is nowhere stated or even implied. There is a strong suggestion of heat, excitement, movement, and intensity. Gottlieb's works from the fifties and sixties are said to be in the style of Abstract Expressionism; they express emotion through their technical aspects. The viewer responds to this emotion and to the manner in which it is conveyed.

Trilithon, a stainless steel and concrete sculpture by John Naylor, 1978 (Figure 135), is a sculptured abstraction. The name means three stones; the architectonic shape reminds one of Stonehenge. The two steel posts set in concrete and their lintel suggest strength. The deep striations and uneven edges give each part individuality and visual interest, as well as providing an interesting play of light and shadow. The use of modern industrial materials makes a novel connection between art and manufacture. As with most contemporary art, the nature of art itself is under consideration as well as ideas and themes.

Despite the predominance of abstract art in the twentieth century, realism has never died out. Particularly in America, a closeness

135 JOHN NAYLOR
Trilithon, 1978
Hirshhorn Museum and Sculpture Garden,
Smithsonian Institution

between artists and daily life has continued in the works of Winslow Homer, John Sloan and the Ashcan School, Edward Hopper, Andrew Wyeth, and many others. In the 1970s major museums have had exhibitions of Super Realism or Photo-Realism, a style of painting in which mundane contemporary reality is caught with microscopic detail. Painters in Mexico turned to realism in order to depict social and political themes. In many countries, government sponsored Social Realism is the norm. As art moves toward the twenty-first century, it is hard to say whether abstraction or realism will dominate.

The Question of Quality

What is art? What is good art? These are the two most frequently asked questions about art. They are asked by philosophers, historians, critics, collectors, and scholars. The nature of art is a philosophical question which is beyond the scope of this book. It is possible, however, to suggest criteria for judging the quality of a work of art.

First, there is the question of taste. Taste varies not only from individual to individual but also from culture to culture and from era to era. Popularity does not guarantee lasting worth. A century ago,

199

learned art critics rejected Impressionism as barbaric and grotesque while praising the sentimentality of the Victorians. Today, museum vaults are full of nineteenth-century paintings at which no one looks. Fashions come and go; sometimes leaving something of value, usually not. Over the years a kind of natural selection takes place, protecting those objects that are most valued and allowing others to deteriorate and disappear. The survival of ancient Greek pottery is due to its being buried in the tombs of appreciative buyers throughout the Mediterranean world. Egyptian kings and nobles took their finest possessions into the tomb with them. Patrons and collectors have bequeathed priceless objects to their descendants, their churches, or their nations.

There is also an element of chance in the survival of works of art. Many ancient sculptures were lost because they were made of bronze which could be reused by later artists. Religion assisted this process. The bronzes were pagan; to the Christians of the Renaissance and Baroque they were not worth saving. Wars have also destroyed some of the finest works. The Parthenon was blown up in a seventeenth-century conflict. Numerous English cathedrals were severely damaged by the blitz in World War II. The fire-bombed city of Dresden held many irreplacable works. Therefore the works that survive from the past are not necessarily the finest of their time. They are, however, those which were held in enough esteem to be preserved and protected. While they may not be the best, they are not the worst.

Scholars agree that certain periods produced unusually large amounts of high-quality art. These rare periods of political stability and economic health encouraged patronage of the arts. Athens in the classical period of the fifth century B.C., Florence in the Early Renaissance, Rome in the first century A.D. and again in the Baroque, are all examples. The finest artists were attracted to these centers and the artistic climate encouraged their development. Patrons were sufficiently enlightened to encourage experimentation and innovation. Without Pericles, Augustus, the Medicis, and the Papacy, a great deal of western art would not have been produced.

This does not, however, tell what it is about the works from such periods and places that makes them distinguished. It is not technical excellence, although the best works of art possess such excellence. Many artists who have perfectly understood the mechanics of painting, drawing, sculpting, or architectural design have produced meaningless, quickly forgotten works. A sense of composition is also important; without it, a work cannot succeed. However, numerous works with excellent compositions, some of which were highly regarded in their own time, have disappeared completely.

Beauty is also not a viable yardstick for measuring the quality of art. The misuse of the word in contemporary English has trivialized it. Movie stars are beautiful, as are products. Almost everything is touted, promoted, and sold as beautiful. There are genuinely fine objects of art that are beautiful. Michelangelo's *Pietà* is an example, but there are equally good ones, like some of Goya's etchings, that are horrifying. Beauty can contribute to the quality of work, but it cannot determine it.

Nor can originality. Every creative expression is different from every other. But every one of them is also dependent on others for existence. During most of history, originality was not given the weight it is today. Copying or adapting was considered a legitimate form of praise. Traditions were consciously continued by artists over generations or even centuries. The twentieth-century demands at least the pretense of originality and penalizes those who fail to observe it. In many cases this leads to efforts which fail except in originality. There may be a very good reason something has not been done before.

What does determine quality? There is little agreement among scholars.

> The aesthetic object *is any thing or quality, whether imaginary or real, that has enough vividness and poignancy to make us appreciate it simply as given.**

According to this the impact of a work determines its quality. The aesthetic object, or the good work of art, moves the viewer. It does not need to be added to, interpreted, or analyzed.

It is a good indication of quality that the viewer can not think of any changes that would make it better. If removing or adding anything to a work of art is possible without harming it, it was not of first quality to begin with. Few people, for instance, look at a Rembrandt portrait and start thinking of ways it could be improved. However, to say that something can not be improved, that it can be appreciated as it is, simply says that it is good. It does not say why it is good.

> For our purpose, good *will represent a state approaching a preconceived and established condition or quality. In terms of form it presupposes an ideal—either an ideal revealed by God or one that has traditionally worked for the protection or to the advantage of man.†*

*Melvin Rader and Bertram Jessup, *Art and Human Values.* Englewood Cliffs, N.J.: Prentice-Hall, Inc., 1976, p. 93.

†Joseph H. Krause, *The Nature of Art.* Englewood Cliffs, N.J.: Prentice-Hall, Inc., 1969, p. 14.

The idea of the existence of an ideal and of the efforts of humanity as a struggle to approximate that ideal goes back to antiquity. From this viewpoint no human endeavour is truly good, because the best is not human. Quality is determined by the closeness of the human effort to the ideal. The problem, of course, is getting people to agree on exactly what the ideal is.

> *When we approach these works (of art) . . . in the spirit of endeavour-*
> *ing to judge on a comparative basis the relative success of his achieve-*
> *ment, we have taken the first significant step toward understanding*
> *the arts.* *

To an extent the quality of a work can be judged on the basis of how well it fulfills the expectations of its creator and of the society in which it was created. There are, however, many examples of art which were rejected by their original culture only to be recognized by later critics as significant works. Rembrandt saw some of his paintings mutilated or replaced by works now considered to be far inferior. Monet's early canvases were used by the Prussians to line their horses' stalls during the Franco-Prussian war. Some artists, on the other hand, were revered during their own time and still are. There is a letter from a wealthy patron in Renaissance Italy begging Michelangelo for anything from his hand, and for any price he cared to charge. Peter Paul Rubens was highly thought of in the seventeenth century and was showered with honors by the governments of Europe. The question, therefore, is how to decide whether a work fulfills the needs of its society. Who judges those needs? Does the modern scholar have a perspective denied to those living in the time studied? Or is today's critic blinded by distance?

Without testimony by the artist, there is no way to know whether a work came up to his or her expectations. Some works are well-documented; others are anonymous. It can not be said that a work lacks quality because the artist is anonymous. Does knowing that an artist was pleased by the quality of a work make it genuinely good? John Singleton Copley thought that his painting improved after he left America for England and received formal training for the first time. Today most art historians and critics think that his American portraits are the finest things he did. Copley's English works are judged by many people today as overdone and artificial, without the honesty and spontaneity of the earlier paintings.

> *In judging the quality of a work of art on the basis of the type of ex-*
> *perience that it offers us, we leave the relatively objective area of judg-*

*Bernard S. Myers, *Understanding the Arts.* New York: Henry Holt & Co., 1958, p. 454.

*ment that we have defined as artistic ability and enter the more sub-
jective area in which we evaluate the significance of the artist's
intention. In this area our judgment of the work of art does not pro-
ceed from what our past visual experience has led us to know is pos-
sible, nor from the degree to which our expectations are fulfilled. It
arises, instead, from what we feel that the work of art reveals to us.* *

In this definition, the quality of a work of art is related to its impact,
to the fullness of its communication with the viewer. Note that
Bates Lowry does not specify what effect the work should have; it is
successful if it moves people. Shall we then judge a work of art by
the number of people who are moved by it, or by the depth of its
emotional impact? Even if one allows such a definition, it leaves the
problem of why a work of art moves people at all, which looks sus-
piciously like a paraphrase of the question of the quality of a work of
art.

All of the above excerpts from much fuller discussions are
thoughtful and useful approaches to the problem of quality. No defi-
nition is going to be flawless, but a good one can provide a basis for
thoughtful evaluation and discussion.

For me, the quality of a work depends on its universality. I as-
sume that there is a structure to reality and that the best art is that
which is most closely allied to this structure. Successful works will
appeal to people across a broad expanse of time and distance because
they comment on the human situation. Relevance is beside the
point, it is too transitory. What is relevant today is frequently forgot-
ten tomorrow. This is not to say that something is good because it is
old. Not everything survives because it is exceptionally fine, but
many things do. A truly fine work of art should be able to reach past
its immediate situation, past the goals of the artist and the expecta-
tions of its culture.

Michelangelo's *Pietà* is an example. The *Pietà* was discussed
earlier (p. 138 and Figure 23) in terms of its composition. It is, tech-
nically, an excellent work of subtractive sculpture. However its ap-
peal is more than that. The *Pietà* was carved for the Roman Catholic
Church, specifically for the Church of St. Peter in Vatican City. The
subject matter is Christian and the interpretation is related to spe-
cific Christian beliefs in Michelangelo's time. In 1964 the *Pietà* came
to New York to be displayed at the New York World's Fair in a blue-
lit setting designed by a Broadway stage designer. People were
whisked by on a moving walkway, and allowed about a minute to
look at the statue from a distance. Very few dared to get off for a
longer look. Yet, even under those conditions, the *Pietà* had the

*Bates Lowry, *The Visual Experience: An Introduction to Art.* New York: Harry N.
Abrams, Inc., 1961, p. 261.

power to move people. People who were not Catholics, not Christians, not Italian, and not from the Renaissance felt the power of a great work. This is the kind of universality that equals greatness. A building like the Parthenon, a statue like the *Pietà*, a Rembrandt self-portrait, they all have this quality of moving the minds and emotions of humanity without regard to period or place.

EXERCISES

It is particularly important to take enough time to appreciate an abstract work. Allow the work to grow on you so that it's unfamiliarity becomes less of an obstacle. Try to think of the work from as many viewpoints as possible.

Put yourself in the artist's place. Why would *you* do a work of the kind you are looking at? It might also help to hear lectures on the work or talk to others about it.

1. Write down your reactions to a work, especially if you are confused or put off by it. Try to decide exactly what there is about the object that conditions your reaction. If you would like to change the reaction, think of any positive features about it and write them down. People sometimes react negatively to contemporary art because of its abstract and unfamiliar appearance, but wish they did not.

2. Is the work representational or abstract? What does this suggest about the society that it comes from? If it is abstract, what ideas is it trying to express? If representational, does it succeed in interesting you in its content? How?

3. If an abstract work reminds you of something concrete, for example, if you see a face or something in it, do not take it literally. Try to see what made you think there was a face. What were you really looking at? What associations did that trigger in your mind?

4. In trying to judge quality, look at a number of works and then rank them in order from most to least successful. Why did you rank them as you did? What appealed to you in the best ones? What was lacking in the worst?

5. If you look at a work of contemporary art and think, "My sister, daughter, etc. could do that" and you can not understand why it should be on public display, try something similar yourself. Then see if you can tell the difference between your work and the one you were looking at.

6. When interpreting an abstract work, think in terms of your emotional reactions. Ask yourself how you feel about the work. Then try to determine what causes this reaction. Is it color, lines, the arrangement? Does your reaction change over a period of time? In a sense you are in a dialogue with the artist that will change as it continues.

Part Four
STYLE

Style. Distinctive or characteristic mode of presentation, construction, or execution in any art, employment or product, esp. in any of the fine arts; as, genre style; Renaissance style; styles in costume.

Webster's New International
Dictionary of the English Language
Springfield, Mass.: G. & C. Merriam Co., 1921

Style. The quality which gives distinctive character and excellence to artistic expression; as, his writing lacks style.

Webster's New Collegiate Dictionary
Springfield, Mass.: G. & C. Merriam Co., 1961

Style. The singular mode of expression employed in the representation of Form. Styles are classified according to such categories as historical period, school, nation or locality, or group of artists. Style also refers to the technique and particular characteristics of an individual artist.

Ralph Mayer
A Dictionary of Art Terms & Techniques
New York: Thomas Y. Crowell Co., 1969

Style. The distinctive and characteristic way of making and arranging the forms of a work of art by which it may be assigned to a particular period, place, artist or period within an artist's life.

James Smith Pierce
From Abacus to Zeus: A Handbook of Art History
Englewood Cliffs, N.J.: Prentice-Hall, Inc., 1968

"Style" is one of the most widely used and misused words in art history and art appreciation. As the above definitions indicate, the word can be used in a number of ways. Often the meaning has to be determined from the context. Style comes from the Latin *stilus*, a pointed instrument made of metal or bone with which the Romans wrote. Even the Roman word had a broader meaning, referring to the way in which different people wrote. In art history and criticism, there are period styles, national or regional styles, local styles, school or group styles, individual styles, revival styles and other general stylistic terms. In each case, the word "style" refers to appearance, and the common factor within a style is that the objects resemble one another to some extent.

A period style is tied to a particular era in time. The architecture, sculpture, painting, and minor arts of a stylistic period are regarded as having common characteristics. Period styles are always international, although they are rarely worldwide. The following is a breakdown of some of the most commonly used period style designations.

Style	Time	Place
Romanesque	11th & 12th centuries A.D.	Europe
Gothic	12th to 15th centuries	Europe
Renaissance	ca. 1400–1600	Europe
Baroque	ca. 1600–1750	Europe
Early Colonial	ca. 1620–1720	North America
Georgian	ca. 1720–1780	England, North America
Rococo	18th century	Europe

Within a given period there may be regional differences in style. During the Renaissance, for instance, works from Italy differ considerably in medium, technique, and intent from those produced in Northern Europe. Such regional or national differences usually result from differing social organizations. In Renaissance Italy, most art works were produced for a small group of patrons, with the principal patron being the Roman Catholic Church. In Flanders (modern Belgium), a middle-class, mercantile society produced more patrons, each of whom bought fewer works. Italian Renaissance art tends to be religious and aristocratic, while Flemish works are more bourgeois.

Compare Giovanni Bellini's *Madonna and Child in a Landscape*, 1480 (Figure 136) to Roger van der Weyden's *St. Luke Painting the Virgin*, 1434 (Figure 137). Both are from the fifteenth century, the Early Renaissance, and have a great deal in common. Each painting shows the Virgin Mary as a human being relating to her child with

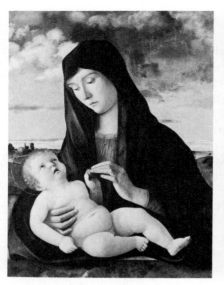

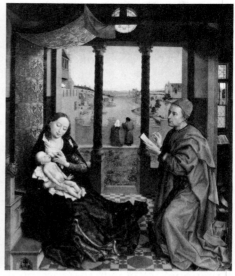

136 GIOVANNI BELLINI
Madonna and Child in a Landscape,
ca. 1480
National Gallery of Art, Washington.
Ralph and Mary Booth Collection.

137 ROGIER VAN DER WEYDEN
St. Luke Painting the Virgin,
1434
Courtesy Museum of Fine Arts, Boston.
Gift of Mr. and Mrs. Henry Lee Higginson.

maternal concern. Overt religious symbolism is minimized to provide a more believable representation. They are far from the abstract, symbolic approach of the Middle Ages; however, there are regional differences. In Bellini's painting, the pair is isolated on a high place overlooking a distant landscape. The figures, although human, have a timeless dignity. Van der Weyden puts the Virgin and Child in a room with several people. Besides St. Luke, there are two people on a balcony in the background. The clothing and setting are contemporary. There is some subtle symbolism, such as the carvings of Adam and Eve on the Virgin's chair and the unexpected presence of an ox, a symbol for St. Luke, on the right; but the personal interactions of Mary, her child, and Saint Luke dominate. The happiness on their faces differs from the solemn calmness of the Bellini figures.

A national or regional style may be subdivided into local styles. In the United States there have been stylistic distinctions between the Northeast, Southeast, Northwest, and Southwest. In Italian Renaissance art, Sienese, Florentine, Bolognese, and Roman works have noticeable variations. In seventeenth-century Holland, Utrecht and Amsterdam produced separate styles. This is especially noticeable in architecture, where the availability of materials and the differences in environment have a major effect on the construction of buildings. Locality has a more subtle effect on the other arts. The artist has different opportunities in a cosmopolitan milieu than in a rural setting. A single work of art, therefore, could correctly be described as being

210

Renaissance, Italian, or Florentine in style. The choice of the proper term depends on context—with how wide a group of works you want to associate with the work when you ascribe a stylistic term to it.

Sometimes a group of artists consciously develops a style. The term "school" is often used for such groups. This does not mean that they meet formally to learn, but that they agree to work together to accomplish certain artistic goals. Later in this part of the book, I discuss how the Impressionists and the Mannerists went about this. Other schools that developed their own styles include the Hudson River School of American nineteenth-century Romantic painters, the Ash Can School of early twentieth-century urban artists, and the Barbizon School of French nineteenth-century outdoor painters.

A number of twentieth-century movements, including the Cubists, Expressionists, Fauves, Surrealists, Abstract Expressionists, Op Artists, and Pop Artists, were not as formally organized but do reflect common enthusiasms. Some, like the Expressionists, had political connections and included writers and musicians as well as visual artists. Others, like the Surrealists, regarded their art itself as a political statement. Still others, like the Cubists and Abstract Expressionists, refused to relate their art to outside factors.

Every artist has his or her own style. Someone's work can be described by period, nationality, and school without denying its uniqueness. A work can have the general characteristics of a larger movement while retaining its individuality. In Chapter 12 I look at the career of the French Impressionist Claude Monet and how his style developed within the framework of the nineteenth century and of Impressionism. Individual styles can also be determined by comparing works of a similar type by different artists. The differences in the way two artists approach a still life, a landscape, a portrait, or a religious scene are indications of their styles.

Styles of the past are sometimes revived. When this is done it is out of admiration for the past and a desire to link the present to its good qualities. The nineteenth century was a time of numerous architectural revivals as I discuss in Part Three. Greek and Roman sculptural styles were revived in the Renaissance and again in the eighteenth and nineteenth centuries. The classicism of Raphael and High Renaissance art was revived during the Baroque and the nineteenth century. The presumed naiveté and innocence of Early Renaissance art was copied by the pre-Raphaelites. Revival styles are never completely accurate, nor are they intended to be. Motifs and ideas from the past are adapted to the contemporary situation. A bank built in the style of a Greek temple works up to a point, but if it is not functional as a bank, the whole exercise is pointless. A compromise between past and present is always the final result.

Romanticism, a style marked by an appeal to the emotions, is not identified with a single period or region. In a Romantic painting, forms are often deliberately unclear; subjects are strange and dramatic, and action is swirling and violent. Color and light are used to intensify emotion. The word "Romantic" does not necessarily refer to love. Romanticism is a revival style, marked by the use of Gothic and other medieval forms. Claude Lorrain was a seventeenth-century French Romantic painter. His painting *Parnassus*, ca. 1680 (Figure 138), shows the poets of antiquity on Mt. Parnassus. The colors are cool, soft blues and greens with a few highlights of red and yellow. The pastoral setting is idyllic, with swans swimming in a quiet pool and poets relaxing on the hillside. Some classical architecture is seen in the background. The eye moves diagonally in a slow gentle progression from lower left to upper right, stopping along the way to take in the details of birds, poets, landscape, and buildings. It is a peaceful, unworldly setting. Poetry is portrayed as a noble activity, associated with the most delicate, untouched places. The emotions are positive; peace and tranquility give birth to creativity.

138 CLAUDE LORRAIN
Parnassus, ca. 1680
Courtesy Museum of Fine Arts, Boston.
Purchased, Seth K. Sweetser Fund.

139 JOHN CONSTABLE
A View of Salisbury Cathedral, ca. 1825
National Gallery of Art, Washington.
Andrew W. Mellon Collection.

The nineteenth-century English painter John Constable worked in a similar manner, without trying to revive Lorrain's style. It is simply that similar intentions may lead to similar results. The painting in Figure 139, *A View of Salisbury Cathedral,* ca. 1825, is a nineteenth-century version of Romanticism. Unlike *Parnassus,* it was painted outside and is a much more believable version of nature. The atmospheric and lighting effects are optically correct, however the impact is similar to *Parnassus.* Both paintings use the same cool earth tones and soft lighting. The Constable lacks identifiable figures, but has the same gentle, inviting calmness. In both paintings the viewer is urged to become part of a peaceful, relaxing world.

Realism has been similarly used at different times. Whenever artists wanted to focus on the facts about everyday subjects, realism, a straightforward treatment without extra effects, was the result.

10
A Period
Style

Words like classical, Gothic, Renaissance, and the like are used to describe a period in history. Sometimes the same term is used to describe both a specific time in history and the appearance of objects created during that time. An example is Early American. This term is used loosely to mean the period before the American Revolution and its art. More correctly, however, we should use the term Early Colonial to describe works done before 1720 and Georgian for works done between 1720 and 1775. But do these terms actually stand for a recognizable sort of creative ideal? Examining works from different media made during the same period does reveal similarities.

Early Colonial

When the first settlers landed in the new world in the early 1600s their energies revolved around survival. Simple shelters were constructed and some basic furniture was built to supplement what had been brought over from England. It was not for some years that their energies turned toward the arts, and the earliest surviving Early Colonial works date from the latter part of the seventeenth century.

A typical New England house of the seventeenth century would consist of one or two rooms. The placement of the door showed which plan had been followed. If the door was in the center, there

214

were two rooms; if on one side, only one room. A one-room house could be expanded to two, at which point the door would become centrally located. The building material was wood and the prototypes were the medieval homes still standing in the rural parts of England. The accent was on practicality and getting the maximum use from available materials. The Paul Revere house in Boston was built around 1676 (Figure 140). It consisted of a main room and an ell, actually a two-room plan bent to fit a narrow urban lot. The façade of the Revere house provides a look at what the early Colonial settler wanted for a home. The building is rectangular, with the second story protruding out over the first, and with a sharply pitched gabled roof. The extended second floor was largely a device to increase the floor space of a building on a limited city lot. The walls are covered with clapboards and are broken by small leaded glass casement windows. Glass was expensive and scarce, thus limiting the number of windows that were possible.

Yet there is an attempt at ornamentation along with this overall simplicity. The timbers of the second story are carved into hanging balls which serve no structural purpose. They break up the horizontality of the house and add curved accents to its straightness. The windows are broken into diamond-shaped panes, which add to the visual interest of the house. The Paul Revere house is a combination of the functional and the aesthetic. People in America were looking for more than shelter from their homes by this point. They needed the pleasure of homes that were visually, as well as physically, satisfying.

140 Paul Revere House,
17th century
Courtesy Paul Revere House;
photo by B. Davi

The Revere house would have held portraits, like *Mrs. Elizabeth Freake and Baby Mary* by the Freake Limner (Figure 141). The unknown artist was probably one of the traveling limners or painters who traveled between colonial settlements painting portraits, signs, houses, or anything else that was needed. As with the Revere house, the source is medieval. The flat, linear style with its fussy decorative accents is similar to the portraits done in England during the reign of the Tudors. The work is basically simple. Mother and child sit in a wooden chair in a plain dark space. There is a small curtain at the upper left. This simplicity is contradicted by the detailed decoration that adds little to the characters of the sitters or the quality of the work as a painting, although it is pleasant in itself. Much time was spent on the details of Mrs. Freake's collar and the tassels on her sleeve. The baby's bonnet is fringed with delicate lace, which is incongruously precise next to her doll-like face. Both figures are flat and stiff, seemingly made of wax rather than flesh and bone. The painting speaks eloquently of a time which longs for more than it is quite prepared to create. The painter has tried to give Mrs. Freake and

141 UNKNOWN
Mrs. Elizabeth Freake and Baby Mary,
probably 1674
Worcester Art Museum, Worcester, Massachusetts

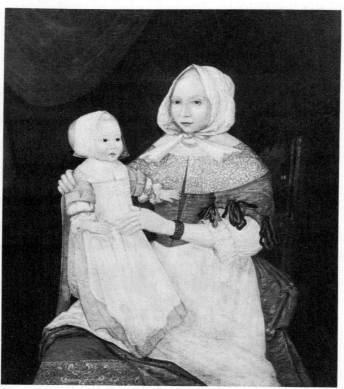

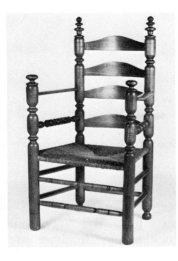

142 American Armchair, 17th century
Courtesy Museum of Fine Arts, Boston. Bequest of Charles Hitchcock Tyler.

her child an elegance and feeling of status which his lack of training prevented him from achieving. There is pride and a vision of a bigger, more splendid future in this painting, just as in the Revere house.

The earliest American-made furniture is related in style to both the house and the painting. An early ladderback armchair (Figure 142) illustrates the same combination of simplicity and decorativeness. The basic shape is boxlike, with straight legs and a slatted back. The material is wood with wicker rushes for the seat. It looks practical rather than comfortable. But there is none of the austerity that might be expected from a chair made before 1700. Instead there are numerous decorative touches. The finials of the back are turned in a spool pattern. There are also turnings in the legs and supports. The slats are carved to imitate architectural decoration. There was very little money or time in America in this Early Colonial period for luxury; but the settlers, reasonably enough, wanted whatever graciousness was readily available.

Other furniture is consistent with this pattern. A blanket chest from the 1600s is elaborately and carefully carved in rich architectural patterns (Figure 143). The chest was the most useful piece of

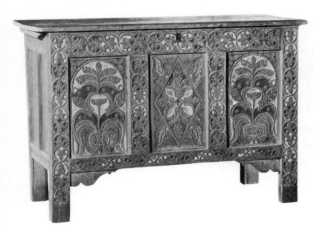

143 Attributed to THOMAS DENNIS Chest, 17th century
Courtesy Museum of Fine Arts, Boston. Gift of Templeman Coolidge.

217

144 HULL and SANDERSON
Caudle cup, 1652–83
Courtesy Museum of Fine Arts, Boston.
The Philip Leftingwell Spaulding Collection.
Given in his memory by Katherine Ames Spaulding
and Philip Spaulding, Oaks and Hobart Ames.

furniture an early settler had. He could sit on it, eat at it, or put things in it. The shape is strictly rectangular and the lines are straight without exception. Flat surfaces, however, are richly embellished. There are floral patterns which were once brightly painted, giving it more life and visual interest. When you have only a few pieces of furniture, you have to get the most satisfaction possible from each of them.

Tableware is no exception. Not only fine silver but humble pewter has it decorations. Silver especially seemed to inspire its makers to heights of ornamentation. The functional nature of the object did not prevent its being embellished with engraved or chased floral decoration. A caudle cup made about 1652–83 (Figure 144) by John Hull and Robert Sanderson is small and simple in shape, except for its elaborate handles. The tulips seem lively and cheerful, making it a pleasant experience to come in from a cold Boston day to drink hot caudle (a mildly alcoholic beverage) from this little cup.

Georgian

After 1700, new and more affluent settlers made their way to the American colonies. They were not faced with the same desperate problems of survival as the first arrivals and they expected a higher level of sophistication and comfort. The Georgian period, as the years between 1720 and 1775 are usually called, is one of exceptional grace and elegance. Everything about this time tells us that we are dealing with different people, conditions, and ideas. Georgian objects are not easily mistaken for Early Colonial ones.

Architecture shows the most immediate and striking difference. Georgian buildings are bigger, more complicated, and more heavily decorated than their Early Colonial predecessors. Georgian architecture was derived from the Renaissance architecture of Europe, which, in turn, was based on classical Greek and Roman models. Books on

architecture were carefully studied and individual motifs from European and ancient buildings were adapted to American homes and public structures. Correctness was the byword, and the formal arrangement of elements in symmetrical and regular patterns was more important than function or comfort.

The Longfellow House in Cambridge, Massachusetts (Figure 145) is an example of Georgian domestic architecture in New England. Brick and stone were common in other parts of Georgian America, but wood remained the preferred material in New England. Although there were regional differences, buildings in the style of the Longfellow House were built wherever the wealthy lived. The house was built in 1759 for a British aristocrat. It is two stories high with a hipped roof topped by a low railing and two tall chimneys. The main block of the house shows a strong sense of balance between horizontals and verticals. The building itself is wide rather than tall. This is offset by four white pilasters that run through both stories, topped by Ionic capitals. The center is marked by a pediment set with a rounded window. The windows are evenly spaced and the façade as a whole has a quiet dignity. The porches that flank the main block were added later.

The interior of the Longfellow House is as symmetrical as the façade. The house is bisected by a hall and staircase. The individual rooms are filled with classic details copied from books. Pediments, pilasters, moldings, and columns are used throughout the house. The

145 Façade of Longfellow House, 1759
Courtesy Longfellow National Historic Site;
photo by Fred Hanhisalo.

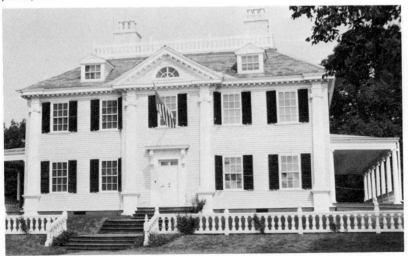

146 Longfellow House, detail of interior, 1759
Courtesy Longfellow National Historic Site; photo by Fred Hanhisalo.

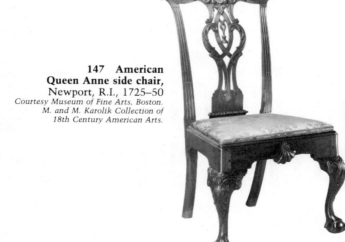

147 American Queen Anne side chair,
Newport, R.I., 1725–50
Courtesy Museum of Fine Arts, Boston. M. and M. Karolik Collection of 18th Century American Arts.

fireplace wall of the parlor (Figure 146) shows the Georgian tendency to pile classical detail on classical detail until the effect becomes almost overwhelming. The fireplace itself is surrounded by double pilasters and is topped by an elaborately carved mantel. The double pilaster motif is repeated in the overmantel, which is surmounted by a broken pediment with oversized dentil moldings. To the left of the fireplace is a wide arched doorway balanced by an identical arched niche on the right. The arches have giant carved keystones and ribbon motifs above them. The dentil molding is repeated along the top of the wall. Each of the details of the wall is correctly done, but the overall effect is one of excess.

The furniture for such a home would have to show the same consciousness of elegance and wealth. A side chair in the Queen Anne style would look appropriate in the Longfellow House (Figure 147 and page 206). It is delicate and curving in outline, with shell and volute motifs worked into the back and legs. The shape of the leg, called **cabriole,** is difficult to carve and uses a great deal of wood, increasing the expense of the chair. Here style is far more important than function. A beautiful chair was worth a long wait, a wait which would not have been possible for the early settlers. The seat is upholstered and hand-embroidered, also a lengthy undertaking. The shapes and styles of furniture that were developed during the Georgian period are still admired and reproduced today.

The Chippendale style, current from 1760–90, is equally sophisticated. This blockfront chest of drawers (Figure 148) is restrained and graceful with its flowing curves uniting it vertically. The shell carvings and brass handles complete the feeling of luxury. Fine woods were available at this time, and professional cabinetmakers replaced the home craftsmen of the earlier century. Like the Queen Anne, the Chippendale style in America was copied directly from English prototypes.

Similarly, most portraits were now done by professional painters imported from England. Although these expatriate artists usually lacked the sophisticated skills of the finest European artists, they far outclassed the simple limners. Tricks of technique such as the representation of fine fabrics and elegant backgrounds copied from prints made these painters much in demand in the larger cities such as Boston, Philadelphia, and New York.

Angelica Kauffmann's portrait of Dr. John Morgan, painted in 1764, is typical of the Georgian approach (Figure 149). Dr. Morgan is shown against a background of furniture and papers on the right, and a distant vista on the left. We know immediately that he is a person of wealth and status as well as a scholar. Dr. Morgan is elaborately dressed in a deeply cuffed velvet coat, silken waistcoat, and ruffled

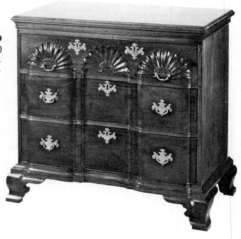

148 GODDARD or TOWNSEND
Chest of drawers, ca. 1760
Courtesy Museum of Fine Arts, Boston.
Gift of Mr. and Mrs. Maxim Karolik.

shirt. One graceful hand points toward his papers while the other pulls back his coat, exposing an impressive expanse of stomach. Today we might consider Morgan overweight, but in his day only the wealthy could afford enough food to get fat. The pose and clothing emphasize both his self-image and his wealth. In fact, if straightness and rectangularity are hallmarks of the Early Colonial period, roundness might well be considered the fashionable look of the Georgian era.

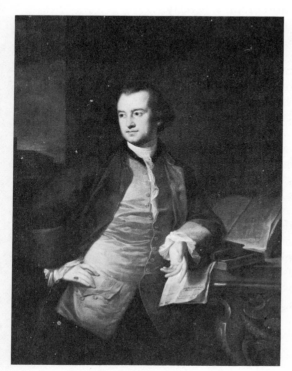

149 ANGELICA KAUFFMANN
John Morgan, 1764
National Portrait Gallery,
Smithsonian Institution, Washington, D.C.

Even the silver and pewter emphasize this new wealth and luxury. A silver teapot made by Paul Revere between 1760 and 1765 (Figure 150) is both gracefully shaped and delicately embellished. The pear-shaped body is surmounted by an acorn-handled lid. The curves of the handle and spout complete the impression of richness. The body of the teapot is engraved with floral motifs surrounding the crest of the Ross family, for whom it was made. An ordinary useful object has become something to take pleasure in while it is used, something which does more than pour tea.

The viewer can fall into a number of traps when trying to discover the period style of an object. Not everything made at the same time looks alike. There are always individualists and people who are either ahead of or behind their times. Moreover, styles are sometimes

150 PAUL REVERE
Teapot, 1760–65
Courtesy Museum of Fine Arts, Boston.
Bequest of Mrs. Pauline Revere Thayer.

revived, and only small differences distinguish them from their originals. But much of the output of a particular time is similar. The same society and the same kinds of problems and solutions cause at least some regularity. Becoming familiar with the general characteristics of various periods often makes it possible to identify works of art and to appreciate them more fully.

The stylistic unity of the Early Colonial and Georgian eras results from the combination of the needs and tastes of a group of buyers with the skills and techniques available to the artists. Rather than consciously setting out to create a style, the two groups responded to a common environment. Other styles have been created by artists in response to changes in techniques, subject matter, or philosophical emphasis.

Impressionism

Impressionism is such a style. The word was first used in a derogatory review of an exhibition in the 1870s. The artists adopted it to describe themselves and their aims. The Impressionists redefined the goals of art. Art should not focus on content, but on the momentary action of light on forms, on bright, outdoor colors, and on rapid brushstrokes that are visible on the surface of the canvas. The artists concentrate on what the eye sees, not on ideas.

"Impressionism" is a broad, inclusive term. The original Impressionists wanted the term to be used that way. People with such different approaches as Monet, Manet, Rodin, Degas, and Cassatt are all Impressionists. Each has an individual style but subscribes to the overall goals of the Impressionist movement.

No style simply appears. Each has antecedents in previous movements, sometimes consciously adopted and sometimes evolving so gradually that even the participants are not aware of it. The Romantics were the first people to paint out of doors. The invention of prepackaged paints freed them to work outside rather than being tied to the studio. The invention of the camera in the 1830s forced artists to reevaluate their arts and adapt to the challenge of mechanically produced images. Delacroix and Turner redefined the use of color, taking advantage of the intrinsic properties of colors rather than subordinating colors to objects. Turner discovered that colors such as red have a far greater impact when used independently. A red-tinted canvas has more meaning than a red hat. The realists pointed out that ordinary people and events can be as interesting as gods and goddesses. Impressionism took the discoveries of the Romantics and Realists and developed them into something new. The Impressionists worked outdoors, took advantage of photography, used color independently, and chose everyday subjects. They added a consciousness that art can be spontaneous and visually oriented. It can show life as it seems rather than as it is. To this end the Impressionists devised the technique of using unblended colors and individually visible brushstrokes. By developing a new technique, the Impressionists came to understand that the artist creates something that is independent of outside reality. This provided a stepping stone to the nonrepresentational art of the twentieth century.

Mannerism

In the past other groups of artists have realized that they were creating a style that was radically different from the major trends of their

time. In the sixteenth century a group of painters, sculptors, and architects rebelled against the mainstream art of the High Renaissance. The Mannerists, as they are called, found High Renaissance art overconfident and superficial because it was based on rationalism and orderliness, on the belief that the world is coherently organized and understandable. Mannerism emphasizes irrationality, dreams, and fantasy. The word "Mannerism" is derived from the Italian *maniera* which means artificial. The Mannerists constructed worlds in art that cannot be explained rationally and which do not abide by the principles of nature. The Mannerists were also extremely conscious of their role as artists and drew heavily on the works of other artists for subject matter.

Rosso Fiorentino's *Dead Christ with Angels*, 1524–27 (Figure 151), exemplifies the Mannerist approach. The huge body of Christ dominates the painting. The figure is taken from Michelangelo's *Pietà*, a sculpture that perfectly represents the self-confidence of High Renaissance art. Here, however, Christ seems to be suspended without visible support. The heavy body almost slides out of the picture onto the viewer. The four angels, adapted from the *Laocoon*, an ancient Greek sculpture, chat animatedly behind the body and pay no attention to it. Their beauty contrasts oddly with the figure of Christ. One of them is even handling the wound in Christ's side. The extinguished candles represent Christ's death and the sponge and nails at the bottom recall the Crucifixion story. Rosso's painting is unsettling and startling, even offensive. It was not, however, meant sacrilegiously. Rosso was challenging people's unthinking faith; their acceptance of religious stories without analyzing them. Mannerism refuses to let comfortable assumptions go untouched. It explores areas of the human psyche that most people would prefer to let alone.

151 ROSSO FIORENTINO
Dead Christ with Angels, *1524–27*
Courtesy Museum of Fine Arts, Boston.
Charles P. Kling Fund.

Post-Impressionism _____

Mannerist and Impressionist artists worked toward goals which in-
fluenced both art and its social context. Other stylistic terms, such
as Post-Impressionism, are less informative. The term was invented
in 1910 by an English critic named Roger Fry who was trying to find
a term for the diverse movements in art that had occurred since
Impressionism and which were different in their emphasis from
the Impressionists. Fry attempted to define what he meant by
Post-Impressionist.

> In no school does individual temperament count for more. In fact, it is
> the boast of those who believe in this school, that its methods enable
> the individuality of the artist to find the completer self-expression in
> his work than is possible to those who have committed themselves to
> representing objects more literally . . . The Post-Impressionists con-
> sider the Impressionists too naturalistic.*

The difficulty is that there is no one set of goals, no one unifying fac-
tor that identifies an artist as a Post-Impressionist. All of them rely
on the discoveries of the Impressionists but reject the use the Impres-
sionists made of these discoveries. Such diverse artists as van Gogh,
Toulouse-Lautrec, Seurat, and Matisse are all called Post-Impression-
ists. It is possible that to critics and viewers of future generations the
works of the Post-Impressionists will look more alike than they do to
contemporary eyes. In that case the term will be redefined to carry
more specific implications.

Such a change has happened to other terms. "Gothic" was orig-
inally used to contrast the art of the later Middle Ages unfavorably
with that of the classical world. Gothic art was thought to be rude,
barbarous, and grotesque. Today it simply refers to European art be-
tween the mid-twelfth and mid-fifteenth centuries. Specific charac-
teristics are associated with Gothic architecture, sculpture, and
painting. What was once considered barbarous is now regarded as
graceful, elegant, and highly appealing.

Like all labels, the names of period styles are only useful for
their associations. It means nothing to call a work Gothic, Romantic,
or Impressionist unless certain motifs, techniques, and ideas are as-
sociated with each term. For the student and connoisseur, however,
they are valuable devices for remembering the dominant characteris-
tics of the art of different times and the relationships between the
artists working in those times.

*Roger Fry, *Manet and the Post-Impressionists.* London: Grafton Galleries, 1910,
preface.

EXERCISES

Look at as many objects as possible from a time period that interests you. The goal of the exercises is to determine visually the dominant characteristics of that particular period. To understand why these characteristics exist, it is usually necessary to do some research; but first you must deal with the objects themselves.

1. Pick out a group of objects. Make sure that they are from the same time period by checking the labels. Include as many kinds of objects as possible; painting, sculpture, decorative arts, and so on.

2. Describe each object carefully. How big it it? What is it made of? What is the subject matter, if any?

3. What technique was used in each? Is there a wide variety of techniques or only a few? This is a clue to the availability of technical information at the time in question.

4. Analyze the composition of each object. How are color and texture used? What devices are present? What are the focal points?

5. Look for similarities between the objects. Is there a type of material, scale, or subject matter that occurs frequently? Are certain compositions more common than others? Is there a similar approach to realism and abstraction?

6. Is there a unifying thread running through the objects? For instance, in some time periods the majority of the art will be religious; while at other times romantic love will be a popular subject.

Do not expect the objects from a single period to be absolutely consistent. There are always exceptions to the rule. However familiarity with the general characteristics of a period style makes it easier to understand the individual objects from that period.

11
An Individual's Style

An artist's style develops and changes over the length of his or her career in response to conscious decisions or gradual shifts in goals and ideals. There are generalizations that can be made about a person's style, but they are limiting. It is more useful for the layperson to consider individual works and to draw conclusions about the artist's style at that moment than it is to attempt a general classification.

Painting

POUSSIN

Nicolas Poussin was a seventeenth-century French painter who worked principally in Rome and who was interested in classical culture and history. Poussin's paintings were highly regarded in his own time and are still admired today. Bernardo Strozzi was an Italian painter who worked in Genoa and Venice at the time Poussin worked in Rome. Although less famous than Poussin, he was a respected, influential artist in his own time. Despite the similarities in time in place, the two artists developed distinctly different styles.

Poussin painted the *Holy Family on the Steps* in 1648 (Figure 152). It is an oil on canvas 27 inches high by 38½ inches wide. The painting shows a group of people seated on the steps of a large classical building. They are surrounded by columns, urns, an orange tree,

a basket of fruit, a golden vase full of berries, and a small wooden casket. Even without knowing the title, certain conventions prove that this is not an ordinary family. The woman in the center is wearing red and blue, the Virgin Mary's colors. The child on her lap extends his hand over a piece of fruit held by another child. This act of blessing identifies the Christ child. The other infant is probably John the Baptist, the usual third figure in such a group. The old woman on the left would be St. Anne, the Virgin's mother, and the man in the shadows on the right is Joseph, Mary's husband.

In the clear, geometric composition of this painting, the family group forms a triangle with the Virgin's head at the apex. Poussin uses light to guide the eye from St. Anne's yellow gown to the Virgin and Christ and down to Joseph's feet on the right, thus reinforcing the triangular configuration. The hierarchy of importance of the figures is clearly established. Mary and her child dominate. Then the eye focuses on St. Anne and the infant St. John the Baptist and finally on Joseph. The rest of the composition is made of horizontals and verticals. The horizontal of the step on which the family rests is broken by three small containers in front of it. In this way, the horizontal line of the steps establishes the space of the painting without

152 NICOLAS POUSSIN
Holy Family on the Steps, 1648
National Gallery of Art, Washington.
Samuel H. Kress Collection.

being monotonous. Other horizontals include the stairs behind the group, the stair walls, and the rooflines of the buildings above the group. The main verticals are the columns, the podium holding the urn next to the Virgin, and the edge of a building at the upper right. There is a marvelous interplay of horizontal and vertical in the basin behind St. Anne. The lighting emphasizes the edge of the basin (horizontal) and the thin streams of water flowing from it (vertical). There are three almost parallel diagonals in the painting. The first is from St. Anne's feet through Mary's head; the second is Joseph's staff; the third is the bank of clouds in the background. No object or effect in the painting is randomly placed and a strong sense of order and harmony pervades the scene.

Poussin limited his range of colors in the *Holy Family on the Steps*. The architecture is done in shades of brown. By this limitation, Poussin concentrates the viewer's attention on the central group. The architecture provides a strong and satisfactory background for the family without drawing attention from them. The other colors used are blue, red, yellow, and green. Blue, red, and yellow are the primary colors of the artist's palette and green is a secondary hue—a mixture of yellow and blue. The colors are uniformly muted and do not attract attention. They are subordinated to the outlines of the figures and objects in the painting and are secondary to the geometric structure of the composition.

The painter's technique is also unobtrusive. There are no bold brushstrokes, no areas of heavy impasto or painterly expressiveness. Light is a major compositional element, as is typical of seventeenth-century painting, but it does not function as a separate point of interest. The light attracts attention to the individuals around whom the painting centers, providing an atmospheric environment which makes them believable.

STROZZI

Bernardo Strozzi's *Saint Sebastian* (Figure 153) was painted in the 1630s. Like the Poussin, it is an oil on canvas of a religious subject. Although the subject is less familiar today than the Holy Family, the identification of Sebastian is established by arrows piercing his body. In Christian art, saints are identified by their attributes. These attributes often reflect the manner of their martyrdoms, but may refer to any notable incident in their careers. Sebastian had the dubious distinction of having two martyrdoms, the second of which was permanent. The late third-century Roman Emperor Diocletian condemned Sebastian to be slain by arrows for his beliefs. He was not mortally wounded, though, as a widow named Irene and her servant discovered when they came to cut his body down. Irene nursed Sebastian

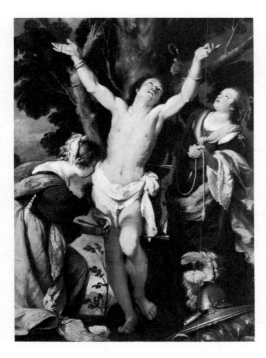

153 BERNARDO STROZZI
Saint Sebastian, 17th century
Courtesy Museum of Fine Arts, Boston.
Purchased Charles Henry Bayley Fund.

back to health only to see him beaten to death in a second execution. His body was thrown into the Cloaca Maxima, the Roman sewer.

Strozzi, unlike Poussin, has painted a dramatic scene that shows Irene and her servant discovering that Sebastian is alive. The servant is bending over to pull an arrow out of Sebastian's leg as Irene unties his arm from the tree. Despite the emotional tension of the incident, the composition is nearly as clear and structured as Poussin's. The basic device is parallelism; Sebastian's body and the tree form the central axis. Irene and the servant flank the axis but are at different heights to add variety. The light focuses the viewer's attention on Sebastian, then on Irene, then on the servant, and finally on the armor on the ground at Irene's feet. The discarded armor is a symbol of Sebastian's having abandoned the prestige of being a soldier of the emperor in order to follow his religious beliefs.

Strozzi and Poussin differ considerably in technique. Strozzi's brushwork is flamboyant, free, and eyecatching. Like Poussin, he uses red, blue, yellow, and green almost exclusively. The paint strokes are less blended and more noticeable than Poussin's. The eye is caught by the heavy impasto on the plumes of Sebastian's helmet, rising out of the glowing metal of the helmet itself. The servant's golden scarf flows around her skirt and down to the ground like a stream of lava. The flesh tones on all three figures are glowing and lively. Sebastian's and Irene's faces shine with emotion. Outlines do not contain the forms and the colors are vivid and sensual.

Nicolas Poussin's *Holy Family on the Steps* is linear and geometric in style, with little emphasis on drama, movement, or facial expression. The composition and technique are subordinate to the subject matter. The arrangement of space is orderly and rational. Poussin emphasizes the intellectual implications of his subject. There is nothing to involve the emotions but much to observe and reflect on. This rational, formal, and highly structured painting invites the viewer to react with equal mental discipline.

In his *Saint Sebastian*, Bernardo Strozzi also used an orderly composition to focus the viewer's attention on the subject. His style, however, is freer and more painterly. His colors and brushwork appeal to the senses and the emotions. Instead of contemplating the story, the viewer is asked to participate, to experience the intensity of the moment. Strozzi is more color-oriented and sensual than Poussin.

Sculpture

Stylistic differences are also evident in works of sculpture, although the characterization of sculptures by their style is complex because the material used plays a large role in determining the outcome of the work. Therefore it is often more enlightening to compare the style of sculptures done in the same medium. Indeed, some sculptors varied their style considerably in response to the medium in which they were working. Donatello in the Early Renaissance and Rodin in the nineteenth century adapted themselves to various sculptural media with astonishing flexibility.

DEGAS
Edgar Degas was a late-nineteenth-century French Impressionist painter and sculptor who was fascinated by motion and studied the movement of race horses and dancers. The moving beauty of the ballerina inspired Degas to try to capture motion in painting and in sculpture. *Dancer Moving Forward, Arms Raised* (Figure 154) was modelled sometime between 1882 and 1895, although it was not cast in bronze until 1919–21, after Degas' death. *Dancer* is a small work, 13¾ inches high, that shows a single nude female in a standard ballet position. The dancer is moving forward with her left leg extended in front of the right leg. Her arms are raised and her hands are held with the palms outward. The dancer lifts her face slightly so that her body forms an S-curve from the leftward turn of the head through a leftward movement of the torso, and a balancing right thrust of the forward leg. The figure is attached to a flat textured bronze base.

Degas' figure is made of seven separate volumes: head, arms, upper torso, lower torso, and legs. There is little feeling of mass since the volumes swell outward and press into space. The surfaces are mostly convex, with a few concavities in anatomically appropriate places. Transitions are smooth and the eye moves around the figure in a smooth series of curves with no abrupt borders. The surface texture of the bronze is smooth but not uniform. There is a flowing quality to the bronze with ripples like waves appearing occasionally, particularly in the arms and legs.

The face of the *Dancer* is anonymous; no attempt has been made to personalize it. The features are generally indicated but have no expression. The figure is open and relates positively to the space around it by allowing the space to flow around it and between the legs. Her individuality is expressed through contour and the suggestion of movement rather than facial features.

BARLACH

In 1937 the German sculptor Ernst Barlach created a bronze called *Old Woman Laughing* (Figure 155). Barlach, who died in 1938, lived to see his work condemned by the Nazis who destroyed much of it. His pessimistic and tragic vision did not fit in with the glorious plans of national socialism. *Old Woman* is a good example of his individual approach. The bronze is in the form of an inverted pyramid 8¼ by 4⅝ by 12¼ inches in dimension. It is a single volume with the anatomy compressed into a heavy, almost featureless unit. The oversized

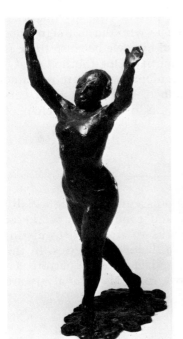

154 EDGAR DEGAS
Dancer Moving Forward, Arms Raised,
ca. 1882–95
Hirshhorn Museum and Sculpture Garden,
Smithsonian Institution

155 ERNST BARLACH
Old Woman Laughing, 1937
Hirshhorn Museum and Sculpture Garden,
Smithsonian Institution

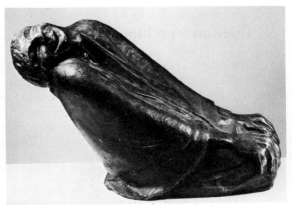

hands reach out to clutch the knees. The grotesque head is thrown back and contorted into a mask of laughter. The transitions are smooth within the volume and the head is kept from becoming a separate entity by the lack of a neck. The face and the hands provide balanced focal points at opposite ends of the triangular silhouette of Barlach's sculpture.

The *Old Woman Laughing* appears massive. The surfaces are textured with enough variety to indicate clothing and flesh but without the fluidity of Degas' *Dancer*. The alternating concave and convex surfaces suggest general anatomical structure, but their edges are blunted as though they were pushed in by the surrounding space. The figure does not reach out in any way, and appears rock-like, solid, and sufficient in itself.

Degas' impersonal *Dancer* symbolizes movement and grace. Barlach's *Old Woman* is hauntingly human and personal without becoming a specific individual. The squat, compressed form, the huge claw-like hands, and the misshapen face are extremely powerful evocations of emotion. The compressed shape of the figure robs it of the joy of laughter. It is a laugh of despair, and the kneeling, deformed figure is haunting in its intensity. Degas' style is light, free, open, and optimistic; while Barlach's is heavy, powerful, tragic, and pessimistic. Degas is the objective observer, catching in his dancing woman the appearance of an ordinary human activity. Barlach's woman represents a different order of reality, the reality of the subconscious, of the world that is felt rather than seen.

Despite the variations in an individual's style throughout his or her career, some factors are constant and provide the art historian with a means to identify the works of artists who did not sign their works. Older works must often be identified by style because there is no documentary evidence of the artist's identity. One method of stylistic identification is to compare small elements which are repeated almost mechanically. A painter, for instance, will often paint ears and eyes in the same way, even though his overall style changes greatly.

Connoisseurship

Connoisseurship is the study of style. Connoisseurs today are usually museum curators who judge the quality and condition of works of art. They are called upon to attribute works to an artist, to distinguish between originals and copies, and to uncover forgeries. In the past, connoisseurs like Bernard Berenson helped wealthy patrons assemble their collections. Today, laboratory methods of analysis are

available to help the connoisseur, but many decisions must still be made on the basis of the trained eye.

Practice is the only way to develop an eye for style. Looking critically and analytically at as much art as possible gradually changes a person's perceptual abilities. Looking is a skill and a talent. It develops over a period of time, with practice, and eventually changes one's perception of life as a whole.

EXERCISES

Once again, to really understand an artist's style requires a combination of looking and study. However, you can judge style on an object-by-object basis and draw conclusions about the artist's work at a particular time. Despite the fact that an artist's style does change, it does not do so overnight, and the individual work represents his or her style at that career stage.

1. Pick out two objects to compare. It is possible to judge style from a single object, but it is easier with two. Choose things that have some characteristics in common to make the differences stand out more clearly. If everything is different, it is hard to pick out the important differences.

2. Repeat steps two, three, and four from the period style exercises on page 227. Be as detailed as possible in your descriptions and analyses.

3. Repeat the process with the second object, trying to relate it to the first one. In the description, for instance, point out the similarities and differences between the two.

4. Synthesize your information. What are the fundamental differences in approach between the two objects? How would you characterize each approach?

A good follow-up to this approach is to do some reading about the artist. Find other examples of work from the same period and see if they resemble the ones you worked with.

12
An Artist's Career

There are two approaches to understanding the changes in an artist's style during his or her career. One is the scholarly approach, studying documents and reading the analyses of historians and critics as well as looking at the works themselves. This approach will provide the most concrete information and should be followed by people who intend to work on a professional level. For the interested nonprofessional, however, a more visual study can be rewarding and informative. Some general background reading combined with close observation and analyses of technique, composition, and impact can provide a good picture of the career of an artist: in this case, Claude Monet.

Claude Monet was born in Paris, November 14, 1840. When he was five years old, his family moved to the seaport city of Le Havre. He disliked school and spent much of his time at the seashore, hiking on the cliffs and playing in the water. Despite this exposure to the out of doors, he began his artistic career by drawing caricatures. By the age of fifteen, he was displaying his caricatures in the window of a local stationery and frame shop, where they were seen by the painter Eugene Boudin. Recognizing the boy's talent, Boudin advised Monet to study the effects of light on the water of the harbor and then paint what he saw. In this way Monet began a love affair with nature and the things that belong to it—sunlight, water, haystacks, and flowers.

In the late 1850s and early 1860s Monet studied in Paris and was

introduced to Pissaro, Renoir, and Manet. He began to paint professionally, and some of his early works were accepted by critics, while his later ones would not be. *Road in the Forest with Woodgatherers* (Figure 156) was painted around 1863. It is an oil painting on a wooden panel and was done over an earlier painting, part of which shows through in the area of the sky. The painting is a landscape showing an autumn forest scene with two people on the left walking toward the foreground carrying huge bundles of wood. The colors are mostly earth tones—greens and browns with highlights of red and orange. The hues are muted and the paint is applied in broad, even brushstrokes. The painting is composed around linear perspective, with a vanishing point to the left of center. Light also plays a major role, cutting the scene in half diagonally, with the upper right sunlit and the lower left shadowed. The two woodgatherers are in the shadow, reducing their importance as focal points.

The impact of *Road in the Forest with Woodgatherers* revolves around light and atmosphere. There is a feeling of spaciousness and warmth. Individual trees do not stand out, nor is there any detail in any elements of the landscape. Even the people are generalized and appear only as forms. Their colors are the same as those of the trees, and they do not take on any personality. The young artist seems interested in catching the general appearance of the out-of-doors rather than in describing any particular scene or event.

156 CLAUDE MONET
Road in the Forest with Woodgatherers, ca. 1863
Courtesy Museum of Fine Arts, Boston.
Henry H. And Zoe Oliver Sherman Fund.

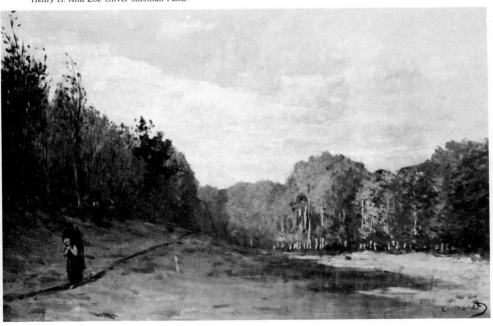

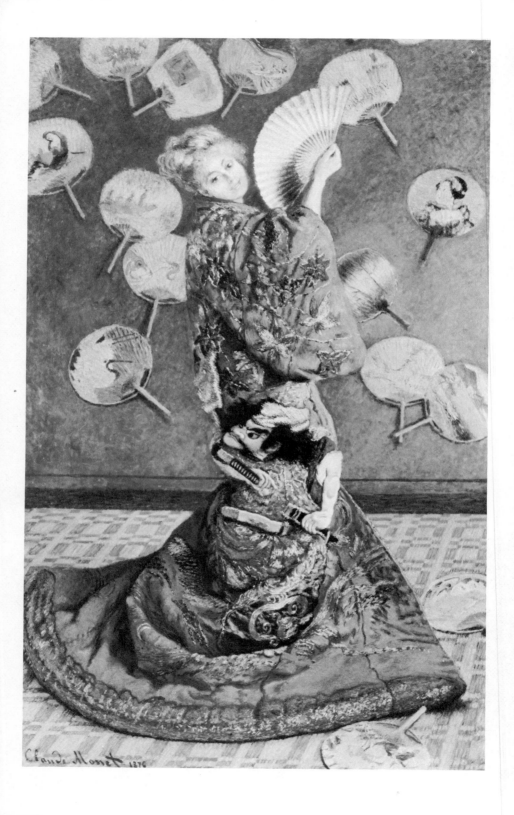

By the 1870s Monet had married and settled in the town of Argenteuil. He often painted his family during this period and was working closely with Renoir. *La Japonaise*, painted in 1876 (Figure 157), is a very different painting from *Woodgatherers*, but that is not unexpected. It would be unreasonable not to expect an artist to reach out in different directions as he matures and develops. *La Japonaise* is a large oil on canvas, 7 feet 7 inches high and 4 feet 8 inches wide. The subject is a blonde woman in a Japanese kimono standing on a patterned floor. The wall behind her is decorated with Japanese fans. The colors are bright and rich, mainly reds and blues.

Monet's change in technique is the most interesting feature of *La Japonaise*. Instead of the broad, soft brushwork of *Woodgatherers*, parts of *La Japonaise* are built up with thick, short strokes of paint which are not blended together. The Samurai figure on the robe and its multicolored border show this change in brushwork. The paint forms ridges on the canvas which add a textural interest that *Woodgatherers* lacks. Monet seems to be more conscious of technical possibilities and less interested in subordinating technique to subject matter. *La Japonaise* was quite successful and brought a good price for its artist.

During the rest of the 1870s and into the 1880s, Monet furthered his interest in the technique of oil painting and experimented with modifications that capture visual and optical effects rather than physical reality. After the death of his wife in 1879, he traveled to different locales to paint and moved to the town of Giverny in 1883. Giverny was his base for the rest of his life, and his home there provided the inspiration for many of his later paintings. In 1885, Monet painted *Poppy Field in a Hollow Near Giverny* (Figure 158), an oil on canvas measuring 24 ¾ inches by 32 inches, which provides an interesting comparison to both *Woodgatherers* and *La Japonaise*. Like the former, it is an outdoor scene. The same one-point perspective composition is used, although the vanishing point is not clearly shown. The colors, however, are far more like those in *La Japonaise*. Red and green predominate, tempered with white, blue, and yellow in different amounts. Unlike either of the previous paintings, no figures appear at all.

Poppy Field is technically an extension of the type of brushwork that appeared in parts of *La Japonaise*. The paint is applied in individ-

158 CLAUDE MONET
Poppy Field in a Hollow Near Giverny, 1885
Courtesy Museum of Fine Arts, Boston.
Bequest of Robert J. Edwards in memory of his mother.

ual, unblended strokes. Close examination reveals that when the art-
ist wants to mix red and white, he puts a stroke of red next to one of
white and lets the viewer's eye do the mixing. The compositional
structure, the focal points, and the impact are all determined by
color. The perspectival arrangement established by the red poppies
ends abruptly about halfway back in the picture when the eye is
shifted in two curves off to the left or right. Varying shades of green
against lighter greens, yellows, and blues give variety and sparkle to
the background. The blue-white of the sky adds further lightness and
provides a natural exit for the eye.

Monet has combined a superb understanding of color with an
extraordinary ability to translate visual experience into paint. When
examined closely, the painting dissolves into individual strokes of
color; but when seen at the normal viewing range, the individual
brushstrokes merge into the forms of objects. There is no drawing;
the artist used no lines. The entire experience is created through
paint itself, unbounded by contours or defined forms.

Recent research and photographic analysis has revealed a tre-
mendous variety in Monet's brushwork. It has also been determined
that (at least in the paintings in the Museum of Fine Arts, Boston),

240

159 CLAUDE MONET
Old Fort at Antibes, 1888
Courtesy Museum of Fine Arts, Boston.
Gift of Samuel Dacre Bush.

Monet began to use white underpainting on his canvas to enhance the vivid quality of the surface colors. For more detailed technical information see *Monet Unveiled: A New Look at Boston's Paintings,* Museum of Fine Arts, Boston, Mass., 1977.

Old Fort at Antibes, signed and dated 1888 (Figure 159), confirms the conclusions suggested by observation of *Poppy Field in a Hollow Near Giverny.* The two paintings are almost identical in size and both are landscapes without figures. *Old Fort* is a view across the sea toward a group of buildings on the left with a purple-hued mountain range in the background. The painting is structured in horizontal thirds, with the water extending into the middle area. The sky occupies the upper third of the canvas. The water in the lower third is a flickering curtain with no suggestion of recession. Dashes of green, turquoise, blue, and white translate paint into wave movement and light. Sailboats are suggested with two or three strokes of paint against the water and purple mountains.

The fort and rocks are severely geometric with a tangible strength, but they are not drawn in any detail. A feeling for internal structure rather than just a representation of surfaces is evident. The mountains are tinted gently from darker to lighter lavenders in a se-

241

ries of repeating pyramidal forms. *Old Fort at Antibes* has the same qualities as *Poppy Field*, but there is a sureness and maturity that comes with experience. Light is used to unify the painting, and the technique of applying unmixed paint in individual brushstrokes is used to great advantage. Different kinds of brushstrokes suggest the flow and motion of the sea, the solidity of rocks and buildings, the remoteness of mountains, and the openness of the sky.

By this point in his career, Monet has become completely oriented to painting for its own sake rather than as a reflection of subject matter. Visual experience, rather than objects and figures, is his subject matter; the virtuoso application of carefully prepared oil paint is his instrument. Under these circumstances there was little reason to paint a different subject in each work, so he began to work with series paintings; repeating the same subject under various atmospheric conditions.

Rouen Cathedral at Dawn is part of such a series (Figure 160). This oil on canvas, 41⅔ inches by 29 inches, was painted in 1894. The craggy outline of the cathedral is shown from an angle in a closeup which shows only part of the façade. The colors are muted blues and browns with a whitish yellow light on the left. There are no figures; no suggestions of life or movement.

The cathedral itself is treated almost cavalierly. Monet is not concerned with its historical interest as an example of medieval church architecture, and suppresses any individuality of decoration.

160 CLAUDE MONET
Rouen Cathedral at Dawn, 1894
Courtesy Museum of Fine Arts, Boston.
Tompkins Collection. Purchased,
Arthur Gordon Tompkins Residuary Fund.

The painting consists of shapes interacting with light. The cathedral tower is both illuminated and obscured by the hazy early-morning sun. The doorways are deep in shadow and the stained glass of the rose window looks like a gaping hole.

Technically, *Rouen Cathedral at Dawn* is unusual. The thick, rough paint provides a visual impression of the texture of the crumbling stones of the centuries-old church. The brushstrokes reproduce the textures of the stone as they appear in the dawn light.

Monet worked on the Rouen cathedral series from 1892 to 1894. The majority of the work was done in a rented room across from the cathedral, where he worked on a number of canvases at once. Since each canvas represented the cathedral under the lighting conditions of a different time of day, he would work on different paintings as the light changed. On some days, the light was never right and he would sit for hours without being able to paint. The two years he spent on the project gave Monet time to consider what techniques would best capture the "envelope" of light that constantly shifted around the cathedral. The Rouen Cathedral series was extremely successful and was admired by such artists as Cézanne, Degas, Renoir, and Pissarro.

After 1900, except for a few trips abroad, Monet worked at Giverny, using his extensive gardens and water lily pond as material for his paintings. In 1892 he remarried and lived comfortably with his family enjoying the critical acclaim that was so different from the scorn his early experiments in Impressionism had provoked.

Waterlilies II (Figure 161) is part of a series of water lily paintings done between 1900 and 1926. It is an oil on canvas, almost square, 35⅛ inches by 36¾ inches. The subject is a close, strictly limited view of a segment of a water lily pond. The lily pads are painted in greens, the flowers in red and white, and the water in blue, pink, and white. There is no depth, no recession, no flickering—just color and reflection. The composition is organized from a series of points

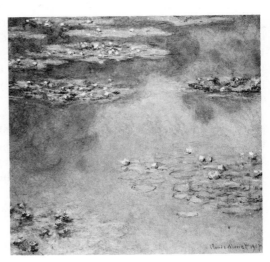

161 CLAUDE MONET
Waterlilies II, 1907
Courtesy Museum of Fine Arts, Boston.
Bequest of Alexander Cochrane.

of view. The observer looks at the water lilies on the lower left from a steeply angled upward bird's-eye view. The angle is less steep in the group on the right, and by the time the eye approaches the top clusters of pads, it is level with them. The overall effect is consciously antiperspectival, the opposite of the three-dimensionalism of early works like the *Woodgatherers*. The inconsistency of viewpoint in *Waterlilies II* serves as a visual reminder that the canvas is flat and that any third dimension is illusionary.

Monet had a long, prolific career which cannot be understood from studying a few paintings; but looking at paintings from various points in his work provides an overall picture of the changes in Monet's style. *Road in the Forest with Woodgatherers* shows the artist's early concern with working out-of-doors. Monet demonstrates an interest in light and atmosphere and a strong sense of color. Figures are not emphasized and there is no story. The painting does not give information about its subject. It captures the experience of the moment.

La Japonaise, from more than a decade later, demonstrates a growing and changing sense of color. The colors are brighter and are more important in the composition of the painting. Unlike *Woodgatherers*, a human figure dominates the painting, yet it is not truly a portrait. Even though the model is his wife, Monet does not reveal her personality, nor does he make her the visual or intellectual focus of the work. Rather, the painting focuses on technical concerns such as the Impressionist brushstroke appearing in details of the Japanese costume.

This technical concern continues in the two landscapes, *Poppy Field in a Hollow Near Giverny*, 1885, and *Old Fort at Antibes*, 1888. Monet retains his ability to construct clear and simple compositions while concentrating on the atmospheric and lighting qualities of each scene. His technique is becoming more precise with an assortment of brushstrokes available for every atmospheric condition.

With each painting Monet shows greater interest in technique and less involvement in subject. *Rouen Cathedral at Dawn* follows this trend. The cathedral is an excuse to adapt complicated painting techniques to the precise representation of the effects of light. The painting is becoming an end in itself rather than a translation of an outside phenomenon.

Waterlilies II goes even further. The lack of a consistent viewpoint, the deliberately limited range of color, and the lack of flickering movements force the viewer to see the painting simply as an artistic creation. The painting's success depends on formal elements such as composition, texture, and color because the painting has no

real subject, no story to tell, and no formal content. Monet has achieved an abstract mode of painting that will greatly influence later artists.

In 1923 Monet had surgery for the cataracts which had been restricting his work for several years. With his sight partially restored, he continued to paint until his death at Giverny on December 6, 1926. By the time of his death, Impressionism was a movement of the past, Cubism had existed for more than a decade and the controversy that had once surrounded his work was long ended. Unlike many artists, Monet lived to gain public recognition and government support for his work. Today his contributions to the abstract art of the twentieth century are becoming more evident. The development of Monet's style extends from a realism not too different from that of Courbet to the boldly contemporary vision of *Waterlilies II*.

EXERCISES
Select a group of works spanning the career of an artist. If you do not have access to a good permanent collection, wait for a special exhibition. Avoid using reproductions to fill in the gaps, because a reproduction is never a substitute for the original. At best, reproductions can provide a useful reminder of paintings you have observed. After you have analyzed the works, do some reading about the artist. An exhibition catalogue is often a good source of information without too much detail. The reading should supplement, not replace, individual observation.

1. Describe and analyze the first object carefully. Consider size, subject matter, composition, and technique.

2. Repeat the process with the second work and then compare it to the first one. Do there seem to be similar concepts behind each with differences in execution or are they basically different? Are they a lot alike? What does the degree of change indicate about the artist's motivations at that particular time?

3. Continue to work with each object both separately and in conjunction with the previous ones. Look for elements that repeat consistently. If anything is limited to one work, it is probably an exception. Reading about the artist's life could provide a reason for the exception.

4. Summarize. What stages can you see in the artist's career? Have there been frequent changes of direction, or a general consistency?

5. Synthesize your observations and your reading. How do the facts of the artist's life explain the stylistic features you have noticed? What conclusions can you draw about the artist's career as a whole?

Bibliography

GENERAL REFERENCE BOOKS

Bray, Warwick, and David Trump. *The Penguin Dictionary of Archaeology*. Baltimore, Maryland: Penguin Books, 1972.
The Penguin series of dictionaries are complete, reliable and reasonably priced in paperback editions.

Fleming, John, Hugh Honour, and Nikolaus Pevsner. *The Penguin Dictionary of Architecture*. Baltimore, Maryland: Penguin Books, 1966.

Gombrich, E.H. *The Story of Art* (13th ed.). London: Phaidon Press, Ltd., 1978.

Hall, James. *Dictionary of Subjects and Symbols in Art*. New York: Harper & Row, Publishers, 1974.
An invaluable resource. Each subject is explained fully and examples are given of specific usages in art.

Janson, H.W. *History of Art* (2nd ed.). Englewood Cliffs, N.J.: Prentice-Hall Inc., and New York: Harry N. Abrams, Inc., 1977.
This is an extremely complete and well-illustrated textbook.

Mayer, Ralph. *A Dictionary of Art Terms and Techniques*. New York: Thomas Y. Crowell Co., 1975.
A standard reference work.

Murray, Peter and Linda Murray. *A Dictionary of Art and Artists*. Baltimore, Maryland: Penguin Books, 1959.

247

Pierce, James S. *From Abacus to Zeus: A Handbook of Art History.* Englewood Cliffs, N.J.: Prentice-Hall, Inc., 1968.
A good, inexpensive reference book.

MATERIALS AND TECHNIQUES
Cennini, Cennino d'Andrea. *The Craftsman's Handbook (Libro dell'arte)* trans. Daniel V. Thompson, Jr. New York: Dover Publications, Inc., 1960.
A good translation of a primary source on Renaissance technique.
Dunstan, Bernard. *Painting Methods of the Impressionists.* New York: Watson-Guptill Publications, 1976.
Hale, Gardner. *The Technique of Fresco Painting.* New York: Dover Publications, Inc., 1966.
A first-hand report by a twentieth-century fresco painter.
Simmons, Seymour III, and Marc S.A. Winer. *Drawing: The Creative Process.* Englewood Cliffs, N.J.: Prentice-Hall, Inc., 1977.
Thompson, Daniel V. *The Practice of Tempera Painting.* New York: Dover Publications, Inc., 1936.
A working artist's view of the tempera medium.
Vasari, Giorgio. *Vasari on Technique.* Trans. Louisa S. Maclehose. New York: Dover Publications, Inc., 1960.
A sixteenth-century artist and critic's view of the art world.

ORGANIZATION AND ARRANGEMENT
Birren, Faber. *Color Perception in Art.* New York: Van Nostrand Reinhold Co., 1976.
————. *Principles of Color: A Review of Past Tradition and Modern Theories.* New York: Van Nostrand Reinhold Co., 1969.
Birren's books are readable and informative for the general reader although intended primarily for artists.
Poore, Henry R. *Composition in Art.* New York: Dover Publications, Inc., 1967.
The diagrams in this book are especially useful.

IMPACT AND STYLE
Myers, Bernard. *Sculpture: Form and Method.* New York: Reinhold Publishing Corporation, 1965.
Rasmussen, Steen Eiler. *Experiencing Architecture.* Cambridge, Mass.: M.I.T. Press, 1959.
Rawson, Philip. *Drawing.* The Appreciation of the Arts/3. London: Oxford University Press, 1969.
Rogers, L.R. *Sculpture.* The Appreciation of the Arts/2. London: Oxford University Press, 1969.
This and the Rawson book are both extremely informative although written in dry academic language.

Index

249

Groin vaults, **82,** 82–83
Ground, 21
Guggenheim Museum, New York, **90,**
 90–91

Hafner Ware, 64
Hagia Sophia, Constantinople, 87
Hals, Frans, 23
Hamadryad (Rosati), 130–31, **131**
Hatching, 43
Haunch, 80
Head of a Man Painted in Wax, **19**
Head of a Woman (Picasso), 69, **69**
Head of Yough (di Credi), 44, **44**
Hepworth, Barbara, 53
Hermes Kriophoros, 173, **174**
High relief, 56
High Renaissance, 225
Hobbema, Meindert, 156–57, **157**
Hofmann, Hans, 29, 129–30, **130,** 165,
 165
Hollow-casting, 64–65
Holy Family on the Steps (Poussin),
 228–32, **229**
Homer, Winslow, 199
Honthorst, Gerard van, 176
Hopfer, Daniel, 102
Hopper, Edward, 102, 132, **133,** 199
Hudson River School, 211
Hue, 123
Hull, John, 218
Hyatt Regency Hotel, San Francisco, 134,
 135

Iktinus, 118–19, **119**
Impasto, 23
Impressionism, 29, 125, 127, 144, 170,
 180, 186, 196, 211, 224, 243–45
Incas, 64
India ink, 42
Indirect carving, 49, 53–54
Indirect painting, 23
Ink, 42
Innovation, 170, 173–80
Intaglio printing, 95, 99–104
Intaglio relief, 56, 58
Intensity of color, 124
Inustion, 19
Ionic column, 76–77, **77**
Iris (Nolde), 30, **31**
Isocephaly, 143

Japanese ink, 42
Japonaise, La (Monet), **238,** 239, 244
Jaunting Cart, The (Toulouse-Lautrec),
 105–6, **106**
Jefferson, Thomas, 190
Jewelry, 182–83

Joel Barlow (Dunlap), **184,** 184–85
John Morgan (Kauffmann), 221–22, **222**
Joseph Moore and His Family (Field),
 114–15, **115**

Kalf, Willem, 156, **157**
Kallikrates, 118–19, **119**
Kauffmann, Angelica, 221–22, **222**
Keystone, 80, 81
Kirchner, Ernst Ludwig, 97, **98**

Lachaise, Gaston, 153, **154**
Lady with a Gold Chain (Rembrandt),
 26–27, **27**
Last Supper (da Vinci), 8–9, 20
Lehmbruck, Wilhelm, 70
Le Nain, Matthieu, 176
Les Invalides, Paris, 88
Light, 131–35
Limestone Figure of a Man (Greek), **49**
Line, 39
Linear Construction No. 4 (Gabo), **152,**
 152–53
Linear perspective, 141–44, **142**
Linear style, 145–48
Line engraving, 99
Linoleum cut (linocut), 98
Lipchitz, Jacques, 70, 131, **131**
Lithography, 104–6
Lombard Madonna (Romanesque),
 117–18, **118,** 194
Longfellow House, Cambridge, **219,**
 219–20, **220**
Lorenzo de'Medici (Verrocchio), 188, **188**
Lorrain, Claude, 212, **212**
Lost-wax casting, 65–67
Louis, Morris, **36,** 36–37, 127, 176
Love and Death (Goya), 103, **103**
Low relief (bas-relief), 56
Lowry, Bates, 203

Maderno, Carlo, 136–37, **137**
Madonna and Child (French Gothic), 56,
 57
Madonna and Child in a Landscape
 (Bellini), 209–10, **210**
*Madonna and Child of the Eucharist,
 The* (Botticelli), 110, 116, **116**
*Madonna and Child, with SS. Francis
 and Clare and Other Saints* (da Rim-
 ini), 195, **195**
Madonna of the Clouds (Donatello), 58,
 58
Madonna of the Niche (della Robbia), 62,
 63
Manet, Édouard, 186, 224
Mannerism, 153, 211, 224–25
Man of the Republic (Roman), 62, **63**